ART FOR A MODERN INDIA, 1947–1980

⇒ O B J E C T S | H I S T O R I E S ⇐

Critical Perspectives on Art, Material Culture,
and Representation

A series edited by Nicholas Thomas
Published with the assistance of the Getty Foundation

ART
FOR
A
MODERN
INDIA,
1947–1980

REBECCA M. BROWN

DUKE
UNIVERSITY
PRESS

DURHAM & LONDON
2009

© 2009 Duke University Press
All rights reserved
Printed in the United States of America
on acid-free paper ∞

Designed by Jennifer Hill
Typeset in Warnock Pro by
Tseng Information Systems, Inc.

Library of Congress
Cataloging-in-Publication Data
appear on the last printed page
of this book.

To Sam

CONTENTS

List of Illustrations ix

Acknowledgments xi

INTRODUCTION: **THE MODERN INDIAN PARADOX** 1

ONE. **AUTHENTICITY** 23

TWO. **THE ICON** 45

THREE. **NARRATIVE AND TIME** 75

FOUR. **SCIENCE, TECHNOLOGY, AND INDUSTRY** 103

FIVE. **THE URBAN** 131

EPILOGUE: **THE 1980S AND AFTER** 157

Notes 163

References 171

Index 187

(plates appear between pages 114 and 115) PLATES

1 M. F. Husain, *Under the Tree*, 1959

2 G. R. Santosh, *Untitled*, 1973

3 Ganesh Pyne, *Woman, the Serpent*, 1975

4 Raghav R. Kaneria, *Sculpture-I*, 1975

5 Bhupen Khakhar, *Man with Bouquet
 of Plastic Flowers*, 1976

6 Krishen Khanna, *The Last Supper*, 1979

7 K. C. S. Paniker, *Words and Symbols*, 1964

8 F. N. Souza, *Landscape*, 1961

9 Gieve Patel, *Two Men with a Handcart*, ca. 1979

10 Ram Kumar, *Varanasi*, 1964

FIGURES

1 Apu at school. Still from *Pather panchali*, 1955 27

2 Charles Correa, Gandhi Smarak Sangrahalaya,
 Ahmedabad, 1958–63 36

3 J. K. Choudhury and Gulzar Singh,
 Ashok Hotel, New Delhi, 1955 60

4 Ramprakash L. Gehlot, Vigyan Bhavan
 Conference Center, New Delhi, 1955 62

5 Satish Gujral, Belgian embassy, front façade
 of main building, New Delhi, 1980–83 87

6 Satish Gujral, Belgian embassy, detail of
 rear of complex, New Delhi, 1980–83 89

7 Interior of Meena's house. Still from *Waqt*, 1965 96

8 Raja running through the modern city.
 Still from *Waqt*, 1965 99

9 M. F. Husain, *Portrait of the Twentieth Century*,
 detail, 1992 105

10 Le Corbusier, Assembly, Chandigarh, 1951–63 110

11 Le Corbusier, High Court, Chandigarh, 1951–63 110

12 View of workers, from Le Corbusier,
 Complete Works, 1957 112

13 Nasreen Mohamedi, *Untitled*, ca. 1976 120

14 Nasreen Mohamedi, *Untitled*, ca. 1971 120

15 Achyut Kanvinde, Dudhsagar Dairy Complex,
 main building, Mehsana, Gujarat, 1970–74 124

16 Sunil Janah, *Steel Smelting Shop, Tata Iron
 and Steel Works, Jamshedpur, Bihar*, 1957 128

17 Raghu Rai, *Traffic at Chawri, Delhi*, 1965 133

⟫ LIKE MOST OF US, I often feel as though I am trapped in my head while writing, dialoguing with the texts and images swirling around in between the ears and behind the eyes—and never quite escaping that bodily space. But writing is nurtured in the sharing. This book comes out of an intellectual space created by students, colleagues, friends, family, and fellow travelers. I have endeavored to embrace the many suggestions, changes of direction, and the molding, buffeting, arguing, and encouraging as I worked on the book. To all those who have knowingly or unwittingly participated in that intellectual activity I extend inadequate and heartfelt thanks. I hope the book has achieved a small piece of what audiences of earlier iterations wished for it.

I am keenly aware of the privilege I enjoy as a member of the Euro-American academy, and as one enabled to have the time and physical and intellectual space to write this book at all. I find it quite astounding that I have been able to spend my time looking at art, watching film, exploring buildings, investigating popular culture, and thinking and writing. I do not take the opportunity to think and write lightly; I find it a weighty and sometimes cumbersome responsibility.

This project has had many generous readers at each of its stages. Its earliest conception occurred in the classroom where I heard arguments about moder-

nity, contemporary art, Orientalism, Asia, language, power, the icon, and space from students examining texts and art and struggling to make sense of them. At St. Mary's College of Maryland my students pointed out the work of P. T. Reddy that sat right in front of me on the walls of the college. After my years of textual training they taught me to see art again. Toward the end of the writing process, the students and staff at the Maharaja Sayajirao University in Baroda raised crucial issues, debated vociferously, and helped me hone my ideas. These moments encapsulate the joy of working intellectually, and I heartily thank the participants for their energies and invaluable contributions to this project. Dialogue with colleagues in India, Europe, and North America speaking from anthropology, gender studies, politics, history, literature, philosophy, art history, and that strange discipline of the nonacademic also helped me hone my thinking, writing, and position. Others supported me, asked naive questions that turned out to be brilliant, and helped me keep my feet on the ground and my head up.

Institutions and colleagues supported me when I was institutionless; this generosity continues to overwhelm me.

I especially thank my colleagues who graciously took on the task of reading early versions of the manuscript and provided invaluable feedback: Pika Ghosh, Ruth Feingold, Deborah Hutton, Kristy Phillips, and Lisa Nadine Owen. My father, Adrian Brown, asked to read the manuscript and provided me with wonderful and extensive notes that have made the book stronger and, perhaps, opened up an audience for it among geotechnical engineers. The two anonymous readers took great care and spent extensive time and energy working with the manuscript to help me hone its thesis and shape its final form. I truly appreciate their sincere and generous work.

I have presented portions of the book in many varied situations, from the roadside in New Delhi to a classroom in Nijmegen. My thanks to all of those audiences for helping me articulate the argument that lies in these pages.

Our teachers inform our thinking, and mine have truly allowed me to flourish, whether my undergraduate mentor George Gorse or my graduate advisers Frederick Asher and Catherine Asher. Our colleagues enable us to do intellectual work and spur us to excel through their example; for these gifts I thank the aforementioned readers, Deepali Dewan, Padma Kaimal, Parul Dave Mukherjee, and my colleagues at Swansea University. Ken Wissoker, Mandy Earley,

Molly Balikov, and the rest of the editorial and production staff at Duke helped me at each step along the way; I am honored to have had the opportunity to work with this professional group of people.

I am truly grateful that those who made the objects reproduced here have generously allowed me to publish their work. We remain a small group of scholars researching this material, and often it is difficult to ascertain the correct information, even when faced with primary documents. I have made every effort to locate the proper copyright holders and owners of these works, and I welcome information that will help us record the story of the mid-twentieth century with ever greater accuracy.

My families in Seattle, Portland, DC, Redlands, Swansea, and Denver have fed and housed me intellectually, emotionally, and physically over the course of writing this book, and without the haven of my mother's home the ideas contained here would not have borne fruit. Many thanks for the literal and metaphorical food and shelter.

I have shared the entire process of writing and thinking this book with my partner, Sam Chambers, who has read every word uncountable times and hashed out arguments over uncountable cups of coffee. It took some courage to find the space to write this book, and we found that space together. Without the we, there would be nothing here.

Material on film from chapters 3 and 5 appeared in my earlier article, "Partition and the Uses of History in *Waqt/Time* (1965)," *Screen* 48, no. 2 (2007): 161–78. Material on K. C. S. Paniker and Satish Gujral in chapters 3 and 4 appeared in "The Modern and the Ancient: Twentieth Century Re-readings of Indian History," *South Asian Studies* 22 (2006): 103–14.

NOTE ON TRANSLITERATION

Rather than burden the reader with complex diacritical marks, I have chosen to simplify the transliteration of Urdu and Hindi words included in the volume. Therefore those familiar with these languages will not see long vowels, nasals, or variants of consonants indicated. Non-English words are italicized at first mention.

THE MODERN INDIAN PARADOX

⇉ THIS BOOK ARISES from a paradox located at the heart of artistic production in postindependence India: how to be modern *and* Indian? On the one hand, an unmarked, presumptively Western modern embraces the universal, has faith in pure form, and understands history as a story of progress. This conception of the modern exerts pressure on those producing art after 1947 in India, a time when modernization programs for industry overlapped with a drive to define the new independent nation. On the other hand, this move toward a universal modern is countered by a desire to recover the supposed "truth" of Indian culture. Indian nation-building efforts have often sought out a lost, imagined, and pure precolonial past, holding it up as a locus for a national identity. Colonialism, of course, cannot simply be expunged from India's history, a reality that those who seek this past purity acknowledge. Furthermore, no narrative of India's history before colonialism can be told without recognizing the role colonialism had in constructing that very history. But these are not the only elements of this mid-twentieth-century paradox. In addition to the drive toward universalism and the desire for a pure, precolonial India, the new nation had to work through a palpable sense of "being behind" on the path to modernity in comparison with Euro-America. Art of the first generation after

independence thus faced a mandate to establish an Indian national identity *and* to participate in a universal modern while attempting to "catch up" in a large asymmetrical game of development. How to be simultaneously modern and Indian, if the former demands an articulation of the universal and the latter requires an attention to the local? How to catch up while still maintaining and building a national identity?

In the chapters that follow, I examine carefully chosen examples that range from oil painting on canvas to Hindi cinema out of Mumbai's Bollywood to demonstrate the ways visual culture, and by extension India itself, negotiates this paradox. How might a milk factory built for a cooperative in Gujarat participate in the construction of a modern India without merely aping Le Corbusier? How does one paint what is arguably the holiest city in India, Varanasi, and simultaneously assert a modern Indian idiom? When do parallel lines drawn in pencil on a piece of paper start to participate in the construction of India's modernity? The examples discussed in this book, from the red velvet floor of Meena's house in *Waqt* (dir. Yash Chopra, 1965; figure 7) to the monumental *chandrashala* entryway on the Vigyan Bhavan in New Delhi (1955; figure 4), trace the outlines of modern Indian art and politics, addressing the question of what it means to be both Indian and modern.

I examine these works because they refuse to be impaled on either horn of the dilemma, choosing neither a naive universalism nor an unthinking indigenism. Instead, all of them take on the *question* of modernity in a postindependence context, and each work explores the possibilities of that question to different ends. These works address the modern/India paradox at a time when India's national identity is only nascent. The two terms of the paradox are in flux and unclear during these decades. What often arises from the struggle with the dilemma in the Indian context is a deeper understanding of the postcolonial condition in all of its complex relations to colonialism, modernity, and national identity. This book thus demonstrates how visual culture in India during the period 1947–80 negotiates the paradox of Indian modernity and argues that this negotiation produces several interconnected understandings of the postcolonial condition.

The theorization of this postcoloniality has shifted over the past few decades. An outgrowth of colonial studies that attempted to understand the particular positionality of formerly colonized cultures, early postcolonial theory ad-

dressed the struggle to articulate subjectivity in the face of a history of Othering by European powers. The publication of *Orientalism* by Edward Said in 1979 deepened the critical analysis both of Eurocentrism and of the construction of the formerly colonized Other. In the 1990s postcolonial theory—following the 1980s work of Gayatri Spivak and the subaltern studies group (Spivak 1988, 1990; Guha 1982; see also Chakrabarty 2002)—turned to an articulation of the post-colonial as understood from the space of the postcolony, rather than through the lens of the Euro-American academy. Homi Bhabha's work has developed the idea of a "third space," articulating postcoloniality as the space "otherwise than modernity" (1990, 118–19; 1994, 6). Many of these authors are also concerned to articulate the ways in which postcoloniality is not simply a problem of the postcolony but an integral part of an understanding of multicultural-ism and hybridity in both the former colony and the former metropole (Brah and Coombes 2001). More recently, the literature of postcolonial theory has begun to make inroads into the question of modernity itself, long the province of those focusing on Euro-American culture. Perry Anderson (1998), Timothy Mitchell (2000), Dipesh Chakrabarty (2000, 2002), and others have uncovered the centrality of colonialism to the production of modernity, not simply as a tangential motivating factor but as a constitutive, core element.[1] This move in the theorization of postcoloniality contradicts discourses within art history that propose a series of "alternative modernities" for regions outside of Euro-America.[2] Instead, the literature investigates modernity's roots in the so-called periphery, acknowledging the integral role of formerly colonized spaces to the constitution of the modern.

It is at this juncture that this book addresses the broad field of postcolonial studies. In large part the discussion of twentieth-century Indian art has been mired in the early constructions of modernity as a European preserve, dependent on its colonial possessions only for referents. Among other things, this has led to the dismissal of the visual culture from 1947 to 1980 as "derivative" of particular Euro-American styles or movements, with little acknowledgment of the colonial roots of modernity. With the new turn in postcolonial theory, this book forges a fresh approach to modernity in India's visual culture, one that takes seriously the paradox of constructing a modernity in the face of both the universalizing modern and the particularity of India.

While the focus of this book is India, the paradox discussed is not only

an Indian one. It appears clearly on the subcontinent, but it is fundamental to the operation of modern visual culture more broadly. The contradiction of universal-versus-national also exists within art from Europe and North America, with the crucial difference that the national or the local often goes unmarked in the West, whereas it is heavily marked in the Indian context. The exceptions to the unmarked European contradiction tend to occur at the margins of the mainstream: in struggles for national identity in the former Soviet states or in calls to articulate minority identity within and across existing state boundaries. But these issues also anchor mainstream European art: a presence less marked makes it no less pressing. By exploring this paradox on the subcontinent, this book invites a similar consideration of the same types of dilemmas at the root of modern European art. The paradoxes inherent in modernism grow in importance as we begin to acknowledge the dependence of modernity on colonialism.

Throughout the book, the term *modern* does not indicate a periodization; I eschew the usage sometimes employed in art history and literary studies in which *modern* indicates either a specific period or a specific genre of art. Instead, *the modern* or *modern* indicates a particular approach to the world embodied in an epistemology of progress, a faith in universals, the primacy of the subject, and a turning away from religion toward reason. The term *modernity* is used here for the condition that embodies this epistemology. While the art historical uses of these terms for a period, period style, genre, or type sometimes overlap with these concerns, I wish to make clear here at the start that while I analyze art as it struggles with modernity, this book does not investigate the art historical Modern Art. Instead I call for a broader understanding of how modernity and the visual inform one another.

Of course, the term *modern* has a rich history, and thus I pay attention to its use by artists, critics, and writers on Indian art during the decades after independence, to mark the difference between that usage and the current one. Only rarely do these individuals use *modern* in an art historical, disciplinary context, and I attend to this fact by taking seriously the intersection of modernity and visual culture during the decades after independence. This approach to the modern enables a historical discussion of this period that articulates art's participation in and production of modernity.

Similarly, my use of the term *postcolonial* is purposive. It does not designate

a temporal period *after* colonialism. *Postcolonial* offers no more of a periodiza-tion than does *modern*, although sometimes both terms are taken as such. Post-coloniality arises out of debates and dilemmas produced by colonial relations of power. *Postcolonial* thus describes the historical, political, cultural, and epis-temological conditions produced by and through the historical experience of colonialism.[3] These conditions present themselves after independence, but they also exist prior to that moment in nationalist debates, anticolonial battles, and movements to express a new national identity. More important, *postcolonial* does not reference a time period, but rather an understanding of the implica-tions of colonialism for those living in a formerly colonized region. It describes a *condition*.

In negotiating the paradox of how to be simultaneously modern and Indian, the works examined in this book help articulate postcoloniality. They show us that the postcolonial is rooted in the modern/India paradox, which itself depends on colonial power relations. If modernity arises from decolonization and independence, it also demands emulation of the Euro-American model of the modern. On its surface, the postindependence articulation of a mod-ern Indian nation is impossible: on the one hand, extricating the nation from earlier colonial relations requires erasing several hundred years of history; on the other, the need to relate to "modern Euro-America" reifies, at least in part, the historical colonial relation. Colonial history cannot be erased, and therefore contemporary India continually negotiates its relationship to its past through the constructions inherited from colonialism. That past, then, is interrupted by the colonial era itself—and more importantly, during the colonial era India's history was written in the service of the colonizer. Substituting a nebulous opposing narrative for this colonial history only serves to reify the colonial one, revealing the interdependency of colonial and nationalist visions of India. Several works discussed in this book attempt to understand this fragmented relation to the past through visual expression; the *struggle* is where one finds the postcolonial. The most successful works take on the paradox directly and use as their subject the fragmentation of India's past and its contemporary identity.

If India is fragmented then it seems that one cannot take for granted either of the terms within the paradox of modern/India. Defining what India might mean was one of the central elements of postindependence politics: this process of definition shaped decisions about architectural commissions, the creation

of museums, and the support of the arts across the subcontinent. Striving for unity within diversity only added to the struggle that defines the postcolonial condition. In the end, these terms are attempts to stabilize inherently unstable objects: India, the modern, and the postcolonial.

COLONIAL, POSTCOLONIAL, AND MODERN

The Indian need to be modern exists in the context of two assumptions: that the subcontinent is not modern, and that modernity is desirable. The former assumption springs from the very definition of modernity. Modernity depends on a differential relation between those that are modern and those that are not yet modern, and colonialism often defends itself as dedicated to bringing those regions of the "not yet" toward modernity. Colonialism and modernity are therefore intimately interlinked. As a result, articulating a modernity after colonialism means unpacking the relations of power that support colonialism, produce modernity, and continue to operate in a postindependence context.

Historians and literary scholars have long been aware of the ways in which modernity relies directly on colonial relations of power, relations that themselves supported European and American economic growth in the eighteenth and nineteenth centuries. Dipesh Chakrabarty has focused on the ideology of progress and development embedded within modernity and has pointed to this historicism as a necessary move in the justification of colonialism in the nineteenth century:[4] "Historicism is what made modernity or capitalism look not simply global but rather as something that became global *over time*, by originating in one place (Europe) and then spreading outside it" (2000, 7; see also Lowe and Lloyd 1997, 1–32; and Prakash 1995, 3–20). Modernity understood from this perspective becomes inseparable from colonialism: the colonial space articulates the difference between civilized and not civilized by placing the "nots" further "back" on the timeline of modern progress. Chakrabarty frames this as the "not yet" of modernity's historicist outlook: colonial regions are not yet ready—for democracy, for industrialization, for, as I argue in this book, the concepts related to abstract art (2000, 49–50, 65–66).

Others have also argued from within Western modern visual culture that progressivism is the problem of modernity. That is, the assumption of the always-new and the value of the avant-garde (in other words, the Hegelian articulation

of negation to move forward) fix a definition of modernism into a pattern of reaction against a set norm and then resolution into another base tradition (Foster 1983; Osborne 1995). These theorists of the avant-garde identify this element of modernity as a problem, and some locate within it the fundamental colonial and sexual relations of power modernity is founded on (Pollock 1992). This work heralds a critique of the avant-garde and of modernism founded on an understanding of the interdependence of colonialism and modernity.

Nonetheless, in the context of the centrality of an avant-garde for modernity, other modernities—and for the world ostensibly outside Euro-America, the plural here is crucial—struggle to articulate themselves in the absence of a canonical norm to work against. Geeta Kapur, for example, argues that India may not have had a modern art if we define the development of such a movement as an avant-garde reaction to an a priori or institutionally defined canon (2000, 288).[5] Hegelian, progressivist models cannot be easily translated for use in postcolonial contexts. India, like other formerly colonized spaces, helped constitute the conception of historical progress (by serving as a foil), and thus we cannot expect simply to replicate such models here.

The difference that the historicist reading of modernity sets up between the normative Euro-American modern and any other culture attempting to establish the modern leads to a valorization of the primitive as authentic, timeless, and nonmodern. One can see this impulse toward the primitive encompassed by the symbolist movement of the late nineteenth century, the Arts and Crafts movement of the early twentieth century, the cubist interest in the formal and spiritual qualities of African sculpture, and the abstract expressionists' interest in Jungian, primordial conceptions of universality and spirituality. This impulse extends outside a strict Euro-American context as well, as seen in Soetsu Yanagi's aesthetic writings of the 1930s and Ananda Coomaraswamy's philosophical arguments of the 1930s and 1940s (Yanagi 1972; Coomaraswamy [1943] 1956). Reading the literature on these movements for their engagement with the primitive and their search for a universal spirituality, one finds artists and philosophers turning to tribal, "indigenous" cultures of lands far away made accessible through colonialism. For Paul Gauguin, the landscape and people of the southern Pacific French colonies served a similar purpose as did India and Japan for William Morris and Charles Robert Ashbee, respectively. Pablo Picasso's use of Malian and other western African sculptural forms in his work

presages the interests of mid-twentieth-century artists such as Mark Rothko and Adolph Gottlieb who investigated the Jungian unconscious through, in part, an interest in tribal cultures.

Thus non-Western art has never strayed far from the consciousness of most major players in the story of modern art history in the West. As the object removed from "the West" that serves to define the latter's boundaries, this constitutive outside demands articulation within the context of a modernity defined as progress over and against either the, at best, static or often simply "behind" state of colonized regions of the world. The concept of the "not yet" allows us to acknowledge how dependent progressive modernity remains on a group of cultures ostensibly behind. In the case of visual culture, the gap between the modern and the "not yet" is reinforced by the romanticization and valorization of the native, primitive, and indigenous Other as a source for artistic inspiration. Stated differently, that Other *needs* to be not (yet) modern for the modern to utilize the aesthetic and spiritual authenticity of the native to shore up a space of Western modernity.

This dependency—the need to freeze the "native" in a particular way to support a vision of modernism—leaves no space for modernity in a contemporaneous non-Western context. That is, the historicity of the modern means that the colonized and formerly colonized nations perpetually remain in a state of not yet, differentiated from the modern by historicist developmental time. Indian modernity, if related at all to European modernity, therefore runs up against several dilemmas. How do those artists in the "native" context vis-à-vis Western modernism find a space for themselves? How do art historians engaged with art produced outside of the flowchart of modern art history place Indian artists? And how can these artists be modern when a major part of the definition of modernity depends on the use of an authentic, native Other?

In India, the discussion of these questions has occurred in a variety of contexts, from the writings of artists and critics in the mid-twentieth century to contemporary debates about the development of an Indian modernism (or the lack thereof). Many of the tensions expressed in the writings of Rothko and Gottlieb, for example, find a space in the writings of their contemporaries in India such as K. C. S. Paniker and Nasreen Mohamedi, who also struggle with issues of materiality versus spirituality. However, as Anshuman Das Gupta and Shivaji K. Panikkar aptly point out (and Paniker and Mohamedi would likely

agree), the Indian context further complicates these issues. When discussing the modern in India, the specter of modernization (as Westernization) also raises its head: "One of the aspects of what one calls modern, i.e., modernization, is invariably an offshoot of . . . industrialization," and industrialization draws on "concepts like scientific rationality, progress, etc." Panikkar and Das Gupta go on to argue that "the modern" proves even more problematic in the case of India since, through industrialization, "India entered into the sphere of the technological modern under [the] dismal circumstances of . . . colonial dominion" (1995, 18). The authors claim that any discussion of Indian modernity must be grasped through this context of colonial domination and industrialization from without. This idea, together with Chakrabarty's contention that Western modernity depended on that same colonialism, provides us with a clearer perspective on the place of an Indian modern: it balances precariously in between a modern defined only through the Other and a modernization insisting that India is not yet modern.[6]

One can surmise that to write postindependence Indian modernity, neither the perspective of Western modernity, nor that of progressivist Indian art-historical development is sufficient. The former leaves no space for a non-Western modernism (or at least no space for a modernism that is anything more than derivative), and the latter pretends that a modern India can be isolated from its colonial history, or that a merely different or alternative Indian modern can be found by following India's artificially isolated history.[7] This is where Chakrabarty's argument takes us. He insists that to understand modernity (in India and elsewhere) one must pursue neither of these options. Ignoring or erasing the elements of modernity that arise from the European Enlightenment means changing the object of study from modernity to something else altogether (2000). Thus one must find a different path that acknowledges modernity's roots both in the Enlightenment and in colonialism.

Like Chakrabarty, Timothy Mitchell rejects the idea that modernities outside Europe or North America might merely be "alternative" ones. Mitchell's approach proves helpful for understanding the modernity produced in the visual culture of postindependence India. He cites examples that range from the sugar plantations of the Caribbean to the disciplinary monitoring of Bengali school children and argues that the constitutive elements of modernity are first constructed in the so-called periphery and only then brought to the

metropole (2000, 2–3). Following Perry Anderson, Mitchell remarks that terms such as *international*, *nationalism*, *modernism*, and *postmodernism* were first articulated on the edges of European power. Sometimes, as in the case of Irish nationalism, they were created in the context of anticolonial struggles; in other cases they arose in response to particular intersections of culture, history, and time in the so-called periphery (Anderson 1998). These histories of the modern complicate the uniform location and production of modernity in Europe, suggesting that the origins of the modern might reside elsewhere.

To note that crucial elements of modernity were created outside of modernity's traditionally assumed space undermines the very fabric of the modern, as it suggests a certain internal inconsistency. From this perspective, we are no longer able to tell the story of the modern in a single temporal line about an (artificially) unified space. Rather than speaking of a plurality of modernities or alternative modernities, each dependent on an a priori, singular modernity from which they differ, Mitchell instead suggests that modernity must be continually *restaged* to preserve an internally unified, unique, and singular presence (2000, 23). That is, the modern only *appears* to be monolithic. It is held together as monolithic through a continual performance and re-presentation of this uniformity. As such, the nonmodern and the non-West often participate in and constitute the staging of the modern.

In this book I trace the staging of modernity as it coincides with the production of India after its independence. During this period, one finds continued references to a European, unified, universalized modern both in art and in critical writing. One also finds a need to participate in that universal ideal while simultaneously constructing a vision of India. The visual and verbal texts I analyze in the following chapters reveal the struggle with what Mitchell's exegesis identifies as a fundamental instability in the modern. The modernity figured in this book is not an *alternative* modernity to some central, foundational modern residing in Europe. Nor is it marked merely by some overarching difference or otherness; it does not reject outright the foundational definitions of modernism. Rather, each theme discussed as I traverse the terrain of visual culture in this period allows for the interruption of the overarching, unified modern — even as the work attempts to re-stage the latter. India's modern reveals modernity's cracks even as it attempts to participate in a full (uniform, clean, universal) modernity.

Between 1947 and 1980, the conceptualization of the "modern" enjoyed a broad range of interpretations among artists, architects, film directors, audiences, and patrons, much as it does today. My project here is to demonstrate the various facets of the paradox of the Indian modern both to elaborate our current hermeneutic framework vis-à-vis modernity and to provide insight into the historical struggle with the definition of the modern for those involved in producing these works.

BACKGROUND; OR, THE OSTENSIBLE CANON

This book is not a survey of Indian art from 1947 to 1980. However, as the period is not well known outside a relatively small circle of art historians, critics, collectors, architects, and artists, I offer here a chronological narrative of this period—in terms of art history and history—to set the stage for the body of the text. The narrative stems from what has begun to emerge as a canonical art history of the period after independence. In part my project is to intervene into this canon making as we are constructing it, and so I also present ways in which the present text attempts to refigure the canon.

The book begins with 1947 because at midnight on August 15 of that year Jawaharlal Nehru, the first prime minister of independent India, declared the country free from its colonial masters. The celebration of independence was marred by the concurrent partition of what had been British India into two separate nations: India and Pakistan. Pakistan was to be the nation for South Asian Muslims and was divided into two geographic regions: one to the west (present-day Pakistan) and one to the east (present-day Bangladesh, East Pakistan until 1971). The movement of people across these arbitrarily drawn borders and according to the constructed division of religion caused widespread bloodshed and devastation.[8]

For artists born prior to independence who produced art during and following this period of upheaval, 1947 meant different things. Some, like P. T. Reddy (1915–96), lost much of their preindependence work; Reddy was forced to abandon his paintings in Lahore as he traveled back to Hyderabad in the newly-created India (Brown 2005). Others continued their art as they had prior to decolonization, even while they were aware of the widespread upheaval in the country. Institutionally, 1947 cannot be considered a full break: art schools in

major cities continued to produce artists and architects as they had in decades prior; several museums founded before 1947 continued to exist; and change, when it came, was gradual. The story of postindependence art therefore finds its roots in pre-1947 movements and institutions.

Shantiniketan, an artist colony and school in Bengal founded in 1901 by Rabindranath Tagore, had as its core project the development of literary and artistic aesthetics connecting to India's past and folk heritage (Dalmia 2002; Hyman 1998, 11). The institution's leaders also pursued a connection to a pan-Asian aesthetic through collaborations with Chinese and Japanese artists as part of a larger nationalist, anticolonial movement. Abanindranath Tagore, Rabindranath's nephew, anchored a separate movement in Calcutta that turned to India's past tradition of courtly arts. Reacting against artists such as Raja Ravi Varma (1848–1906), whose Western academic oil paintings of Hindu subject matter were seen as emulating colonial models too closely, Abanindranath turned to tempera and watercolor and looked compositionally to Mughal miniature paintings (Dalmia 2002, 2).[9] Shantiniketan benefited from the Tagores' elite status in Bengal, which allowed the school to operate as a regional magnet for rising artists. The model of intellectual retreat the school expounded was not repeated elsewhere and thus exists as a distinct type of art schooling. The following generation of artists in Bengal, including Nandalal Bose (and his student K. G. Subramanyan), took the ideas of both Shantiniketan and Abanindranath further, abandoning the nationalist focus on the restoration of Mughal glory in favor of a focus on folk and local traditions. In the case of Bengal, this meant that they looked to the paintings of traveling minstrels or *patua*s, the popular temple paintings of Kalighat in Calcutta, and various three-dimensional craft traditions such as terracotta sculpture and wood toy making. The atmosphere at Shantiniketan supported the development of artists under the leadership of Bose, Ramkinkar Baij, and Benode Behari Mukherjee.[10]

The bridge from preindependence nationalism to independent India for the art world in Bengal was therefore somewhat smoother than the one in Bombay,[11] where the Progressive Artists' Group established in 1947 pushed Indian painting in new directions. Many of the artists involved directly or indirectly with the Progressive Artists were trained at the Sir J. J. School of Art, established under the British and focusing, by the 1930s and 1940s, on teaching students contemporary movements in European painting.[12] The art schools, of course,

have their own histories of engagement with colonialism and its aftermath, maneuvering back and forth between the two poles of universalizing a Western aesthetic and valorizing an indigenous ancient or folk idiom (Dewan 2001). During the 1930s and 1940s, students of the Sir J. J. School produced paintings in varying styles, exploring the colors of Henri Matisse, the cubism of Picasso, and the symbolism of Paul Klee or Joan Miró. The Progressive Artists moved well beyond student-level emulation of these Western painters to appropriate Euro-American techniques and theories into works of art that illustrate the extent to which these artists came into their own. In many ways, while the art schools themselves struggled with the two horns of the modern Indian dilemma, much of the art produced by those trained there successfully negotiated the paradox.

M. F. Husain, who has become one of the more famous personalities and artists arising from the group, pursued iconic figural forms through strong brushstrokes and baroque, dramatic, centrally focused compositions. F. N. Souza worked with the figure as well, looking to the head and face, organically breaking its boundaries and rules with circular gestures that communicated a frenetic energy. S. H. Raza began from an abstracted landscape focus and shifted to an idiom appropriated from tantric art, incorporating a geometric symbolism that connects the broader universe to the microlevel of the body and the local. Unlike stylistically driven movements, however, the Progressives did not produce a unified visual aesthetic; rather, they joined together to direct Indian modern art away from imitation and to create an independent space for it within modernism.

Several members of the core group including Raza and Souza traveled to Europe—the former settling in France and the latter taking London by storm in the 1950s before permanently relocating to New York. The group was, like most at this time in India, short-lived: once these artists went overseas in the early 1950s the group dissolved. Yet the length of its existence does not reflect the weight of its influence on the shape of Indian art during this period. Other artists, related to but not officially a part of the Progressives, also became central to the movement's effects.

The painter Krishen Khanna, for example, exhibited in the same spaces as did the Progressives, and he was close friends with many in the group. Critics, too—such as Geeta Kapur, whose writing continues to exert a formative influ-

ence on our understanding of modern Indian art—traveled in these circles. In some ways, the Progressives offered not a single new direction for Indian art, but rather a pivot around which various artists, critics, galleries, and collectors could redefine what it meant to be Indian and modern in the postindependence context. While not a complete break from former practices (for rarely do *complete* breaks actually occur), the Bombay movement of the 1940s and 1950s created a space from which artists could comfortably work with European visual modes without being dismissed as derivative, and they could do so while maintaining a strong connection to Indian subjects and visual culture.[13]

Other cities had movements that similarly shaped their regions. While the Bombay Progressives have in recent years transmogrified in art-history thinking into a type of "all-India" marker for the 1940s and 1950s, important regional groups in Madras and Calcutta in fact changed the landscape in those areas and beyond. In Bengal, the weight of nationalist artists including the Tagores and the leadership of Shantiniketan's art school meant that making a statement in postindependent India involved distinguishing oneself from the Tagores and the so-called Bengal school (Kapur 1969, 4; 1978a, 191; Dalmia 2002, 3). The Calcutta Group formed in 1943, and its members continued to work together until the late 1940s. Exhibiting in both Calcutta and Bombay, they earned some of the earliest positive reviews for a new Indian modern art and helped spur the opening of gallery space in Calcutta. Artists such as the sculptor Pradosh Dasgupta and the painter Nirode Mazumdar emerged from this movement, looking to the school of Paris (including Picasso, Matisse, and others) and to various forms of abstraction rather than Shantiniketan for inspiration.

The scene in Madras saw its roots in the local colonially established art school, the Madras Government College of Arts and Crafts, with which many of the postindependence artists were associated. K. C. S. Paniker established the Progressive Painters' Association (PPA) in 1944, which then served as a central organization for the promotion of modern Indian art in the decades after independence. Paniker's leadership shaped much of the direction of the PPA. Early on the group pursued experimentation with various European painting styles influenced by Vincent Van Gogh, Gauguin, and similar painters. Later the PPA established a variety of approaches to the problem of modernism in India, much like the group in Bombay. Paniker's work explored the exoticization of script, using unreadable text to probe the barriers to understanding across cul-

tures. He also experimented with local folk idioms, helping promote indigenous forms while simultaneously acknowledging their capacity to dialogue with modern artists. Paniker also founded Cholamandal, an artist cooperative meant to support these ideals through the promotion of folklore, craftsmanship, and collaboration between artisans and urban artists (James 2004).

In New Delhi, the All India Fine Arts and Crafts Society (AIFACS) had already been founded in 1930 as a means of promoting contemporary art in the colonial capital. The AIFACS was not the only group centered in New Delhi; the Delhi Shilpi Chakra was founded around 1950, in part due to the influx of refugee artists after Partition. As the capital city, Delhi drew many artists from other regions into its fold. This concentration of artists, the existence of an international community, and the city's vibrant political climate created the momentum for the foundation of the National Gallery of Modern Art in 1954. Delhi's political position thus helped support its artists in ways unavailable to other cities. The national Lalit Kala Akademi, founded by an act of parliament in 1954, supported publications and exhibitions of contemporary art from all over India and produced regional academies along similar lines.[14] Artists such as Jagdish Swaminathan, who founded Group 1890 in New Delhi in 1962, brought artists from Baroda, Calcutta, Madras, and Bombay together in the capital (Dalmia 2002). Delhi thus became a locus for various artists and art movements and developed into a center for galleries dealing in contemporary art.

The story of the smaller provincial city of Baroda (now Vadodara) generally remains a separately told narrative, one centered on the establishment of a contemporary school of fine arts there at the M. S. University in 1950. Designed to be distinct from colonial predecessors, the faculty of fine arts sought to push the postindependence movements in Bombay, Calcutta, and Madras in new directions. Baroda has often been treated as its own phenomenon because while it had its roots in the earlier movements, it remained separated from the bigger, colonial cities due to its location in Gujarat. Artists from major metropolitan areas such as N. S. Bendre, a member of the Progressive Artists' Group, taught at Baroda from the beginning; other faculty members came from Calcutta (K. G. Subramanyan), and still others were trained at Baroda or elsewhere (sometimes Europe) then to return, including Gulammohammed Sheikh.[15]

As a school with teachers and students of diverse backgrounds, Baroda produced artists who moved away from both the nationalist Bengal school's

valorization of the Indian past and the post-1947 amalgamation of modern abstraction and an Indian aesthetic. Looking to indigenous roots, different media, and international styles of painting from other non-European regions (e.g., Central America, South America, and Africa), these artists took a variety of paths and then went out into India to teach and work in many locations ranging from large metropolises to smaller regional capitals such as Bhopal. Artists like Jyoti Bhatt, who explored photography, and Jeram Patel, who took a blowtorch to wood to produce the base for his paintings, began their careers at Baroda. Interactions with local indigenous crafts encouraged by Subramanyan produced new directions for artists like Raghav Kaneria and Sheikh; Bhupen Khakhar's sometimes playful, sometimes serious manipulation of collage and paint produced a new idiom for the depiction of space and exemplified the use of mythologies relevant to contemporary India's political and social situations. As many directions as Indian art took in the second half of the twentieth century, Baroda seems to be a part of all of them. Transcending other regional movements it often becomes a topic of its own.

The stories of the many art schools and groups discussed above illustrate the difficulty of encapsulating the post-1947 period in any singular manner. The painter Raza gave voice to the confusing nature of the period: "This was a time when there was no modern art in our country and a period of artistic confusion. We were particularly torn between western academic ideas and traditional Indian art springing from the Renaissance in Bengal" (quoted in Bahadurji 1984, 35; and Dalmia et al. 1997, 12). It thus becomes difficult to create a smooth narrative describing these decades. Dividing the story into regional, group-based studies as I have done above makes the telling slightly easier, but it also elides the overlaps and erases the physical movement of artists around the country. The canonical narrative above also entirely leaves out the story of architecture, primarily because the existing important texts on contemporary art movements in India focus almost completely on painting, with a few gestures toward sculpture and even fewer toward photography (Sokolowski et al. 1985; Dalmia et al. 1997; Sheikh 1997; Dalmia 2002). This bias toward the two-dimensional reflects the gallery focus—indeed, sculpture is difficult to sell on the art market and remains in second seat to painting—and also indicates the focus of important collectors during this period (Modi et al. 2000). Developments such as installation art, larger sculptural forms, video art, and perfor-

mance only emerge after the temporal focus of this book, in the 1980s and 1990s, arising from many of the activities of artists and architects discussed in these pages. In the face of these aporias in the history of twentieth-century Indian visual culture, this book seeks to bridge some of the gaps and draw new connections among movements, artists, architects, art schools, and patrons.

In this approach the book also moves away from the artist-centered one common in contemporary publications, particularly as individual artists have become commodities on the international art market. Husain, Raza, and Souza may not yet be household names everywhere in the world, but their work is marketed and sold through books, gallery and museum shows, and essays organized around recognizable names rather than around more nebulous historical groups or regional schools. As a result, a relatively large body of literature details the lives of these artists and the narratives of their work. Geeta Kapur's excellent first book is the standard in this regard: it was published in 1978 at a time when biography-based art history was still widely in use and at a time when the artists she discusses were so little known that her contribution largely founded the study of India's twentieth-century art (Kapur 1978a). My project here enters the conversation at a different historical point, when the biographical approach no longer answers our questions, and the lives of the artists have in large part been published.[16] Rather than grounding my analysis in it, I therefore use biography only sparingly within this volume. The bibliography includes monographs on the individual artists I discuss, and many of the major group publications include short biographies of each artist.[17]

THEMATIC ORGANIZATION

To carry out the tasks set out above, I have organized the chapters thematically. Chapters 1 and 2 address two aspects of a stable presence felt beyond the temporal boundary of 1947. "Authenticity" explores a general continuity from preindependence nationalist art to the decades after independence, focusing on the central theme of the authentic. In this chapter, that theme is found in the subject matter of the guru under the tree, encapsulating the idea of an "authentic India" in a rural, traditional vision of village life. Examining three instances of this trope—in architecture, painting, and film—the chapter articulates the distinction between this "authentic" and that sought after by earlier

nationalist artists. The chapter illustrates a critical break between the vision of an India-to-be in the eyes of the nationalists and that of a newly established Indian nation.

Chapter 2 addresses the theme of the icon and the development of an iconographic pattern for post-independence, modern Indian art. Whereas pre-1947 artists utilized various Hindu, Christian, and historic figures to anchor their works in an Indian sensibility—reinterpreting either Hindu icons in a Western mode (as in Ravi Varma's painting) or painting Christian icons in a local Indian idiom (as in Jamini Roy's work)—postindependence artists examined the centrality of the icon for Indian national identity. The chapter therefore analyzes the reworking of the iconography of Hindu gods and the composition of popular calendar prints, and it also looks at the concept of the icon as it is found in the architectural emblems of public buildings. Iconicity proves to be a central motivator for the articulation of postindependence Indian art and architecture, one springing from an earlier concern with the icon but rearticulating and sometimes self-reflexively challenging the iconic mode.

Chapter 3 takes on another underlying theme in the staging of modern Indian art, namely, the oft-repeated view that Indian culture has, from ancient times, had a particular affinity for storytelling and visual narratives. "Narrative and Time" expands outward from narrative and storytelling to encompass the concepts of time and temporality, not only by examining the role narrative plays in modern Indian art and architecture but also by investigating the almost stereotypical understanding of contemporary India as existing simultaneously in the medieval or ancient era and the modern world. The film *Waqt* (1965) anchors this chapter, and from that foundation I develop analyses of architecture, interior design, photography, and painting that bring into question understandings of time, history, and narrative.

Chapter 4 seeks to comprehend the location of technology and science in India's search for a modern artistic identity. While clearly central to the rhetoric of Jawaharlal Nehru and his government, modernization through technology was not obviously a central part of modern art, particularly of the fine arts like painting. However, science and modernization proved crucial for the development of many different areas of the fine arts, from technological advances in architecture and photography to mathematical and geometric elements used in drawing and painting. This chapter traces a line from Nehruvian rhetoric to Le

18 INTRODUCTION

Corbusier's architectural technologies and mathematical, geometric imagery that articulates the ways in which modernization, science, and mathematics shaped an idea of the modern for Indian art and architecture.

This discussion continues in the fifth chapter on the urban. As the book begins with the rural, it ends here with the question of the city, the megalopolis, and the vision of an imagined modern space in India. But space for a modern India must be negotiated against the backdrop of the desperate search for healthy, safe, affordable places to live, and so this chapter tips between fanciful constructions of urban space in film and the extremely (and literally) concrete, examining architects' efforts to build suitable housing for India's population and to plan reasonable cityscapes within which this housing can take shape. The chapter tackles the ways in which the city figures as a space of both hope and despair, thus serving as a metaphor for the larger struggle to find a modern Indian art.

The epilogue addresses the question of the next generation: where do these elements of modernity lead in the decades before and after the turn of the millennium? While some artists continue along the path of the first postindependence decades, many others move into an entirely new mode of questioning. Criticism of the dominant understanding of India's relation to the West had begun in the 1970s, but it truly started to take shape in the 1980s as questions of identity politics rose, third-world feminism challenged assumptions about the universal nature of "woman," and analysts began questioning the unity and inevitability of the so-called developing world. The art world in India changed with the emergence of a new gallery scene, several periodical publications with excellent reproduction quality, and easier, cheaper access to the technologies of video and film.

This book offers an intervention into the canon even as that canon is forming, and it also assumes a readership that may not be familiar with India's particular art scene during the period under discussion. It was thus tempting to include as many images as possible to provide a survey of these decades, that is, to deliver a holistic package of India's struggle with modernity in visual culture. This approach, however, is one best served by a book other than the one I have chosen to write. My goal in this volume is not to survey the artistic production of modern India as a whole, but rather to focus on the problem outlined in this introduction, namely, the paradox of India's modernity. My targeted ap-

proach, achieved by delving deeply into a few select objects, demonstrates how close visual and historical analyses provide us with a great amount of data from which to work. It also allows readers an accessible entry point for the period, its visual culture, and the conceptual problems therein.

The images included here lend themselves to analyzing the paradox of the Indian modern, but they should not be taken as the only valid choices. I have chosen representative examples: each one might be substituted by a different piece of the same artists' oeuvre or by an entirely different object that speaks to similar issues. The book should therefore be used as a starting point for discussions of larger bodies of work rather than as a prescriptive list of the only works fitting this analysis. I have chosen images because they speak to the problem at hand in a particular chapter. Each chapter includes a variety of media, and the book as a whole includes both canonical and noncanonical objects. I have selected them as a group because together they open up new ways of thinking about India's modernity, to which each work offers something slightly different from the others. Many central artists are thus not represented here—not because their works do not speak to the discussed themes, but because I privilege a depth of analysis for each work over a quicker surveylike approach.

I have tried to balance various media across the book, including sculpture, photography, architecture, drawing, and film alongside the more traditional painting. Yet a complete balance is not always achievable, and in many ways certain imbalances reflect the extent to which scholarship and criticism have addressed particular media. In each chapter I explore the way in which thematic elements operate across traditional boundaries in painting and architecture, photography and sculpture. I do not include every medium in each chapter; I do choose combinations that may appear counterintuitive at first and come together because of the chapter's thematic focus. In this manner the book produces a new view of the canonical artists and objects outlined above. This allows the intersections and overlaps among the works to rise to the surface.

Overlapping takes place among the themes as well, as the book folds back on itself several times. I return to the same images in multiple chapters, rereading the works in new pairings and through different lenses. Paniker's *Words and Symbols* series and the film *Waqt* are therefore examined multiple times, producing differing but related readings and demonstrating the ways in which the themes of the book cannot be isolated from one another. Nasreen Mohamedi's

drawings, Le Corbusier's Chandigarh buildings, and Charles Correa's projects echo across several chapters. I encourage further interconnections with objects not discussed here, although I have resisted the temptation to list artists' names, works, or movements as expansions, a type of exegesis often more alienating than helpful. My hope is that the focused discussion of a few works will spur further investigation along these lines.

Each chapter takes a different approach to our still nascent understanding of a complex period in Indian art history. I offer these analyses as an addition to the existing literature to raise new questions and promote new research into the visual culture of post-1947 India. Taken together, the chapters of the present book trace the shape of art and architecture during the period after independence, providing a context for an in-depth engagement with these objects and the visual culture of these decades as art staged the modern in the face of the paradox of being both Indian and modern.

AUTHENTICITY

In India, the sky has profoundly affected our relationship to builtform, and to open space. For in a warm climate, the best place to be in the late evenings and in the early mornings, is outdoors, under the open sky. Such spaces have an infinite number of variations: one steps out of a room . . . into a verandah . . . and thence on to a terrace . . . from which one proceeds to an open courtyard, perhaps shaded by a tree . . . or by a large pergola overhead. At each moment, subtle changes in the quality of light and ambient air generate feelings within us—feelings which are central to our beings. Hence to us in Asia, the symbol of Education has never been the Little Red Schoolhouse of North America, but the guru sitting under the tree. True Enlightenment cannot be achieved within the closed box of a room—one needs must be outdoors, under the open sky.—CHARLES CORREA, *Charles Correa*

CHARLES CORREA'S ARTICULATION of an Indian relationship to space and sky opens his essay "Blessings of the Sky." In the text, the blessing of the title finds an echo in his reference to enlightenment, one that encompasses both a Western conception of learning and an understanding of *moksha*, or release, derived from both the Hindu and Buddhist traditions. While religion certainly forms a part of his conception of the spiritual, this open-to-sky rubric so crucial to Correa's understanding of Indian aesthetics relies not on a single religion, as the general reference to enlightenment indicates, but rather on the relationship of humanity to the environment. This is a broad understanding that can encompass many traditions.

Correa's catholic and progressive inclusion of multiple religions as Indian threatens to recapitulate Orientalist ideas of an essential pan-Asian spirituality. His articulation of a uniquely Indian or Asian spatial sensibility, contrasted directly with an equally generalized Western space, exhibits a continuity with a colonial understanding of India. Like Orientalist scholars of the nineteenth century who sought to essentialize India's climate as tropical and its culture as spiritual, Correa valorizes India by pointing to an authenticity that this region has and the West lacks.

Both colonial and nationalist rhetoric have used the trope of the authentic village space to value India's history and culture, claiming a level of purity for India's past glory that served both to justify colonialism and to suggest India's current spiritual superiority to the industrialized West. Mohandas Gandhi, of course, is the most well-known proponent of the idealization of the village as a source for India's strength and heritage (Larson 1995, 198–200; Alter 2000, 83–112). Figures such as Ananda Coomaraswamy and W. G. Archer claimed legitimacy for India's visual culture through arguments valorizing both its spiritual purity and its connection to present-day village life (Coomaraswamy [1943] 1956; Archer 1974). During the early decades of the twentieth century, the battle was still to claim that India had any art at all, and asserting its philosophical and spiritual superiority over the West helped build the case for India's cultural heritage (see Mitter [1977] 1992). As we shall see later in discussions of Le Corbusier's approach to India, this same valorization of spiritual purity found within both religious art and the life of the village also supported modernist appropriations of India as primitive (Kahn 1987, 19).

Nationalist arguments, themselves revisions of colonial approaches to the subcontinent's heritage, were retooled in the postindependence context. Rather than abandoning them altogether—although experiments with turning to pure abstraction, for example, did take place—the decades after independence saw artists sometimes looking to the authentic village space as an essential element of Indianness. This maneuver meant that they participated in the overarching essentialization of India as a place of villages and villagers. Inherited from colonial and nationalist discourse, this sense of authenticity served to construct unity within the diversity of the new India, connecting India's new national image both to an invented ancient past and to more recent preindependence discourses. Yet the adoption of an earlier vision of authentic India occurred alongside a critique of its idealized qualities.

I find this critique to be salient in the three examples chosen for this chapter: a film, a painting, and one of Correa's buildings. These objects share a concern with the authentic and locate that authenticity within the village space. They have been chosen not because they are unique, but because they are representative of the larger struggle to articulate an Indian modern after independence. And they all do so during the 1950s when the turn toward the village was the strongest. After this point, the village fades as a locus for understanding India's

identity (although it never disappears). Yet even in its heyday, as these three objects demonstrate, village imagery did not constitute as clear a move toward the authentic as one might expect. A scene from Satyajit Ray's film *Pather pan-chali* (Song of the Road, 1957; figure 1) seems to echo Correa's guru-under-the-tree motif while subtly undermining it as well. Correa's own Gandhi Smarak Sangrahalaya, near Ahmedabad, (1958–63; figure 2) embodies his open-to-sky philosophy and does so in a monument to the loudest proponent of village politics, Gandhi. But even here one finds the authentic breaking down. M. F. Husain's painting *Under the Tree* (1959; plate 1) is representative of his larger body of work focused on the village; it, too, participates in a larger questioning of the authenticity of the village space.[1]

In this chapter I trace the connections among these three works and analyze their position at a particular historical moment in the mid-to-late 1950s. This is the period in which works such as these were both linked to earlier political and art-history concerns and taken to project a new idea of Indianness. Each of these works finds itself tied to nationalist, pre-1947 understandings of the Indian—understandings linked to colonial conceptions of the subcontinent. But each also distinguishes itself from earlier trajectories of India-identification, creating new conceptions of Indianness in the post-1947 context, whether by deconstructing the vision of purity the village ostensibly embodies or by pro-ducing a modern Indian understanding of that purity. Thus the three together demonstrate the relationship of 1950s visual culture to pre-1947 approaches to imaging the subcontinent, drawing out continuities across the "break" of independence. At the same time, these three works bespeak a new relation to the authentic in the postindependence period. Despite Correa's focused verbal statement regarding the centrality of open-to-sky spaces and the authenticity of the village, I argue that each of these works challenges the unifying, ho-mogenizing, and stereotyping aspects of the trope of the village.[2] Rather than rejecting the village as theme, however, these works offer an acknowledgment of the postcolonial condition's constant negotiation with the inheritance of colonialism.

Ray and Husain present an image of the village that, rather than embodying a monolithic, pure space, offers a hierarchical space of struggle—a location that represents independent India in all of its positive and negative qualities. Thus communal tensions are not ignored, nor are class and caste distinctions.[3]

The ideal's valorization breaks down in these two examples, to be replaced by a messy vision of village India. Correa's building must also somehow reconcile this deconstructed ideal with his idealized vision of unity across the subcontinent. To do so, he turns to the unity within modernism and joins it with the construction of the open-to-sky space he sees as characteristic of India. Correa thus ends up appropriating the authentic from pre-1947 discourse and rearticulating it for a postindependence context, one that has lost the certainty of its own authentic past and, in Correa's hands, looks to modernist purity to reclaim it. Recontextualized as a part of the new nation's endeavor to produce a balanced secular democracy, these turns to the authentic become attempts to solidify an image of India as independent, while ironically never losing their dependence on earlier colonial and nationalist constructions of an "authentic India."

ESCAPING THE AUTHENTIC

Although one finds some idealization in Ray's image of the village school, the filmmaker is not known for rose-colored views of Bengali country life. Rather, his work, particularly in the *Apu Trilogy*, reveals the tender moments of family life in small-town Bengal while also painting a picture of social maneuvering and strife. The school scene toward the beginning of *Pather panchali* illustrates this tension between the idyllic space of "country folk" and the struggles that Apu and his family must negotiate throughout the narrative (see figure 1). Ray's film probes Correa's under-the-tree space to paint an image of "authentic" India that eschews idealism, uncovering the problems that come with essentializing the village as pure.

Apu comes from a Brahmin family; his father dreams of being a writer and attempts to find work performing Sanskrit ceremonies for various clients in the area. Yet Apu's father also works for a landowner, and his family barely gets by, living in the ancestral home but unable to repair its ruinous walls and thin roof. The birth of Apu is a joyous occasion for the family, and Ray gives us a wonderful scene of Apu's first day preparing to go to school—drinking milk (despite the fact that little milk comes from the emaciated cow), getting his hair combed by his sister Durga, and walking down a path through the countryside, hand in hand with his mother, passing a bespectacled, educated Brahmin man who

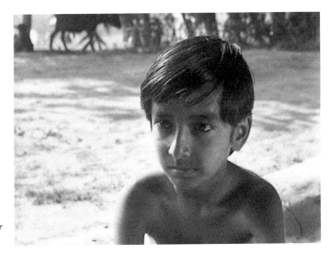

1 Apu at school. Still from *Pather panchali*, dir. Satyajit Ray, 1955

carries an umbrella. With this lead-in to the school scene, viewers warm to the family fussing over Apu as both his sister and his mother look at him with great tenderness. Ray's image of the mother and son walking into the village follows a path that splits the screen vertically: the two walk away from us, upward in the frame, as the Brahmin man walks toward us. The movement of the figures in this scene depicts our hope for Apu as he goes off to learn, someday to return as the grown, educated Brahmin we see coming toward us.

Once we arrive at the school, however, we understand the practice of education to differ somewhat from the vision of the hopeful preamble. If Correa is right that the guru under the tree replaces the little red schoolhouse in India, then we have here a bastardization of that vision, one halfway between the two extremes. Schooling does take place underneath a structure, but it is an open one: a pavilion supported by bamboo pillars and roofed with thatch. The "guru" is the provisioner for the village as well: we watch as he simultaneously makes deals with the young girls that come to purchase food and recites a passage from the *Ramayana* for the students to copy onto their slates. While we understand the space as a multifaceted one—both a store and a school—we are never allowed to grasp its full spatial extent. That is, we know it is open on all sides except the one where the schoolmaster sits, but we only see his dais, with the provisions laid out in front of him as he scowls at the schoolchildren. Initially,

the camera focuses in on his torso, pulling back only slightly to include the hand of a girl on the left purchasing flour. It then swings to the right as another girl asks for rice and gives her money. The camera then moves downward to show us that the boys in the back row are playing tic-tac-toe on a slate, passing it surreptitiously between them.

Our sense of claustrophobia is alleviated somewhat by a shot outside the pavilion, showing us Boidnoyath, one of the elders of the village, who comes in past the fence and immediately comments on a huge hole just inside the compound, asking if it is meant to kill people. Yet our desire for escape from the stifling space of the school is reinforced even in this outdoor shot, where the boundaries of space are reasserted both visually with the fence (and the pit in front of it) and verbally with the elder's somewhat comical question, linking the pit with the ultimate boundary: death.

The entire scene appears to provide a comedic break from the narrative—similar to Shakespearean pendant scenes that insert two minor characters to lighten the mood and simultaneously to give a context for the main story line. The scene also highlights the fallacy of idealizing village learning and the local guru. Once Boidnoyath enters the space and sits next to the teacher/provisioner, we see the two-faced nature of this multitasker more clearly. He laughs and jokes with his guest (but reprimands Apu sternly for smiling as well), all the while keeping one eye on his charges and yelling at them intermittently. Ray films this scene from the left of the pair on the dais, so that we cannot see the students but instead only the teacher's face as it switches, Janus-like, from obsequious nodding and smiling to fierce, demonic yelling. His double-faced personality is underscored both by the in-between nature of the space (as open and not-open to the sky, and as school and shop) and by the way in which Ray films that space. The camera pens us in with frontal shots of the teacher's platform, images of the students from above so that we see only the floor, and restricted, framed views to the outside that show us the bounded nature of the place. The feeling of entrapment is matched by an opposing dream of escape, found in the boys' tic-tac-toe game and in the comedic shot of a villager trying to escape a discussion with Boidnoyath as he leaves the school. First we see the Brahmin (umbrella under his arm) as Boidnoyath calls for him to wait, and then, a second later, we see him walk surreptitiously off out of sight to the left. This moment of humor gives viewers a break from the

weight of the school scene, but it also reminds us of our own desire for escape from the space.

Apu echoes this desire a few beats later. On Boidnoyath's departure, the teacher discovers the slate passing back and forth between the boys. He shakes with rage and demands they bring it forward. He then has the culprit dragged to the front of the room by his ear. We see a switch being pulled from the sack of flour and the anger on the teacher's face. Then we hear the switch on the boy's hands while we watch the faces of first the girl (who had come in for rice earlier) before she runs out of the school, and then of Apu. The latter's face is framed the same way it was when he laughed earlier: with trees behind him—the space of freedom and escape. His reaction to the beating is all we see, followed by a quick cut to a figure in the distance, running along a path, free in the countryside. Again, the trope of escape—the Brahmin man escaping Boidnoyath's questions, the girl escaping without completing her errand, and Apu mentally escaping the school—is given to us in this succession of images, each one echoing our own desire to leave behind the scene's claustrophobia. The horizontal perspective of escape (in contrast to the vertical path to approach the school) alleviates both our tension and Apu's, but interestingly it leads nowhere. We do not get Apu's return home in the next scene; he does not burst through the rickety doors of the ancestral home and find his mother. Instead, we cut to a scene of his mother and grandaunt negotiating their power in the home. We are thus left with a sense of escape, but with no confirmation of it. It serves only as a break—a sigh of relief after the school scene, one that leaves us unsure as to whether this is just Apu's dream, our dream, or an actual escape from the suffocating space. The escape's lack of destination (in the narrative and also visually—the figure in this scene moves horizontally, and we do not know where that leads) reinforces the tension between hope and despair found throughout this film and its two sequels.

In comparison to this depiction of the school, Correa's articulation of an ideal space in the Indian village comes up short. That is, Ray demonstrates the tensions of village life, and indeed the conflicts involved in negotiating modernity within the context of the village dynamic. Correa's statement on the village space, on the other hand, seems to idealize it and place it as a uniform, ahistorical basis for Indianness that can be equally deployed to analyze ancient monuments and to produce contemporary architecture.

Ray's *Apu Trilogy* captured the imagination of India's urban intelligentsia because it delivered a nuanced portrayal of village life, depicting it not as an untarnished ideal, but as a space of real Indian struggle. This sort of portrayal accentuated the moral fiber of Indians in the face of insurmountable odds (Dwyer and Patel 2002, 21). It continued a theme found in preindependence films, in which downtrodden villagers often rebelled against evil overlords (in an echo of colonial relationships that was none too subtle). While the overlords usually won out, the villagers' power remained in the minds of those leaving the theater (Mishra 2004). But *Pather panchali* offers a more complex view of India's moral landscape, one in which escape is figured in trains and electricity lines, as well as in bullock carts and barefoot sprints across landscapes. The village is far from pure in Ray's vision, and his space of learning resists Correa's valorization of an Indian authentic—much as do Husain's agonistic discussions under the tree, as we shall see.

THE AGONISTIC VILLAGE

In Husain's *Under the Tree* (plate 1), the spindly, multilimbed titular plant frames the composition to the right, arcing into the top corner in a futile attempt to shelter those below. This tree hardly operates as a botanical symbol of village warmth or as a valorization of the purity of village life. A close look at the painting's composition, color, and subject matter draws out a postcolonial vision of the village rather than a nationalist one. *Under the Tree* focuses on the heated, evenly-matched, and seemingly unending discussion of three figures in the center, figures flanked by two more static individuals, one seated and one standing. Ironically, it places none of them fully in the shelter of the village tree. The ongoing, inconclusive, open discussion depicted in Husain's work is agonistic, offering a political understanding of debate other than one that seeks to achieve a particular goal or fully resolve tension. Instead, we see here a celebration of the very *process* of discussion itself, one in which the tension of postcolonial life cannot be resolved, but must be thoroughly and continually debated. It is a painting of agonistic discourse.

As a result, Husain's work depicts a village, with Correa's guru under the tree, without simply recapitulating a pure, authentic village space. The village cannot be a purely innocent referent for Indianness, as its use in colonial, nationalist,

and postindependence political and visual rhetoric makes it a space fraught with past appropriations and generalizations. Husain does use village-based imagery in this and other works of the period,[4] but *Under the Tree* attempts a rearticulation of the village as a fragmented, multiply layered space. Husain's village examines earlier, bucolic generalizations of the rural in India to develop a language of the postcolonial village in which discussion leads not to conclusion but rather to the continuation of debate and in which the hierarchies of class and caste are not resolved in a vision of perfect wholeness but instead remain inherent to the fabric of village life.

The painting presents an agonistic space of discussion through bodily interaction. The central grouping of three engages in heated debate: the brown, sari-clad woman second from the left gestures emphatically to the yellow-clad central figure, who returns a similar motion below, as the third points upward with two fingers, perhaps in benediction or to direct our focus to the skies, but certainly to engage with the dynamism of the other two gestures. Their arms form a triangle, and at the center of this compositional unit Husain has placed a diffuse asterisk form, echoing in weight and brushstroke the spindly branches of the tree and connecting this painting with numerous others employing this motif. His *Between the Spider and the Lamp* (1956), for example, includes not only the spider form but also a diagrammatic star or asterisk at the top of the composition; Husain uses the motif again inside an oil lamp to represent light in his dark image of a woman entitled *Blue Night* (1959), and again to mark the head in his iconic image of *Gandhiji* (1972).[5]

The star form in *Under the Tree* is used to draw our eye to a particular element in the painting: the gestures among these three people and the energy they produce. The asterisk thus stands in as a physical symbol of the interaction itself. As in the other paintings that use this iconography, here the abstract, blossoming symbol marks the energy of the three debaters locked in conversation. The form works because it both draws them together and indicates the emanation of their energy outward from the center of the composition.

In *Gandhiji* the star substitutes for Gandhi's iconic face, leaving only his equally iconic body and clothing behind. In *Blue Night* the lamp seems not to shed light on the subject, and so the tension embodied between the fact of the light, indicated by the asterisk, and the lack of light produces a similar tension of presence and absence as that in *Gandhiji*. In both works Husain's asterisk

stands in for the most powerful moment in the painting, marking it as important while simultaneously erasing it, thereby producing tension in our viewing of the image. In *Under the Tree* the asterisk references the energy of dialogue shared among the three central people. This energy forms the core of the work's articulation of the village: living in community involves debates circumscribed by the opinions and gestures of those involved and resisting definitive conclusion.

In centering the debate, the painting brings into question the idealized conception of the village found in, for example, Gandhi's vision for a village-based nation. The village has been deployed in political discourse as the site of a pure, primitive source for Indian identity, or as a site where Gandhian nation building takes place through idealized local representational bodies. While Gandhi's own deployment of *panchayat raj* is much more complex and nuanced than merely a return to village utopia, his thought is often used to valorize the village as the primary locus for national identity.[6] Rather than use the village in this utopic manner, Husain's painting depicts the discussions, arguments, and tensions that must also take place to produce a truly participatory politics in this setting. The centrality of the triangular arrangement of the villagers' arms works together with the dynamic gestures indicating their active engagement with one another. Underlining the energy of the debate at hand—the disagreements that, existing within the circle of arms, will never be fully resolved—the asterisk reminds us of the tension and excitement within the village, which can no longer be taken for a sleepy foundational site of modernist nation building.

But there are others in the painting as well, further complicating this scene, as they exist in a separate spatial and compositional sphere. Whereas the central figures are painted in pale earth hues—browns and yellows of varying tonalities—the person in the foreground is rendered in deep green and black, separated from the bulk of the composition through this color shift. This figure raises the left palm to face us in a gesture (*mudra*) evoking both the "fear not" or *abhaya mudra* of Buddhist iconography and the symbol of the Hand of Fatima, used in Islamic ceremonies such as Muharram. Seated or squatting down, the green figure has a head marked by blackness, by a void, much like the head in *Blue Night* and Husain's much later *Mother Theresa* images of the early 1980s. The only individual of the five to be painted this way, this body pushes forward toward the viewer, facing out and gesturing toward us. The only other

frontal form stands in the background, depicted in gray to differentiate him from the three conversing figures. He—and despite leaning toward the male, the figure remains gender ambiguous—directly faces the picture plane and, unlike the rest of the figures in the painting, wears little or no clothing. Like that of the person in the foreground, this gray body's face is a blank, but in this case it takes the form of a white-gray oval above shoulders clearly squared to face us. If the foreground person is anchored to the ground in the bodily gesture of squatting, the figure in the background floats without feet, disconnected from the activity of the center or the gesture of the foreground figure—an onlooker, passive and somewhat distant from the central action.

The two frontal bodies bracket the three in the center, not entering into their dialogue but delimiting its scope, providing its context. Where we relate to the figure in the foreground through the proffered gesture, the gray figure offers no such interaction: these two represent opposing modes in their relation to the viewer, from engagement to disengagement, aptly framing the internally focused dynamism seen in the central trio. The bracketing visually limits the extent of the dispersal of the discussion, giving us an explicit boundary beyond which it cannot travel. With this framing of the village dialogue, Husain's painting articulates the limitation of discussion as the locus for a unified Indian national identity. In the wider discourse of 1950s India, where the Gandhian idealization of the village had taken root in the imagery of the nation, *Under the Tree* provided an alternate understanding of the village.

Husain's painting simultaneously presents what occurs physically under the tree and what this means conceptually for an understanding of Indian society. That is, Husain gives us an image of activities with their implications. He does so by dividing the composition not only into two linked but separate spaces—the tree and the people—but also into multiple *times*. While the space of the title links the group of three with the two individuals that flank it, they do not interact with one another. This lack of interaction produces a temporality akin to that found in the theater: the same stage setting embraces different times and different activities potentially linked through the space they inhabit, but not occurring simultaneously (see Kapur 1969, 3). This allows the painting to deliver an overarching vision of what the space underneath the tree might mean for an Indian village.

Furthermore, the fear-not multivalent gesture of the figure in the foreground

embodies the religious diversity of the village. This figure references at once a Hindu guru under the tree, the Buddhist Enlightened One preaching the dharma, a Christian gesture of blessing, and the Islamic symbol of the Prophet's family in the form of the Hand of Fatima. The meanings of both the gesture and the figure join together these spiritual traditions of India, linking them all to the space under the tree and the ideal village. Further, the nudity of the standing figure at left gestures to figures of standing Digambara (sky-clad) Jain monks, supplementing the religious references. The two figures bracketing the central dialogue acknowledge the importance of religion within the context of the village, but also indicate its position at the edges—always there, but nonetheless marginal. The squatting figure also suggests, in the coalescence of Hinduism, Buddhism, Christianity, and Islam within a single body, the overlapping qualities of India's many religious practices and their visual forms, something Husain's work often explores. We find Indian religion represented not as a particular type, but rather as a general spirituality of the sort promoted under Gandhian nationalism: a secular-leaning spirituality tied up with images of gurus from multiple religious traditions.

Like Correa in his statement about the guru under the tree, Husain shows us here the importance of that locus for articulating India's particular space of debate, learning, and enlightenment. Husain is known, especially in his work between 1948 and 1960, for his exploration of village life in India (Kapur 1969, 4; Alkazi 1978, 17; Kapur 1978a, 128). He is also known for the creation of a personal mythology through the appropriation of commonly used, legible symbols that, when taken together, produce a larger message—here, the star/asterisk, the *mudra*, and the tree itself (Kapur 1969, 3). Husain's painting comments positively on the ideals of learning and discourse, but the analysis cannot end there. Husain's central figures, while on the one hand possibly engaging in ideal community discourse, could also be arguing vociferously, disagreeing, as their gestures point to different spaces and produce antagonism among them. That is, rather than an ideal public sphere in which communication and discourse can take place freely, here we have the space of agonistic discourse, which involves argument, leaves certain individuals outside of its orbit, and consolidates power in the hands (or in this case, in the arm gestures) of a few (contra Habermas 1991). With the rearmost figure left out of the discussion, ostracized by the strong emotive qualities of those in the center, any idea of inclusivity is

lost. Husain's work thus points to a hierarchy in village life often overlooked in bucolic representations seeking to reclaim an edenic rural space as a dream of India-before-colonialism.

Under the Tree deploys the spiritual, authentic center of the village to underscore the persistent and continual negotiations of India's political, class, religious, and regional diversity. Rather than a utopic discourse of agreement and harmony, we see here a productive, energetic, and potentially destructive discussion, one that neither includes all members of the village community nor suggests an expansion beyond the edges of the canvas. Yet these figures do indeed share one space, and while that space may not be as pure or authentic as hoped (as indicated by the dry, brittle tree), it still serves as an intersection, one useful for an ongoing discussion of India's existence as a new nation.

BETWEEN THE BRANCHES: OPEN TO THE SKY

If Ray's film depiction contrasts heavily with Correa's assertions about the ideal space of the village school, and Husain's painting undermines the purity he seeks in the space under the tree, perhaps an examination of Correa's own architecture from this period will shift our understanding of his words and periodize the articulation of "open to sky." Correa's first and second projects as the head of his own firm were both commissioned in 1958. One, the Handloom Pavilion in Delhi, was finished that same year (within six months of the commission) to serve as a space for an international exhibition of handloom arts. The other, the Gandhi Smarak Sangrahalaya, or Memorial Institution, at Gandhi's Sabarmati Ashram in Ahmedabad, took until 1963 to complete its initial phase (see figure 2).

Both buildings offer an open-to-sky aesthetic combined with a modular geometric plan that, in the case of the Gandhi Memorial Institution, allows for an expansion of the complex as the collections grow. In the Handloom Pavilion, the roof floats above the plastered walls to let light in through the space created between. Much like a tent covering—and comprised of a wood support covered by handloom cloth—the roof provides an airy, skyward aesthetic even where the building is not fully open to the sky. One of the central four square modules of the pavilion is indeed open to the sky and houses a garden, around which visitors move through the exhibits. The design further breaks up space

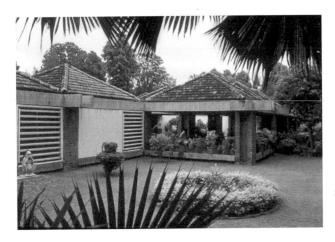

2 Charles Correa, Gandhi Smarak
Sangrahalaya, Ahmedabad, 1958–63.
Photograph courtesy of Miki Desai.

by placing the exhibitors on different levels, which flow from one to the other
in a mazelike pattern. The stepped-platform plan encourages movement and
suggests a pilgrimage path at a shrine (Cantacuzino 1984, 11). Moving up and
down through various horizontal spaces, visitors focus on one segment of an
exhibit at a time, all the while remaining connected to the sky and the upward
movement of the roof.

The Handloom Pavilion's floating roof over walls of sun-dried bricks and
flowing, multileveled space foreshadows several of Correa's architectural con-
cerns both in his housing and in his more public commissions (Frampton 1996,
12–13). Movement among levels and the opening up of the roofline can be
found in much of his work, whether through literal gaps between the wall and
roof, as here, or through other means such as double-story terraces or the use
of pergolas to regulate heat while welcoming light. The Gandhi Memorial Mu-
seum at the Sabarmati Ashram is no exception.

Gandhi lived at the Sabarmati Ashram (so named because of its location on
the banks of the Sabarmati River) from 1917 to 1930, and he began the famed
Salt March to Dandi in March of 1930 from this site. The ashram buildings of
Gandhi's time are modest, consisting of tile roofs, whitewashed brick walls,
stone floors, and wooden doors (Kahn 1987, 20). Correa also used these ma-
terials for the new structures at the compound, echoing the earlier buildings in
both simplicity and medium.

It seems that Correa's museum reprises the village-level vernacular, referencing an authentic core, and, as we shall see, providing open-to-sky spaces throughout the compound. The simplicity, however, stems not only from a local vernacular but also from the idiom of international modernist architecture (Pandya 2002, 9). The strong horizontality of the spaces and the use of textured concrete to accent the edges of walls and floors clearly indicate a Corbusian influence. The clean lines of the stone floors, strong lintels, brick piers, and large stone benches combine with the geometry of the adjustable wooden louvers to provide a light-dark contrast on the interior and exterior surfaces, while also allowing for a variation in airflow depending on the time of day and the time of year.

Unlike Le Corbusier's monumental structures at Chandigarh, the museum emphasizes the human scale of the setting, appropriate to Gandhi's humanizing of the freedom struggle. In part, the building achieves this greater modesty because it consists not of a singular structure, but instead comprises fifty-one six-meter squares—some enclosed, some open, and some partially enclosed, depending on the role each square fills. The museum collections are housed and displayed in fully enclosed buildings to protect them from the elements; pathways in between, however, are shaded but open to two or more sides. Garden and water elements are fully open to the sky, and they provide light and relief to the horizontality of the remaining structure (Kahn 1987, 166). This segmental approach to building centers much of Correa's practice and is an element of Indian culture he finds both in village spaces and in historical imperial architecture (Correa 1989, 166–7). This "disaggregation" of space, as he calls it, yields several byproducts, so that "one steps out of the box to find oneself in a verandah, from which one moves into a courtyard—and then under a tree, and beyond onto a terrace covered by a bamboo pergola, and then perhaps back into a room and out onto a balcony, and so on. The boundaries between these various zones are not formal and sharply demarcated, but easy and amorphous. Subtle modulations of light, of the quality of ambient air, register each transition on our senses" (Correa 1989, 167). For the Gandhi Memorial Museum this means that spaces flow one into another in such a way that the enclosed exhibit space segues naturally into a covered porch, which looks out into a small square garden or out to the Sabarmati River itself. The effect of this suits a pilgrimage site: visitors come to learn about Gandhi's story and the impact of his life on

India and the world, but they also come to be near a space where Gandhi once worked and lived. Rather than separate the historical and biographical didactic presentation from the experience of Gandhi darshan or *baraka* (spiritual proximity) that pilgrims to the ashram achieve, Correa's memorial signals to visitors that the two are one and the same. Correa's disaggregated spaces tie the ethos of the museum/ashram/pilgrimage site together, moving visitors around those spaces by modulating—as he says—light, air, and temperature.

Likewise, the earlier, more modest ashram buildings are integrated into the site by virtue of the plan's openness. Correa's use of local materials in his new structures, including tile roofs, wooden doors, stone floors, and bricks, reinforces the connection to the earlier buildings. Yet the materials in Correa's section of the complex operate in utterly different ways than in the earlier structures. Where wooden doors and verandah posts break up the square box of Gandhi's home, and the whitewashing of the walls underscores the literally homespun aesthetic of Gandhi's movement, in Correa's buildings the firm parallel lines and clean surfaces, regularized paving stones, and horizontal slats of the louvers contribute to a different type of austerity, one that, ironically, one cannot find in handmade items, but only in industrial products. This is not to say that Correa used some sort of industrial modular construction to produce the buildings, but rather to point to a distinction between the *khadi*, or homespun, sensibility of the ashram buildings and the modernist lines of the museum.

Correa's museum employs the idea of the village's disaggregated space and melds it with the pared-down forms of modernist architecture. As many have pointed out, the building owes more to Louis Kahn's Trenton Bath House (1954–59; see Serenyi 1984, 77) than it does to the nearby ashram buildings or to historical precedents in local Ahmedabad architecture. The pavilions may serve a similar function to that of *chhatris*, small umbrella-like structures found atop Mughal tombs, or that of the open trabeated structure of the local palace and tomb complex of Mahmud Begarha at Sarkhej (late fifteenth to early sixteenth century), but their formal antecedents lie closer to Kahn's bathhouse. The roofs do not overhang the walls, the horizontality of the lintels is strong and unbroken, and the texture of the wood and brick provides interest without interrupting the austerity of the architectural forms.

Rather than look to formal Indian precedents for the Gandhi Smarak Sangra-

halaya, one should turn instead to Correa's analysis of the way space is arranged to take advantage of both the Gujarati climate and the way in which inhabitants move through various types of space within that context. This approach based on a conception of an Indian ideal form owes much to observations of village structure, but it also relates to Le Corbusier's ideal Mediterranean architecture of open courtyards and shaded spaces. Correa appropriated the ideas behind vernacular village organization, climate control, and local media and transformed them into something entirely different. Rather than merely quote the *chhatri* form or mimic the grandiose imperial architecture at Sarkhej, Correa constructed a modern space following rules he saw in the vernacular and historical spaces around him (Correa 1989, 106). At the same time he has maintained a connection to modernist precedents, precedents that themselves look to ostensibly traditional and primitive village forms for inspiration.

In the end, Correa's building emerges as a spiritual space, one celebrating the life and actions of Gandhi in a pilgrimage site conducive to study and reflection, as well as facilitating a Gandhi darshan for those who visit. But much as there exists a distinction between the austerity of Gandhi's ashram buildings and the austerity of Correa's modernist forms, one must also distinguish between a spirituality stemming from Indian belief systems and one stemming from the sacredness with which modernist architects considered their forms and projects. That is, if modern architecture should be about the offering of the spirit, as Balkrishna Doshi characterizes Kahn's approach to his work (Doshi 2002, 21),[7] then the interpretation of Correa's buildings must acknowledge the strength of the spiritual pull of modernism alongside that of the architect's interpretation of indigenous traditions. Correa has brought these two "faiths" together—a modernist spirituality with an understanding of the local space of pilgrimage—and it is this successful amalgamation that makes his buildings so powerful (see Kahn 1987, 19).

Thus Correa's Gandhi ashram finds within modernism a way around its traditional eschewing of religion in favor of science and reason. By choosing his modernist sources carefully—looking to two modernist architects with affinities for the village and the primitive—Correa finds a path that reconciles the modern and an "authentic" Indianness. Correa's essentialization, however, carries with it many of the same problems that both the nationalist and the modernist rhetoric about an authentic India shouldered.

Both Correa and Gandhi rearticulated Indian belief systems and drew individual strands from those systems that contributed to their respective causes. This is not to equate Correa's architectural career with Gandhi's revolution in political resistance, but rather to point out that both men employed Vedic, tantric, and Brahmanic texts and practices to support their own ideologies. In his essays Correa has reiterated this connection to ancient India, linking it to present-day architectural concerns (Correa 1982, 1989, 1991, 1996). Correa's open-to-sky articulation of his own work and of the entirety of Indian architecture, from the villages of Rajasthan to Shah Jahan's Jami Masjid in Old Delhi, serves as a unifying theme that supports his own understanding of what it means to be Indian (Correa 1996) and that connects his work to earlier canonical architectural monuments. As Vikramaditya Prakash points out, Correa's many references to open-to-sky space and his repetition of the trope of the guru under the tree begin in the early 1980s, well after building the structures in question here (Prakash 1995, 207, 219; Correa 1982). This period after 1980 coincides with the beginnings of the Festivals of India around the world, festivals not unlike the earlier colonial exhibitions of the nineteenth and early twentieth centuries.[8] These events brought together the arts and crafts, theater, architecture, and other cultural products of India and presented them in gallery, museum, and large exhibition settings all over the world during the early and mid-1980s. Correa wrote the keynote essay and curated the "Vistara" exhibition of Indian architecture for the Festival of India in the Soviet Union. The essay, revised and published as "The Public, the Private, and the Sacred" in 1989 (and again in 1991), includes the paragraph about the guru under a tree.

The 1980s Festivals of India, in addition to raising awareness of India's culture, also exoticized and homogenized India (Prakash 1995, 216; Dalmia 2002, 4). This is not to say that the exhibits lacked diversity, but the very idea of presenting India as a singular culture (even if in a positive light) involves selectively choosing what is properly deemed "Indian" and deploying these ideas across the exhibitionary spaces. Alongside a surge of what have become known as Raj nostalgia films of the 1980s (e.g., *The Far Pavilions*, *The Jewel in the Crown*, and *A Passage to India*), the Festivals of India reinforced a colonial valorization of what is good about the subcontinent: a continuous concern for authentic spiri-

tuality and a devotion to a long history of philosophical inquiry. As Amartya Sen argues, this ostensible authenticity emphasis in writings about India can be found in both colonial-era discourse and in nationalist and postindependence self-definitions (Sen 1997). Like Correa's themes of open-to-sky architecture and the guru under the tree, this sort of positive pronouncement about Indian culture reinforces the stereotype of India-as-spiritual, somehow more in touch with its philosophical side than a monolithic West. It implies, therefore, that India is not concerned with the practical, the political, or the day-to-day.

Correa's own focus on the day-to-day lives of the desperately poor in Bombay and elsewhere in India counters and balances his understanding of Indian space. Since the 1960s, Correa and many other architects have taken on the very material problems of housing, transportation, and infrastructure that plague large cities in India, cities often populated by recent immigrants from rural areas (Shaw 1999). The rise of his rhetoric about open-to-sky spaces in the 1980s must thus be understood as a reawakening of a nationalist valorization of the spiritual—and in particular, the Hindu—element of Indian culture, falling in line with earlier nationalist arguments about India including those by Coomaraswamy, E. B. Havell, and others.[9] In other words, given Correa's commitment to producing changes in the cityscapes and architectural surroundings of those living in India's major cities, the turn to an abstract, spiritual, and universalizing ideal form appears to be a contradictory, counterproductive mechanism. And yet, when situated in the context of the valorization of ancient and spiritual India in the 1980s, this post hoc understanding of Indian space, from the Indus Valley to the present, makes sense as part of a larger Hindu-nationalist identity-building project.

The parallels between Correa's open-to-sky purity and earlier preindependence moves to raise India's historical status are striking. Coomaraswamy's writings exemplify this earlier period, as he produced many essays in defense of Indian aesthetics and art in the early twentieth century. At a time when some British scholars deemed Indian art barbarous and uninteresting, Coomaraswamy argued that in Indian art one found a pure, authentic spirituality lost to Western industrialized culture. For example, he described the process of producing art for a temple as one of visualization, meditation, and working in a "yogic state" ([1934] 1956, 5–7), based on his interpretations of various Upanishads. While practices of respect and even worship might enter into the

creation of a temple sculpture, one also finds many examples in Indian history where artists of various religions constructed temples, carved images, or painted decorations on religious buildings of another sect. Coomaraswamy's universalizing spiritualization of Indian art allowed him, and others, to raise the status of India's visual culture. Yet unfortunately, his arguments also reasserted those of earlier British Orientalists who had found in the ancient languages and texts of India its spiritual and linguistic worth, to the exclusion of other aspects of Indian culture.

Coomaraswamy stands as one example of a wider trend to label India as a spiritual haven against the industrial vacuum of the West. During the period of the Arts and Crafts movement in Britain and as modernist aesthetics showed an increased interest in primitive cultures, many scholars and artists followed Coomaraswamy's lead. Correa's open-to-sky and guru-under-the-tree tropes recall this nationalist romanticization and spiritualization of India's culture, and the rising Hindu-centered culture of the 1980s certainly looked to these elements as central to an Indian identity.

While Coomaraswamy saw the degradation of Indian culture as a product of broad Western industrialization, Correa reacted against a *particular* understanding of the modern. This is the vision of the modern linked to industrialization and figured by the Miesian skyscraper—the towering box out of step with its surroundings and representing a pure, universal form (Kahn 1987, 18, 167). The 1950s and early 1960s were an era guided by Nehru's optimistic and hopeful vision of a modern, industrialized, and working India, one that both valued its artistic cultural heritage and moved forward into the modern age of dams, machines, and factories (Nehru [1946] 1960; see chap. 4 of the present volume). By the 1980s this optimism had given way to both pragmatism and disillusionment with the unfulfilled promises of independence (Chatterjee 1998). Thus, in a move similar to that of earlier nationalist scholars and politicians, Correa, in the context of the "Vistara" Festival of India exhibition, articulated an understanding of Indian architecture grounded in a universalized allegiance to an essentialized, primordial relationship to the sky.

Importantly, however, Correa's essentialized interpretation of Indian architecture emerges only in retrospect. Correa's early buildings certainly do incorporate open-to-sky spaces, but a more honest analysis of the Gandhi Smarak Sangrahalaya, for example, emphasizes the ideologies of modernism over the

continuities of an imagined Indian aesthetic. Correa's early work rather speaks to the *critical union* of a village ideal and a modern one. The authenticity modernists sought in primitive forms works here in concert with local materials to produce a modernist vision of the pilgrimage site. The Gandhi Memorial Museum can thus be placed in the context of Nehruvian optimism for a modern Indian future, as much as it might be understood as a recuperation of the village form and as describing the relationship of Indians to the sky.

THE PROBLEMATIC OF THE VILLAGE AND THE MODERN

While Correa's statement does not incorporate the subtle critiques of the guru-under-the-tree space and of the valorization of the village that Ray's film and Husain's painting do, his work cannot be understood as lying wholly within the realm of the village aesthetic either. All three works discussed here walk the line between the modern and a valorization of the authentic Indian village space that draws "Indian" and "modern" comfortably together while never losing sight of the fundamental problem at the heart of that union.

In Ray's work, the use of framing to produce a claustrophobic sense of the schoolhouse and a need for escape refuses to give us a fully romanticized vision of village life. Indeed, Ray's oeuvre as a whole presents both the positive and the negative aspects of rural living, valorizing neither the village space nor the industrial elements that intersect that space. Highlighting different levels of access to the discursive space of the village, Husain's *Under the Tree* allows the viewer to understand the tensions of village life and its potential as a space of agnostic dialogue. Correa's work brings together a modernist faith in the purity of form, horizontality, and the interaction of light and shade while producing a space of pilgrimage, deploying the spirituality of modern seekers of primordial truth to reinforce the sacredness of the site of Gandhi's ashram.

These three works thus illustrate the appropriations and intersections of the idea of the authentic in the context of constructions of Indian modernity in post-1947 art and architecture. The influence of nationalist rearticulations of colonial valorizations of Indian culture is clear: one finds the authentic in the village, next to the tree, in the connection to the sky. But Coomaraswamy and his colleagues in the nationalist movement were caught in a trap: they worked so hard against the colonial construction of an India without history,

art, or culture that they cemented India in a past at once ancient and spiritual. Correa, Ray, and Husain manage through their work to negotiate the paradox of Indian modernity while dodging its trap. What differs for these three artists—and for the 1950s, during which all of these works were produced—is the interpenetration of this authenticity with the search for a primordial truth so central to modernist aesthetics. In this intersection, each of these works finds the means to articulate an Indian modernism negotiating the paradox—one which, at least in part, acknowledges the problems with using the Indian village as the essential Indian space and places that problematic at the center of modern creations.

THE ICON

SPIRITUALITY IMBUES MANY different aspects of modern Indian art, not just those associated with the seemingly authentic purity of the village space, as discussed in the previous chapter. In addition to looking to particular locales for spirituality in India, or to specific groups of people (village/rural), postindependence visual culture turned to the icon in Indian religions, including images of various gods and goddesses. Works of this period also probed the symbolic abstraction often found in religious art forms—from the phallic emblem of Shiva to the cosmic diagrams of Tibetan mandalas and meditational yantras. These two directions stemmed from an understanding of Indian heritage that partially rested in a Hindu iconography, but the imagery also often looked to Christian sources, primarily those indigenous to the subcontinent. With movement in both figural and abstract directions, Indian artists found space to explore the modern without having to choose the hegemony of European- or American-inspired international abstraction, whether that of the school of Paris or abstract expressionism.

The engagements with iconicity, symbolism, and spiritual heritage rarely involved simple celebration—religion in independent India was fraught with

communal tensions. The Nehruvian struggle to create a secular state in the face of an ongoing polarization of Hindu-Muslim relations, followed by Indira Gandhi's destructive policies toward the Sikh community, meant that religious identity—and political discourse centered on religion—often anchored discussions about what it meant to be Indian and about who could come to the political table. Many works of this period—including those of Ganesh Pyne, Laurie Baker, F. N. Souza, Krishen Khanna, Charles Correa, M. F. Husain, and others—directly address religious themes; others focus on the icon or refer to religious architectural design more indirectly. The neotantric artists worked through religious imagery on a more abstract level, rarely fully embracing a figural mode. Following the preceding chapter's discussion of a new understanding of the "authentic" in postindependence India, this chapter examines the overlapping realms of religion and spirituality, focusing on the use of the icon in art. In this case, *icon* refers both to a physical image of a deity and to the more abstract concepts of metaphor, allegory, and metonymy, in which objects or symbols might stand in for ideas. Icons chosen here include both those directly related to Hinduism and Christianity and those unrelated to specific religions, but with compositions that reference a long history of iconic imaging in India. The works produce an Indian modern by working through an international language of iconicity, an element of visual culture found in most regions and periods. They anchor this international move in the subcontinent in distinct ways, from the choice of icon to the style used. At times, they deploy a deeper understanding of India's own iconic heritage, looking in particular to the South Asian *murti*, a Sanskrit term used to describe the deity-as-object in a worship context.

In the mid-twentieth century, turning to religious themes to explore India's identity was nothing new. Amartya Sen argues that the colonial and nationalist valorization of Indian culture lay in the recuperation of religious, philosophical, and metaphysical aspects of Indian thought found in texts and, extending his argument to Ananda Coomaraswamy's legacy, in the practices of artisans and worshippers (Sen 1997; Coomaraswamy [1943] 1956, 1957). Artists at Shantiniketan, such as Jamini Roy and Nandalal Bose, worked with iconic imagery in their paintings, incorporating religious (in Roy's case, Christian as well as Hindu) and local folk imagery. Abanindranath Tagore, of the Calcutta-centered Bengal school, had already employed Mughal iconography—a sort of imperial iconic form—to recall a high point in the Indian past, and he used Hindu ico-

nography to produce an image of Mother India, deploying the goddess for the nationalist cause (Guha-Thakurta 1992). His work constituted a reaction both direct and indirect to Raja Ravi Varma's earlier work of the late nineteenth century, which had consolidated an image of Indian culture behind a Sanskritized Hindu literature. This legacy energized nationalism and aided in the throwing off of the British yoke, but it also helped produce an image of the subcontinent as solely Hindu (Mitter 1994, 201).

This genealogy of Hindu iconic painting (including the problematic subtext that Hinduism stands in for all religion in India) undergirds the works of the postindependence period. The continuity of subject matter, including Christian and Hindu icons—and in the case of Husain's work, Islamic imagery as well—involves these works in the struggle to define India in terms of the country's religious iconographic past. In different historical contexts, whether in terms of post-Partition communal politics or of regional or local variations on iconicity,[1] artists have produced varied responses when engaging with the problematic terrain of Hindu icon-centered imagery. Pyne, working from Calcutta, brings his experiences of death and suffering during the 1942 Bengal famine, the destruction prior to Partition, and the 1971 Bangladesh war to bear on his understanding of the iconic figure. Many of Husain's works depict iconic images of Hindu, Muslim, and Christian figures, some adorning churches and others in murals or independent paintings; this subject matter has sparked well-known attacks on Husain from Hindu fundamentalists ("India's Harassed Artists" 1996; Guha-Thakurta 2004, 237–67). Souza's depictions of Christ also embody an iconic sensibility, one that reflects Souza's—and India's—difficult relationship with Christianity, both colonizing and indigenous.

Major church commissions may serve as sites to work out a modern-Indian-Christian sensibility on a large scale: Correa's collaboration with Husain at the Salvacao Church in Bombay and Baker's St. John's Cathedral both create modern spaces that reflect local Christian practices and heritage. The relative absence of major modern architects constructing Hindu temples or even Islamic mosques, despite the fact that the Birla family and others have funded major new temple construction across India since independence, shows that contemporary patrons of religious foundations resist engaging with modern architectural movements.[2] At a time when Jawaharlal Nehru declared major industrial works to be India's new temples and when communal tensions ran high,

temple and mosque construction remained largely in a traditional mode, one that forcefully asserted its position in the past, just as Hindu nationalist rhetoric reworked that same past (Subramaniam 2000).

This chapter thus articulates how religion, spirituality, and the icon come together during this period of searching for a modern Indian aesthetic. Again, we find a paradox inherent in the question itself: if modernity means, in part, to throw off the yoke of religious ideology—to create a secular, reason-driven space of enlightenment through science and technology and to eschew spiritual belief systems as traditional remnants of a past the modern citizen has moved beyond—then the turn in India's twentieth-century art toward the spiritual, iconic, and religious form works against that central stream. However, even during Europe's Enlightenment and the subsequent development of modern art (in an art historical sense), spirituality and religion were not far from the minds of artists or critics; Vassily Kandinsky and Paul Klee, for example, engaged in deeply felt spiritual searching. What differs markedly for those working against the backdrop of both nationalist struggles with Indian religious identity and the communal tensions flowing from Partition and other post-independence sociopolitical events is perhaps the intensity of the debate over the sacred and the secular, the religious and the political. For since its birth as a nation, India's very existence as a secular democracy has been in question and come under attack from a range of religious sources. The art produced in this context gives shape to the continual push and pull between religion and reason, tradition and technology, the past and the future.

The artworks and buildings discussed in this chapter together show the contours of these problems and demonstrate how iconicity has been employed to find a way through the modern/Indian paradox. I begin with the quintessential icon for South Asia, the murti, and discuss the neotantric work of G. R. Santosh, followed by the Christian-Chaitanya inflected work of Pyne. These two painters offer very different approaches to the icon, much as the two buildings I examine here—the Ashok Hotel and the Vigyan Bhavan—offer two different examples of architectural elements reused as iconic symbols for India. I close with a sculpture and a painting that both reference popular icons: a Raghav Kaneria piece that looks to pathway icons, and a Bhupen Khakhar painting that derives its composition from calendar prints. Each of these objects speaks in a different way to the question of iconicity, and together they map the ways in

which the visual culture of the decades after independence turned to the icon to navigate the tensions between "Indianness" and modernity.

An icon, a religious statue, an image of a god, a marker of a god, or an object that serves as the focus of worship—all these elements are captured by the Sanskrit term murti, which cannot be easily translated into English. Because of the history of Western approaches to Indian imagery, dating back to the Middle Ages (Mitter [1977] 1992), the translation "icon" implies a certain static, objectlike quality in the term, an implication undercutting the dynamism of the original murti. The murti enables the presence of the god, who breathes life into the sculpture and enters it, allowing worshippers to see (darshan) the deity not just in a recognizable guise, but truly as a presence (Fuller 1992; Eck 1998). The understanding of the icon I bring to the question of modern Indian art is therefore not one of a static form, a congealed image *of* something ineffable now brought into a mundane context. Iconicity acknowledges that the images play with the static-active nature of the term *murti*, drawing from it a sense of strength and permanence while simultaneously allowing for a movement into the future. Murti is a perfect metaphor for the balance these works strike between the "traditional" past and progress toward a new modern future.

One way this balance occurs is through a turn to an internal tradition, specifically tantra. Tantrism is both Indian and hidden and serves as the inspiration for several artists loosely grouped under the category "neotantric." G. R. Santosh (1929–97) was one of a handful of artists forming the core of this group and exploring the potential of the sexually charged, symbol-driven imagery of the tantric idiom. His *Untitled* from 1973 (plate 2) embodies much of the iconography the painter pursued throughout his life. I have chosen this work here because it represents the wider movement of neotantric art: many of the symbolic moves Santosh makes can also be found in the art of his contemporaries including Biren De (b. 1926), S. H. Raza (b. 1922), and P. T. Reddy (1916–96).[3] In *Untitled*, Santosh uses key elements of tantric art—the *bindu*, or cosmic dot, the cosmic diagram, the lingam-yoni pairing—to produce an image hovering between abstraction and representation and employing a symbolic language that looks simultaneously to the traditional and to the modern.

Neotantrism is less an organized movement than a conglomeration of artists whom critics and art historians see as addressing concepts related to the renewed interest in Buddhist and Hindu tantric practices during the 1960s and 1970s. Tantra itself evades precise definition, as scholars of religion continue to disagree on its boundaries and core elements. Current consensus draws on a set of texts called Tantras, the earliest of which was composed in the fifth century CE (White 2000). Tantra centers on an understanding of the universe as "the concrete manifestation of the divine energy of the godhead," which tantric practitioners, or *tantrikas*, channel through the microcosm of the human body and its energies (White 2000, 9). The interconnectedness of macrocosm and microcosm, and the understanding of their unity, form one core element of tantric belief. The mandala, or cosmic map, allows practitioners to access this macro-/micro- universe that gives a place to the various energy-bearing elements of the world including gods, demons, and animals, as well as the human body. Indeed, the body forms a crucial part of tantric practice, as the energies within it parallel macrocosmic energy (*shakti*). Thus a tantrika will use mantras or sound syllables such as the root syllable "Om" to connect the body with that larger universe. In some tantric contexts the union of bodies in sexual practice also achieves this connection between microcosm and macrocosm. Like all religious systems tantra has changed over time, defying easy categorization.

Indeed, attitudes toward tantra in scholarship and popular culture have shifted, revealing as much about the moment of interpretation as about tantra's meaning. In the early twentieth century, Western scholars of India saw tantra as a "hidden" form of Buddhism and Hinduism, thereby revealing lingering Victorian attitudes that saw in tantrism a degradation of the religions of India (Bhattacharyya 1982, 26). Scholars assumed that Brahmanical Hinduism based on the Vedas and the Upanishads formed the core of Hindu religious practice and that tantrism constituted an unwelcome, radical outsider with a consistently marginal status. Thus scholarship ignored tantrism until the 1930s and 1940s, when several writers began translations of some of the core tantric texts (Filliozat 1937); their work was followed in the 1960s and 1970s by studies of temples and other artistic remains of earlier tantric cults (Boner 1962, 1972, 1982).

Uncovering something hidden within religious practice played into the exotic, esoteric image of India already cultivated by colonial discourse. The

search for knowledge about tantra came to a head in this period in part because of the greater accessibility of Tibetan Buddhism following the exile of the Dalai Lama from Tibet in 1959. Coinciding with a growing Western interest in what was broadly termed Asian spirituality—sparked in part by the interaction of the Beat poets with Zen in the 1950s (Fields 1992)—tantric scholarship soon moved into the mainstream with major exhibitions and publications on tantric art, most prominently Ajit Mookerjee's *Tantra Art* and Philip Rawson's *Art of Tantra* (Mookerjee 1966; Rawson 1971). The 1960s and 1970s mark a high point of interest in the visual and conceptual aspects of this ostensibly hidden form of Hinduism and Buddhism.

More recent scholarship has reevaluated the "hidden" quality of tantra, arguing in contrast that it enjoyed mainstream patronage and support during certain historical periods.[4] The ubiquity of tantric art forms and the patronage of these forms by prominent historical figures point toward a much less stark distinction between orthodox and unorthodox than previously assumed (White 2000, 31–4; Harper and Brown 2002; Brown 2002). Today scholars are beginning to contextualize the very idea of tantra as "hidden" as participating in Orientalism, in its concomitant exoticization of India, and in the need for debauchery in India to stand in contrast to a presumed Victorian reserve.

Yet in the mid-twentieth century, when the neotantric art movement began, the attribution of hidden qualities to tantra still predominated. In the writings of Mookerjee and Rawson, objects from diverse periods and regions inhabit similar conceptual spaces, producing a dehistoricized vision of tantra. In this context, the purity of the objects—as Indian and uniformly timeless—remains unquestioned. A philosophical interpretation committed to the purity of metaphysical categories undergirds the organization of these texts on tantric art. It allows the objects, symbols, and practices to transcend time and to present a unified South Asian cultural heritage. It is from this image of tantra and tantric art that Santosh draws his imagery, and it is here that he finds the appeal of tantra: a universal yet Indian conceptual and visual well from which to drink.

In *Untitled* we see a bindu anchoring the lower half of the composition, acting as a source for the energy that emanates through several geometric forms. Two overlapping triangles—one pointing upward, another pointing downward—form a solid cream-colored diamond shape behind the bindu. The multitude of triangular forms this produces highlights the generative properties

of the bindu; we see smaller triangular forms coming into contact all around the central dot. These interlocking triangles—the Sri Yantra—are set within a deep red-orange oval surrounded by a cream-colored border that drips downward at its forward edge. The space of this painting, much like that of Santosh's other works, recedes backward despite the two-dimensionality of the painting's forms. Here, this produces a vaginal, yoni-like shape that supports the larger, vertical egg-shaped form that dominates the composition. Santosh has therefore taken the two-dimensional image of the yantra—one of interlocking triangles surrounding a bindu—and placed it in an organic abstraction of the phallic-vaginal union often seen in Shaivite contexts. This three-dimensional space pushes the flat forms into action, making the viewer participate in placing these objects somewhere between the two-dimensional symbol (Sri Yantra) and the three-dimensional sculpted lingam-yoni.

The symmetry of this image can be found in many neotantric paintings; it follows the pattern of tantric paintings, drawings, and sculptures published in the books by Mookerjee and Rawson. The symmetry adapts of various yantras representing the union of the macrocosm and the microcosm, of the body with the universe, and of the deity with the devotee. Rather than merely use the geometric lines and diagrammatic elements of the yantra, Santosh presents us with a full, egg-shaped form that hovers in between two and three dimensions and brings the harsh lines of the yantra into a more organic realm. In other works, Santosh often uses parts of bodies to the same effect—they hover among geometry, symbolism, and figuration, employing the yoni or vaginal image to provide symmetry and meaning through the body. The liminal position of the human form in his work—existing between representation and symbol—is echoed in the variation of line created by his application of paint. In reproductions of Santosh's paintings one senses a precision in shape and line that dissipates when examining them in person. His lines are very painterly and almost three-dimensional. They waver in width and often bleed at the edges. This produces a tension between the precise, geometric compositions and the looser, palpable application of paint.

This tension points to the power of Santosh's neotantric images. They hover between the poles they reference, be they the traditional space of tantric art or the forward-looking space of the modern. Santosh offers up a particular kind of murti, one that encapsulates the abstract form of the lingam-yoni pair,

but does so with the organic, egg-like shape within the lingam, figuring more strongly the interconnections between the two. The large ovoid form in the image also references the egg-shaped stones found throughout India that are taken from rivers and set up as shrines along the roadside or next to trees, as well as connecting directly to the reproductions of tantric paintings found in Mookerjee's catalogue. Santosh's *Untitled* communicates Indianness while also engaging with two aspects of modernism: abstraction, and the search for an authentic, pure expression through that abstraction. In tantrism, Santosh and the other neotantric artists find an idiom that allows them to tap into the constructed authenticity of Indian spirituality so popular in Western culture in the late 1960s and early 1970s, thereby at once probing a local—or perhaps even national—spiritual heritage and presenting the problematic in the context of geometric, pure abstraction. Santosh has captured this balance while maintaining the presence of his hand in the image, showing the viewer the fuzzy-edged uncertainty found in this joining of modernity and Indianness.

MURTIS: SAINTS AND DEITIES

Neotantra is perhaps the most obvious melding of the icon and modern Indian art. Other artists have used the concept of the murti to populate their own, constructed, otherworldly spaces. For Pyne, this space is saturated with imagery of death and loss, perhaps inspired by his own experiences growing up in Calcutta during Partition and later witnessing the famine and destruction of lives caused by the Naxalite violence of the late 1960s and early 1970s and by the war with Bangladesh in 1971 (Datta 1998, 49). Pyne often turned to figures from poetry, legend, and religious narrative to depict elements of the dark world in which he found himself. Whether the images are related to the life of Chaitanya or are taken from the personal and political events going on around him, Pyne's work captures the core elements of these stories and events through iconicity.

His *Woman, the Serpent* (1975; plate 3) exemplifies a different kind of icon making than Santosh's symbolic organic abstractions. Centered on the figure of a woman, Pyne's composition echoes a tripartite form often associated with images of the divine (whether Christian, Buddhist, or Hindu): a primary figure facing front, flanked by two subsidiary figures—here a sapling tree bearing fruit to the left, and a serpent to the right. The obvious biblical reference to the story

of Eve and the serpent in Genesis is here composed as if in a triptych of the actor, Eve; the tempter, the serpent; and the temptation, the fruit. The painting indicates Pyne's interest in a wide variety of iconic figures from a range of sources, religious and otherwise. The focus on woman-as-icon arises not only from the iconography of Eve in the Garden of Eden but also from sources in earlier Bengali art of the nationalist, preindependence period, whose romantic aesthetic became a source for Pyne (Kapur 1978b). In other words, these earlier art movements provided a model for how to be an artist, engage in world culture, and look to one's local histories and visual cultures (Sen 1996, 144; Datta 1998).

Artists working before independence thus provided a range of source material for Pyne to choose from. The Tagores of the Calcutta-centered Bengal school, led by Abanindranath and his cousin Gaganendranath, turned to Japanese aesthetics, cubism, Romanticism, and Mughal Indian imagery to explore the potential for a pan-Asian aesthetic, international modernism, and a nostalgic return to an Indian past. In contrast, both Jamini Roy (1887–1974) and Rabindranath Tagore (1861–1941) looked to so-called primitive cultures—in Rabindranath's case, the Santal cultural group of eastern India—to produce an Indian art that was simultaneously "natural" and, in its abstractions and use of primitive source material, modernist.[5] Rabindranath and the group of artists at Shantiniketan reacted against the Bengal school's fascination with Mughal miniatures and aesthetics (related to a nostalgic romanticism) and in the 1920s turned instead to a bolder style marked by an interest in folk idioms. This shift to the folk can be seen in Roy's work, which appropriates local painting traditions such as those of Kalighat and Bengali village scroll painters (patuas) for source material, producing figural compositions with bold, strong outlines and uniform, unmodulated coloration. Rabindranath's educational complex and art school, which later became Visva Bharati University, was located well outside Calcutta at Shantiniketan and continued the fascination with the primitive into the next generation. Artist-teachers such as Nandalal Bose and the sculptor Ramkinkar Baij produced work based on Santal and other local folk idioms (see Datta 1997, 29–35).[6]

While many artists of the postindependence era eschewed the Bengal school, particularly its early romantic view of the Indian past, much of this turn-of-the-century nationalist aesthetic remains in Pyne's work (Kapur 1969, 4; Datta 1997,

30; 1998, 38; Hyman 1998, 11). Stylistically, Pyne draws from the wide variety and richness of the Bengal school and its foil in Shantiniketan, not just from Abanindranath's watercolors, looking also to the iconic presence of Roy's stark figures, for example. The subject matter of preindependence Bengali art, too, continues with Pyne. The earlier works also turned to prominent figures—religious, historical, or contemporary—to anchor real people in the struggle to further the nationalist cause and explore the everyday struggles of people in Bengal (Datta 1997, 29). The layering of artistic heritage in Pyne's work is thus matched by an awareness of the importance of the figure for Bengali art.

It is important to realize that the iconic elements of *Woman, the Serpent* spring from a local Bengali idiom as well as from a wider artistic and cultural context. My initial reading above of the image as a reworking of the Judeo-Christian Garden of Eden moment of temptation is matched or even surpassed by one steeped in a particularly Bengali context. The coloration of the figure—a woman with blue-toned skin wearing a red garment and a peacock feather on her head—points to a potential Vaishnavite interpretation according to which we see here references to Radha-Krishna iconography, and perhaps even to one of Pyne's recurring themes, the person and philosophy of Chaitanya. This layering of Judeo-Christian and Bengali iconography deepens Pyne's use of the figural icon and of religious iconography in the painting; it also demonstrates the multiple levels on which the icon operates to articulate an Indian modernity.

Chaitanya (1486–1533), the founder-saint of Gaudiya Vaishnavism in Bengal, brought a particular focus on bhakti to the region in the form of emulating Radha's devotion to Krishna, an avatar of Vishnu. Recreating Vrindavan—Radha's and Krishna's earthly playground—in Bengal, Chaitanya and his followers created a movement that centered on performances and songs about the loving couple sung in the local vernacular rather than in Sanskrit (Ghosh 2005). From the early 1970s onward, Pyne was fascinated by Chaitanya's life, and many of Pyne's paintings from this period use Chaitanya's biography as source material (Datta 1998, 52).

Looking again at *Woman, the Serpent*, one sees elements of Gaudiya Vaishnavite imagery. The reference to Radha in the garment of the central figure and to Krishna in the blue skin suggests the cross-dressing play the two engaged in that the Gaudiya tradition celebrates (Haberman 1988). Pyne's use of a mask-

like face, almost hovering in front of the skeletal neck that barely supports it, reinforces this vision of role-playing and gender reversal. Likewise, the flat, cartoonish breasts, framed by a long gold chain stretching from shoulder to shoulder, seem artificial when compared to the careful modeling of the figure's knees through the red drapery. Pyne has given us several visual clues here to suggest a reference to Radha and Krishna. Their union, and the bhakti emulation of that union as devotee-to-deity love, is central to Gaudiya Vaishnavite practice.

The tree, too, may resonate both with Judeo-Christian and Gaudiya imagery, as it simultaneously suggests the apple tree in the Garden of Eden and the neem tree under which Chaitanya is said to have been born. Chaitanya's appearance, as "the fair one" or Gaura, with a golden hue, comes from this story of his birth, as the neem fruit shares this light golden color. In Pyne's image, a single fruit hanging from the sapling draws the eye with its brightness in an otherwise somber palette and supports both iconographies (as apple or as neem fruit), while the leaves hover between the pointed cluster of the neem and the similar crab apple leaf. Furthermore, the emphasis on the forested region of Radha's and Krishna's Vrindavan, and its recreation in Bengal at Vishnupur, the Gaudiya Vaishnava capital, adds to the importance of the tree in this image. Again, Pyne's treatment of the subject supports an interpretation anchored in Gaudiya Vaishnavism, as he has both obscured the leaves enough to provoke question and highlighted the fruit enough to make clear its importance.

The third element in the tripartite composition, the satanic snake of the biblical tradition, also invites multivalent interpretations. For, rather than twining the snake around the tree as happens in much Christian iconography, allying it with the object of temptation, Pyne here has separated the serpent, set it upright, and placed a bulbous form over its head. Inside this small shape rests another figure, suggesting Krishna in his triumph over the poisonous serpent Kaliya, whose fangs he avoids by dancing on Kaliya's multiple heads. Here the serpent has only one head, but the hovering figure remains directly over it, and the head is turned inward, gesturing to the central figure. This pose suggests the aftermath of Krishna's victory over Kaliya, when, after the serpent asks forgiveness and supplicates Krishna, Krishna spares him, banishing Kaliya to the ocean.

Pyne's painting therefore evokes Bengali Gaudiya Vaishnavism as well as

Judeo-Christian iconography, all the while centering the imagery on a female, goddesslike figure. Having studied Bose's use of tempera pigment (Sen 1996, 144; Datta 1998, 46), Pyne develops the goddess theme in relation to the earlier nationalists' use of both this local medium and the image of the deity, echoing Bose and also earlier figural works by Abanindranath Tagore.[7] The layering of religious iconography from two different traditions—a characteristic of Gaudiya aesthetics (Ghosh 2005)—allows Pyne's painting to transcend a simple identification with either, making the two mythologies enter into dialogue in his own idiom. The work addresses both Western and Indian audiences—while simultaneously speaking to neither fully. Pyne's use of the icon allows the painting to transcend both time (pre- and postindependence contexts) and religio-cultural space, articulating its own project of negotiating modernity in independent India.

I want to close this analysis of Pyne's painting by noting the particular context in which the work developed—not just this single painting, but Pyne's entire investigation of Chaitanya and the development of his own figural idiom. Pyne's dark, romantic, almost gothic style engages directly with the upheaval around him. Horrific images of famine and war emanated from his immediate surroundings in Calcutta, as refugees from Bangladesh and the rural areas around the city flooded in. His skeletal figures and barren settings remark on this despair and produce an internal contradiction for *Woman, the Serpent*. Indeed, if it represents a retelling of Krishna's and Radha's *lila*, or play, one certainly finds missing the lush forest and their optimistic and loving intercourse described in the songs and writings of Gaudiya Vaishnavism. Likewise, the Kaliya story has less to do with Radha than with Krishna ridding the world of a poisonous, environment-destroying demon, curing the world of that negative force. The central figure's necklace may also reference Pyne's earliest memories of death, further underscoring the despair of the figure's form itself: "I will never forget my first brush with death. It was 1946, and communal riots were taking place all over Calcutta. My family had been evacuated from our 19th century mansion. One day, while walking about, I stumbled upon a handcart heaped with dead bodies, being wheeled into a morgue. On the top of the pile lay the body of an old woman—stark naked, her body had turned ashen. There were fresh wounds on her breast that were oozing blood and there was [a] shining necklace around her neck. I was shaken by the sight. Since then, I have been

obsessed with the dark world" (Pyne n.d.; see Datta 1998, 20). Pyne and others employ his early moment facing death to explain the undercurrent of darkness in his work, clearly shown here in this central figure.

Pyne has given us these elements in the context of the fall from grace found in the Bible—the seeking of knowledge and failure to trust in the godhead. The neem/apple tree on the left of the painting struggles to survive, producing a fruit much too large for its small frame, suggesting the apple's burden of earthly knowledge. Neem fruit, known for its bitter taste, represents the hope inherent in Chaitanya's birth, the bitter reality of the world itself, and the curative, antiseptic properties of all parts of the neem tree. It thus encapsulates the tensions and contradictions of this image: simultaneously dark and hopeful, poisonous and curative. *Woman, a Serpent* embodies the paired despair and hope of Pyne's surroundings and does so by offering an image emblematic of the traumatic early 1970s in eastern India.

Pyne's layering of Christian and Vaishnavite imagery, his references to personal experiences in Bengal and to broader conceptions of death, and his positioning in relation to nationalist preindependence romanticism allow his work to speak to both an international and a local audience. He does so, however, by producing an imagery that exists in neither realm and thus enbodies the concerns and the mood of the postcolonial condition. Returning to the concept of the murti, one can see that this icon is in no way passive or static, just as the murti embodies a living god that sees and is seen. Pyne's ghostly figures flash between various identifiable referents, seeing and seen, never quite fixing their location, and as such they give us iconic images of postcoloniality as ethereal fragmentation.

ARCHITECTURAL ICONS

If Pyne's painting in particular, and the idea of the icon in general, translates from the concept of the murti to a nationalist nostalgic iconography and into the artist's dark vision of Gaudiya Vaishnavite/Christian imagery, architecture offers a different trajectory. Rather than the focused engagement with an icon that Pyne and Santosh have explored, architecture offers an iconography of surface elements—a cladding of references that link modern buildings to India's past.

In 1955, when Nehru and Le Corbusier were collaborating on designs for Chandigarh's governmental complex, thereby moving Indian architecture and aesthetics in a "high modernist" direction, the creators of several buildings in New Delhi followed a different strategy in their search for a modern Indian idiom (see chap. 5 of the present volume; Prakash 2002). They employed a combination of bold architectural gestures anchored in various versions of an Indian past. The architects of both the Ashok Hotel in the diplomatic area of New Delhi and the Vigyan Bhavan conference center around the corner from the National Museum took what is often called a revivalist approach to the question of Indian architecture after independence. Revival styles are seen as combining elements of earlier architectural forms on their surfaces to link these structures, however new, to the past. However, their use of iconic architectural elements, from the chandrashala to the *chhajja*, belies the notion of a simple revival: rather, these structures undercut earlier attempts at hybridity and appropriation, reclaiming an Indian architecture for the new nation.

The Ashok Hotel (1955; figure 3), built by J. K. Choudhury and Gulzar Singh, uses everything from chhatris to large chandrashala archways to alleviate the blocky form of a traditional high-rise hotel. The decorative elements reshape the surface of the building, accentuating the massive ceremonial entryway and allowing the edifice to command both its immediate garden area and the larger park space around it. Choudhury and Singh transform older decorative elements such as the large, central arch, or *iwan*, of the projecting main façade wing and echo those found on Sultanate and Mughal architecture in the Delhi area. They employ red and white contrasting stone, a gesture to local structures like the Alai Darwaza (1311) and Humayun's tomb (1560s), both in south Delhi. These references are accentuated through the use of *jali*s, the carved stone screens found in palace and tomb architecture throughout Delhi.

At the Ashok Hotel, borrowings from earlier architecture are transformed into almost gargantuan elements of this high-rise structure. The main iwan arch, filled with jali stonework, rises over six stories; the balcony that projects out over it (*jarokha*) is supported by three-story brackets flanking the main arch, reemphasizing the strength of the façade and almost overwhelming the high-rise itself. Elsewhere on the structure these elements appear on a smaller scale: chhatris adorn each corner, overhanging chhajja eaves provide a horizontal accent under the top story of the building, and horizontal bands of red

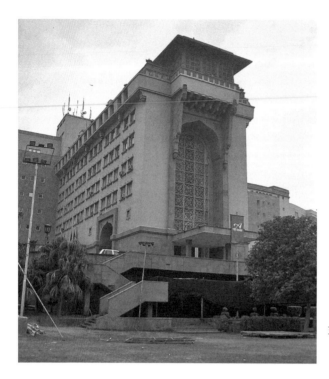

3 J. K. Choudhury and Gulzar Singh,
Ashok Hotel, New Delhi, 1955.
Photograph by the author.

sandstone accent the windows. But it is the main façade that commands atten-
tion, jutting out into the garden and marking the building as a massive tribute
to Indian architectural heritage. Alongside other structures from this period in
New Delhi—such as the Rabindra Bhavan (Habib Rahman, 1959–61) with its
appropriation of, for example, the chhajja eave—this structure looks positively
flamboyant, a baroque celebration of Delhi's architectural past.

This type of appropriation is not, of course, new; each of these elements has
been borrowed and reworked again and again across India's architectural his-
tory (Metcalf 1998, 12–14). Found on palace and fort architecture as well as on
religious structures, these architectural ingredients proclaim a certain iconog-
raphy of Indian historical power, resting on the practices of Mughal emperors
and the rulers of kingdoms in northwestern India. It is rumored that Nehru en-
couraged this so-called revivalism in the Ashok Hotel (Lang, Desai, and Desai
1997, 185), a surprising claim in the context of his other more modernist patron-

age, but not entirely shocking given the diplomatic surroundings of the hotel, nestled as it is between the governmental area of New Delhi and the growing landscape of modern embassy structures to its south and west. Reminding foreign visitors and residents of India's powerful past was particularly important in this urban context. The chhajja roof, jarokha balcony, large pendant brackets, jali screens, and monumental iwans here create an iconography of India's past inserted into the diplomatic dialogue that forms after independence and looks to India's future.

The iconography of the Ashok Hotel thus engages with earlier reimaginings of New Delhi in Sir Edwin Lutyens's and Herbert Baker's designs for the capital of the early twentieth century. Yet the hotel does not merely recapitulate New Delhi's colonial vision, instead taking the appropriation of an Indian past in entirely new directions. Where the structure of the Rashtrapati Bhavan echoes the main Sanchi stupa, or burial mound, in its dome and refers to Indian Islamicate architecture in its decorative chhatri pavilions, its appropriation of earlier architectural form differs markedly both from earlier colonial eclecticism and from the iconic quotations on the the Ashok Hotel's façade. If Indo-Saracenic structures such as Sir Swinton Jacob's Albert Hall in Jaipur (1887) presented a pastiche of excerpted architectural elements in one building, Lutyens and Baker smoothed out the differences between various elements, rejecting (at least in part) the Indo-Saracenic baroque for an imperially inspired classicism flavored lightly with Indian Buddhist references (see Metcalf 1989, 212, 238). The New Delhi built in Lutyens's and Baker's conception between 1912 and 1931 served to support a new vision of empire, one more focused on Britain's centrality than on a melding of British and Indian elements. The Ashok Hotel, rather than subtly seasoning a Western-inspired architecture with Indian elements, proclaims several select iconic forms on its surface, loudly articulating a new relation to India's past as an independent nation. The incorporation of the iwan, the jarokha, and the jali does not flow seamlessly into the form of the building, but instead juts out of the structure, demanding the viewer's attention.

This iconography takes a different turn in the Vigyan Bhavan conference center (figure 4), built the same year as the Ashok Hotel. In its case, the monumental element is not an iwan but instead a chandrashala, referencing the Buddhist excavated halls at Ajanta (fifth c. CE) while also calling to mind several

4 Ramprakash L. Gehlot, Vigyan
Bhavan Conference Center,
New Delhi, 1955. Photograph
by the author.

other monuments of the region. Lutyens, too, had referenced Buddhist imagery
in his monuments on Raisina Hill in New Delhi, looking to Sanchi stupa for
its domical shape and the form of its railings. Rather than accentuating the
vertical—as the iwan does for the Ashok Hotel—the chandrashala, widened
and thickened, accentuates the horizontality of this building, anchoring it to
the earth with both its form and its dark coloration against the white façade.
Flanked by two narrow windows that rise to mark the full elevation of the build-
ing, the main entryway seems even wider than it is. Indeed, the façade seems
artificially manipulated, pressed down from above, and one gets the sense in
photographs that the picture has been stretched horizontally. In person, the
elements on the façade are therefore quite striking. The chhajja eave and a jali
railing at the roofline subtly reinforce the overwhelming horizontality, allowing
the chandrashala entry to claim the attention.

The two flanking windows add an additional architectural reference to the
façade, suggesting the thin verticality of minarets. The peak of the windows
takes a form that appears to echo the central chandrashala opening. However,
the shape also recalls the double-dome silhouette of several Mughal tombs,
most famously of the Taj Mahal in Agra. Paired with the white coloration of
the building, this gesture to Islamicate architecture flanking the monumental

chandrashala allows the structure to speak both to local Delhi idioms and to the precolonial past. Yet the design does so in a subtle manner, allowing the trumpeting of the central Buddhist form to overwhelm initial considerations of the building, and thus dodging allegiance to any single religion.

The Vigyan Bhavan was built under the auspices of the Central Public Works Department with Ramprakash L. Gehlot as the primary architect (Lang, Desai, and Desai 1997, 206).[8] Like the Ashok Hotel, it was to receive a great deal of international attention as it served as the venue for various international conferences. Unlike the Ashok, however, with its elaborate façade, the Vigyan Bhavan impresses with its simplicity, anchoring its message in a wider field than in the red and white contrasting sandstone and in the architectural elements of Delhi's earlier rulers. Here we have a reference to a pan-Indian architecture rooted in forms associated most strongly with Buddhism. India had chosen as its national emblem the Ashokan imperial-and-Buddhist lion capital; similarly we have here a choice of Buddhist architectural iconography as an anchor for this international conference venue in the heart of New Delhi. The irony that at Ashoka's namesake hotel the architects turned to more recent architectural forms highlights the various levels at which the revivalism takes place.

Both of these buildings present a new iconography for postindependence architecture. While colonial architecture also referenced past Indian forms—for example, Bombay's Indo-Gothic Victoria Terminus (now Chhatrapati Shivaji Terminus, built 1878–88) or the imperial classicism of Lutyens and Baker in New Delhi—these two examples of revival architecture in New Delhi relate to the past through an iconic monumentality. In both the Ashok Hotel and the Vigyan Bhavan the structures use particular elements of Indian architecture as icons: the six-story iwan-jali-jarokha combination of the Ashok Hotel and the massive weight of the chandrashala at the Vigyan Bhavan. Rather than work these elements fully into the fabric of the structure, these mid-1950s buildings proclaim their heritage with iconic exclamation points (V. Prakash 1994, 226; see Venturi 1977). Analyzed this way, the buildings do not merely reference India's architectural past. Rather, the reference takes place at an additional level of remove, as the hotel and conference center rearticulate colonial appropriations of the past for a new, independent India. In doing so, they call into question the historically varied attempts to produce mixed British-Indian forms during the colonial era, instead downplaying the concept of amalgamation and

putting the iconic elements of architectural Indianness quite literally front and center. These structures relate to the past much like later 1980s Western postmodernist appropriations of the classical idiom do: by exploring the crucial markers of Indian imperial pasts in grand scale simultaneously to celebrate that heritage and to question its uses and reuses.[9]

POPULAR ICONS 1

For his sculptures from the 1970s, Raghav R. Kaneria (b. 1936) uses a much more intimate source and smaller scale, modifying the easily recognized iconography of village pathway icons.[10] The simple roadside shrines that he cites usually take the form of decorated stones and are worshipped as embodiments of local deities. Found both in villages and cities, these uncomplicated, brightly painted, eye-catching forms serve popular Hindu practice across India (Mookherjee 1987). Kaneria's works thereby transcend the boundary between high and popular art.

Often attached to a large tree or natural outcropping of rock and sometimes marking a crossing (or *tirtha*) over a river or road, these icons take the form of decorated stones, reused older murtis or relief sculptures from temple ruins, or sometimes the base of a large tree itself. Orange or saffron-colored paint marks the object as sacred, gold foil is sometimes used to cover rocks or even sculptures, and plastic, prefabricated eyes are glued to the surface, pointing to a crucial aspect of worship in the Hindu tradition: sight, seeing, or darshan. Usually these pathway icons relate to a larger pantheon, and if asked, locals will tell you they are a particular local emanation of Vishnu, Shiva, or the goddess (Mookerjee 1987).

Unlike the grand gestures of the buildings discussed in the previous section, these icons, nestled against a tree or along the roadside, draw one's attention more subtly. They transform a preexisting natural phenomenon and reveal its sacredness. They indicate the work and worship of a locality, showing passersby that the site is special to those who live near it. The versatility of the icons—rocks with paint, eyes, and foil adorning them—allows their use by a variety of worshippers; they simultaneously serve the needs of both the local population and of those passing through. Thus these icons are easily legible, but unlike the high-art references of the Buddhist chandrashala arch or the imperial jarokha

balcony, when artists look to this type of image, they cite everyday practices and objects of worship.

In his *Sculpture-I* (1975; plate 4) Kaneria uses broken materials such as a terracotta bowl and what seem like cast-off clay pieces to form his circular icon, wrapping portions of the broken clay in gold foil, placing two plastic eyes around a ridge to be understood as a nose, and situating the whole within a square wooden recessed box to be hung on the wall. The colors of Kaneria's work echo those of pathway icons; the earthen materials vie with the gold foil and the saffron-colored paint adorns the outermost terracotta piece. Natural wood protrudes from the face; knotted forms delineate a vertical mouth at the bottom and suggest either hair or a bunched headdress.

Where the Vigyan Bhavan's façade simplifies the chandrashala form—exaggerating it through bold, sweeping gesture—here Kaneria amplifies the details of roadside icons, placing foil, paint, eyes, terracotta, and wood on certain portions of the piece so that their operation on the surface is highlighted. For example, the foil, rather than coat the whole, covers the bottom third of the face, below the mouth, and around the back of the head form, suggesting a beard or a halo, respectively. Pathway icons do not normally incorporate this kind of design; usually the foil either marks particularly important sacred elements of the sculpture (a small piece on top of the stone or between the eyes) or covers the entire stone. In Kaneria's piece, in addition to representing a beard and a halo, the foil extends over the nose ridge out to the temples. It appears masklike, revealing the clay beneath and celebrating the contrast between the smooth, matte clay and the rough, shiny foil. The halo behind and the twisted wood constitute the piece's most complex textural elements, and they draw the focus away from the two eyes in the center—as if Kaneria were balancing the practice of darshan with that of teaching, as represented by the connection between the halo and Buddhist pedagogic traditions. Could the element on the top of the head make reference to a Buddhist *ushnisha*, ostensibly the expansion of the historical Buddha's head after he gained enlightenment?[11] One of the sculpture's most powerful elements is its malleability; the pathway icon's multivalence and openness translates to a modern appropriation of the icon, allowing it to reference a range of religious, cultural, and artistic frames.

Around the central face, a concave bowl of orange or saffron-painted terra cotta with rough—even broken—edges reminds the viewer of the material

underlying all of the gold foil and wood texture. That hemisphere, in turn, is set at the center of a deep, square shadow box made of wood and painted black inside. Compositionally, we have an iconic face set within a circle set within a square—a yantra, perhaps referring to the tantric visual culture so popular during the 1960s and 1970s. The work fits with characteristic elements of tantric art, from its vertical symmetry to the dark, central hole referencing the bindu. Indeed, the progression from wood to clay to gold to orange provides an outward movement from that dark space, recalling the centrifugal movement of energy from the bindu form.

The powerful geometric elements of the image are matched by the strange space in which the icon floats, as if it were unmoored from its "original" context, set here within a specimen box for viewing, and allowed to be gazed upon as a representative of Indian popular culture. Kaneria, who traveled around northern and western India with Jyoti Bhatt, photographing the visual culture of villages and rural areas (Bhatt 2002), here abstracts one element of that visual culture, translates it, and puts it on display in a museum. The piece is now in the collection of the National Gallery of Modern Art in New Delhi, a primary site for the construction of a national identity after independence (Guha-Thakurta 2004, 175–204). Kaneria's translation celebrates the formal simplicity of the roadside icon, highlighting the uncomplicated, organic, circular shapes and the media both of nature (wood, stone, clay) and of things manufactured (plastic eyes, gold foil paper). Kaneria brings together in his work materials appropriated from other contexts—whether a broken bowl, toy eyes, or knots of wood from a tree—and the sculpture shows us how this popular form utilizes the vocabulary of both modern and postmodern art: found objects, reused mundane materials, the abstraction of the human form, and the incorporation of the organic in medium and shape. Thus this icon sits at the intersection of the visual culture of popular Hinduism and the critical questioning of materiality found in the contemporary art world.

This syncretism also produces tension within the work. *Sculpture-I* presents us with a series of broken elements: a huge gash across the center of the face, a gaping hole in the piece, the organic mishmash of the mouth and head ornament, the uneven pieces of the "halo" and of the hemisphere in which the head sits—these disparate pieces suggest something amassed from things cast aside.

Reuse is common in popular pathway icons, and it is often found in earlier Indian art as well, particularly at moments of transition from one ruler to another. Rulers of the Delhi Sultanate in the twelfth century reused columns from earlier structures to construct their mosques—in part to facilitate swift construction and in part to claim legitimacy from past rulers (Meister 1971; Asher 1992, 3–5). British colonial architecture appropriated elements from various periods of Indian architecture, whether the *bangla* roof, the chhatri, the stupa-shaped dome, or the iwan arch. These borrowings did not constitute direct reuse, but, as in the cases of Albert Hall in Jaipur and the dome over the viceroy's palace in New Delhi, they do directly quote existing structures in form. These imperial citations and appropriations find an echo in Kaneria's citation of a particular popular pathway icon image and reveal a tension between the positive motivation behind the exploration of the village and the problematic line between exploration and exploitation. Like the imperial appropriations that came before, that of popular imagery is always a double-edged sword.

Yet Kaneria's appropriation is not that of a culturally or historically distant Other, but of a local and ubiquitous form that one sees on the roadside in the country as well as tucked in corners in urban areas. The sheer familiarity of the source material undercuts the feeling of exploitation. One can immediately understand the reference to pathway icons, and Kaneria's reworking of these familiar objects gestures simultaneously to village and imperial practices of reworking old material and to piecing together disparate elements into something whole.

At the same time, the very form of the sculpture questions that wholeness. Kaneria's broken pieces do not quite fit together: they reveal their gaps, and the textures are not actually meant to meld with one another. Instead, we have a disrupted whole, something fragmented. It refers to a popular icon but then disrupts that familiarity with, for example, the gash across the face and the oddly open and rough mouth. The smoothness of the saffron bowl around the face only underscores the dark holes within it. Rather than piece together a new, modern whole, Kaneria's work instead presents us with a fragmented iconic image.

This fragmentation is further highlighted by the piece's positionality as an object on display, an object that represents India to a wider audience of viewers.

Popular visual culture is of course often deployed as a marker for Indianness both in and outside the country. The compilation and distribution of images of India's various tribal and folk practices have their roots in the nineteenth-century colonial compendia of photographs and continue with the establishment in 1979 of the Crafts Museum in New Delhi—the latter an attempt to enter into this history of labeling and displaying without reproducing its damaging effects (see Jain 1989). Kaneria's sculpture enters into dialogue with these histories; it floats in its box, out of its context, mutely hanging with its mouth open, as if pinned there like a preserved beetle or butterfly specimen.

But rather than merely being a specimen of Indian culture, the sculpture also references specific religious modes of seeing and relating to objects. The icon, or the murti, serves as the locus of communication between the mundane world and the otherworldly, and through the eyes—through darshan—we can both see and be seen by the object. Here, that seeing is mediated by the awareness of an additional formal space of seeing—the museum—which removes this particular icon from the immediate location on the side of the road or at the neighborhood corner. By putting the icon on display in a shadow box, darshan is overlaid with a one-sided "looking-at" the object, just as these roadside icons, once put into compilations and presented in coffee-table books, become objects that represent India instead of sites that facilitate communication with the gods. Kaneria's piece articulates the difficult, indeed paradoxical, relation between the practicing artist and the space of the village almost thirty years after independence and twenty years after artists first looked in earnest to the village as a source for an Indian iconography. Playing with the problematics of both museum display and translation, Kaneria's icon *embodies* the paradox of India's modern. The sculpture deconstructs, as a mute witness, the folk-modern idiom. *Sculpture-I* offers up an objectified morsel of Indianness, though not of popular Indian culture. Instead, we as viewers are reminded of our own complicity in the construction of an India focused on objects like pathway icons neatly framed for us in books, photographs, and museums. We can therefore see, in this fragmented form in the shadow box, an approximation of what a postcolonial icon might be.

If Kaneria's sculpture works through a type of popular image to deploy its iconicity for a modern message, Bhupen Khakhar's painting takes a folk idiom and uses it to depict the folk of India. The people addressed in Khakhar's work, however, are not village inhabitants, but rather urban dwellers. Khakhar's paintings describe the intersection of the city worker—whether tea-shop denizen or watch repairman—and the white collar milieu with which he was familiar both as an artist and as an accountant (Kapur 1978a, 158). His works depict these individuals while borrowing compositionally from popular prints and employing a style that embraces both kitsch and pop.[12]

The Khakhar painting I focus on here, *Man with Bouquet of Plastic Flowers* (1976; plate 5), draws together many of the themes of this chapter in that it uses a central iconic figure and rearticulates an Indian artistic past and a Western visual tradition both modern and historical. The painting demonstrates the way in which icon can transform into allegory. This transformation is something each of the icons discussed in this chapter *might* accomplish, and it is a move that this painting about a personal moment in Khakhar's life makes successfully.

Like many of Khakhar's paintings, this work is often understood through the lens of the artist's personal experience. In this biographical vein the work honors Khakhar's close friend Shri Shankarbhai, who died the previous year. The work clearly pays tribute to someone now absent, with memories of that human presence poignantly aligned with images of empty tables and inanimate reminder. In this interpretation, the work takes part in Khakhar's struggle to articulate the depth of feelings for his departed friend, perhaps related to the early loss of his own father (Hyman 1998, 20). It is unclear whether Shankarbhai was more than a friend to Khakhar, who in the 1980s began to discuss his homosexuality more openly in both text and image. From that perspective one might understand the memorial celebration of Khakhar's friend as a thinly veiled tribute to his lover. Various personal elements coexist here, and the power of the painting, the choice of a large scale, and the use of the kind of iconic composition usually reserved for heroic or godly figures may stem from Khakhar's experience.

While this analysis is helpful and can be used as a starting point, the painting offers up further meanings beyond this biographical one, as it also speaks to the wider postcolonial condition. The work articulates the fragmentation of self, history, space, and reality that characterizes postcoloniality. These elements all depend on the iconicity of the image, around which a series of dualities pivot. Khakhar's work positions death against life, absence against presence, passivity against action, past against present, and representation against reality. Each of these smaller pairings contributes to the recognition of a fragmented, postcolonial world.

The figure after which the work is named—the *Man with Bouquet of Plastic Flowers*—centers the painting and serves as its principal icon. The man, slightly greater than life size, is shown from the hips up, facing the viewer. Unlike Khakhar's earlier works, which are small and intimate, this work is almost a meter and a half square, and the large scale constitutes a crucial element of its iconicity. On a foundation of deep, burnt red–orange paint, this primary figure faces us, staring impassively with arms crossed in front of him in a protective, closed gesture. The bouquet of the title tilts toward us in his left hand so that we can see its bright colors, broken only by its white wrapping. Rather than inviting us in, however, the movement of the flowers toward the picture plane operates much like the gaze of the central figure: to challenge us and keep us at a distance. All these elements reinforce the status of the central figure as icon. He is distanced from us by both the flowers and his gaze; viewers might connect with him, but they may not share his space. This relation echoes that of a worshipper and a deity in the Hindu practice of darshan.

Six smaller tableaux frame the central figure, three to each side, providing further support for his iconicity. These vignettes operate much as similar subsidiary images do in calendar prints, various mandala compositions, and narrative images: they remind us of particular moments or locales in the central figure's life, acting as triggers for an additional story. Such a composition has ancient roots in relief sculptures of the Buddha surrounded by scenes of his life, or in Hindu reliefs of Vishnu surrounded by his avatars. Likewise, the painting may draw on the widespread Christian iconography of Christ surrounded either by the twelve stations of the cross or by scenes from the New Testament. In twentieth-century India, similar compositions are used to depict historical and religious figures, including posters with the iconic photograph of Gandhi

walking toward Dandi on the Salt March, surrounded by depictions of him from various stages in his life. These images, sometimes called "uplift posters," were well-known to Khakhar, who collected calendar prints and other popular imagery (Hyman 1998, 49; see Pinney 2004). Elements of each of these iconographies contribute to this painting, and thus one can make out a wider iconographic program in Khakhar's icon, much as one might do with the cosmic map of the mandala.

Several immediate lines can be drawn across the image. First, the left-hand scenes all focus on small groups of people, three in the upper two scenes and an ambiguous absence of multiple figures (two teacups, one glass, one chair) in the bottom one. The right-hand scenes focus on one figure each: sitting on a swing, reclining in a chair, or resting within a painting on a sideboard. Connections operate horizontally across the canvas as well: the swinging figure with his knee raised echoes the central seated figure in the vignette opposite—both draw their respective knees to their chests. In addition to this echo of a posture, both vignettes represent activity: the group at top left is actively engaged in discussion and study, while the lone figure on the right is actively swinging. The pair in the central vignette on the left mirrors the gestures of the man reclining on the right. These paired vignettes both take place in a bedroom, and while the poses depicted appear restful, they suggest activities other than sleeping. Finally, the bottom left-right pair lacks a living figure, but the pair contains echoes of absent human presence. At left, the empty table tilts up so that we may see both the vacant chair and the dishes arrayed for more than one person. On the right, a sideboard contains objects, a painting of objects arranged on shelves, and a painting of a man emerging from a blue background. These right-left pairings provide several of the dualities within the work: group/individual, presence/absence, and active/passive.

The work employs space and color to reinforce the mapping of these dualities. For example, as often found in Rajasthani and Mughal painting, the floor of the swinging man's space also operates as the roof of the bedchamber below, implying that while we may be seeing two different times, the space is continuous. The sideboard and the table in the bottom vignettes are vastly out of proportion in comparison to the other four small scenes. The chair on the left blocks our path into the painting and, with the verticality of the sideboard in the right-hand corner, the two pieces of furniture operate like a mandala's cor-

ner guardian figures. Thus we cannot fully enter the scenes above or the space of the central figure. Our access remains limited to a visual connection, much as in darshan, which allows the devotee to relate to the deity, but only through vision. Here, we see the icon, but we cannot go further; the furniture blocks our way.

The iconographic composition of the painting links the emptiness of the two bottom tableaux with the emptiness of the top quarter of the painting, producing connections across the work that take place at the same time. The central figure shares his space with the townscape, and his desolate expression echoes the emptiness seen in the upper and lower registers of the painting. This area is "now." The four tableaux in the middle depict past stories and vignettes. Significantly, these four images begin at the same horizontal point as the central man's arms; the plastic bouquet marks the transition from protective furniture scenes to arm gestures of the present and memories of the past. Purposively, then, these four past scenes are arranged in relation to the upper torso (middle bedroom pair) and the head (upper active pair). The temporal duality of the present versus the past is thus linked with absence/presence, reinforced by the emptiness of the painting's top and bottom registers.

While these dualisms may well relate to Khakhar's experience, or even to similar experiences the viewer has had, the work also operates on a larger scale (somewhat literally, in terms of size), addressing in its array of imagery broader issues of loss, humanity, death, and even reality itself. Like Pyne's *Woman, the Serpent*, Khakhar's work engages with themes of death and loss by using a central human figure with a masklike, darkened face. The pendant elements in each work—the triptych in Pyne, the narrative scenes in Khakhar—contribute to the power of the central figure, both explaining its presence and complicating its meaning. In each work symbolic elements—fruit, serpent, flowers—connect the painting with larger narratives or customs. In Pyne's painting, these symbols anchor the work in both Christian and Vaishnavite contexts; in Khakhar's, they reference rituals surrounding death and loss stemming from a European tradition and worship rituals arising from popular Hinduism. Thus the work extends beyond the personal to the larger cultural, historical, and political context.

Having examined the program of the image and the dualities mapped onto the mandala/calendar print composition Khakhar employs, I turn now to parse

the central icon itself, as well as the bouquet of flowers that functions as the icon's attribute. The flowers are painted differently than the rest of the work, their integrity as blossoms broken and fragmented—a breaking up perhaps meant to depict the surrounding wrapper, but also possibly referring directly to cubist modes of representation that break apart objects and show them as fragments. This differentiation from the rest of the work points to its importance. Why fragmented cubism? Why, according to the title of the work, plastic flowers, and not fresh ones? These choices point to a concern with reality and representation. Khakhar's work manipulates not only space and time but also the question of whether these are painted figures or paintings of painted figures, as in the painted painting at the bottom right. The level of remove from reality in the painting on the sideboard echoes that of the plastic flowers. The flowers are also dissonant in the context of the mandala/calendar print composition. They reference European practices of mourning at gravesides, something not culturally universal and at a remove from the rituals surrounding death on the Indian subcontinent. That the flowers are plastic reinforces this remove from an imagined "authentic" Indianness: one feels an artificiality about the gesture of giving flowers. The fragmented binaries of the painting— past/present, active/passive, real/represented, living/dead, present/absent— come together as one in the flowers. They are neither living nor dead, not fully real, and they do not occupy the same representational space as the rest of the painting. They cite a ritual from a European tradition, but they are not wholly alien to a puja-centered Hindu context, in which offerings (puja) are brought to a deity in the form of flowers, garlands, coconuts, and the like. They transcend the dualities that the painting sets up elsewhere. Here, they mark the boundary between living and dead, present and past, East and West, guiding us toward a larger message about absence, loss, memory, and in the allegorical move I foreshadowed earlier, the position of postcolonial India.

Khakhar's painting allegorizes the position of postcolonial India by exploring the connection to the past through a loss of that same past. It also generates a productive vision of Indianness through its playful relationship to reality, whether with plastic flowers or with painted paintings. The barrenness of the image's present alludes to the mid-1970s context in which it was painted; the painting conveys not only Khakhar's personal loss but also the loss of innocence and civil rights in the aftermath of Nehru's death in 1964 and during the mid-

1970s Emergency.[13] If the Ashok Hotel and the Vigyan Bhavan used past architectural elements to produce a new, hopeful Indian architecture that reworked the past, Khakhar's painting draws together past compositional patterns with the contemporary to produce a large-scale comment on the disappointment and desolation of the mid-1970s in India. Both the buildings and this painting transmit their messages through symbols or convey them through objects that reference particular concepts. But once put together in Khakhar's work, the spatial and the temporal fabric of the composition produces a human allegory for the loss of 1950s optimism figured in the hopeful plastic flowers and the empty townscape, lacking its crucial humanizing element.

The icons discussed in this chapter each draw on India's past, and they each rearticulate that past for a postindependence India. Icons tend to concentrate meanings, carrying a weighty load as they straddle past and present visual cultures. Icons enable this bridging of time, as new meanings can be attributed to them without abandoning earlier ones—whether that involves making a Buddhist chandrashala arch massive or recreating a popular print in oil and on a human scale. Furthermore, icons are often seen as something particularly Indian, something ubiquitous in Indian culture that permeates each corner of the subcontinent. This equation of icon and India raises the specter of Hindutva,[14] or the equation of India with Hinduism with India. More broadly, and equally disturbing, it also boils India down into one essential component, a move that erases the complexities seen so clearly in the treatment of "icon" by the works in this chapter.

Thus the icon works in several ways: as a murti, symbolically serving as the focus of attention, sight, worship, and thought; as an esoteric concept, seen in both the work of Santosh and Pyne; as a referent, a metonym, standing in for something larger than itself, referencing both the past and various uses of the past; as a larger-than-life allegory; and finally as a device of translation and communication across the boundaries of folk and high art, the mundane and the unique, modern and Indian. The turn to the icon in postindependence art means more than a celebration of a form seen as essentially Indian. Iconicity allows India's visual culture to negotiate successfully a space within modernity.

NARRATIVE AND TIME

All that we have in India still lives—several centuries at the same time. The eternity of it all, that is what matters finally.—RAGHU RAI

⇶ THE PREVIOUS CHAPTER explored the icon; this chapter investigates perhaps the most iconic element of Indianness found in discussions of Indian art: narrativity. Tracing a line to depictions of the lives of the Buddha at sites such as Sanchi and Bharhut (both first century BCE), scholars and artists have seen the visual story, the telling of a tale through images, as one of India's distinctive traits (Dehejia 1998). But India is not alone in claiming narrativity as a core element of its culture. In the European context, Roland Barthes has made the case for narrative-as-universal: "Narrative is international, transhistorical, transcultural: it is simply there, like life itself" (Barthes [1966] 1977, 79). Thus India's claim on narrative as essential to the subcontinent—something drawing its visual culture together—participates in both a modernist universalizing of narrative, and, at the same time, a localization of narrative. Hence we see again the peculiar and profound paradox of an Indian modern, and we witness once more the negotiation of this paradox in the art of narrative and time.

Narrative comprises a wide range of possible subject matters, including the very practice of storytelling itself *as subject*. Thus works might engage with specific Indian narratives such as the great Indian epics (the *Mahabharata* and the *Ramayana*), stories of various goddesses, or, as we saw in the previous chapter,

accounts of the lives of saints like Chaitanya. Visual renderings of Christianity have formed part of the subcontinent's art since the religion's inception, and in Bengal, Jamini Roy of the preindependence generation rearticulated Christian stories in his work at the intersection of local folk idioms and grand narrative (Roy 1997; Guha-Thakurta 2005). Early in its development film also turned to religious stories with the genre known as the "mythological," which explored various gods and heroes of the subcontinent's religious traditions. The preindependence period saw a focus on narrative as a primary way to proclaim Indianness in the context of a rising nationalist movement.

In postindependence India this trend continues in that artists still use particular subjects to evoke India's current and past heritage. But narrative is more than just storytelling and more than just a choice of subject matter that plugs into particular versions of what India is about. In the face of Partition, which saw agitation for regional recognition in the form of political battles over language and the tension between establishing a secular democracy and asserting the Hindu aspects of Indian identity, telling stories became a political affair fraught with the weight of rising communalism. Part of what resulted from this tension was a turn toward investigating the history of India to explore how the Hindutva polemic of India-as-Hindu springs from a very particular manipulation of India's past, and to work to counter those constructions through visual culture.

One of the more important documents in the project of rethinking India's past is Jawaharlal Nehru's *The Discovery of India*, written while he was imprisoned by the British authorities prior to independence. The book takes as its foundation the idea that India's history grounds its independent identity (Nehru [1946] 1960). Nehru asserts that control over knowledge about India resides in knowing India's past, and in part his text attempts to overcome colonial knowledge production in favor of a new view of India's heritage and of its trajectory into the modern era. Nehru's text is imbued with the struggle to unify a diverse subcontinent, particularly in light of the rise of communal tensions (Prakash 1990, 389). His historical narrative thus highlights elements of history that brought the region together without relying on religion. The hoped-for end result was to bring India onto the international modern stage as a singular, if internally diverse, unit. Nehru's modern rewriting of history produces a double meaning for *discovery*, one critical of the notion of colonial discoveries and one highlighting the need for Indians themselves to rediscover their own country.[1]

In part, Nehru wrote against colonial efforts to "know" India, which sought to discover the subcontinent's past by depicting its monuments in painting, print, and photographs and by excavating its history through the Archaeological Survey of India. Imaging the past of India in ruins was matched by an effort to present the subcontinent as living among these ruins, stuck in the picturesque decay so valued by Western viewers (Rohatgi and Godrej 1995; Brown 1997). This deployment of the picturesque led to the justification of colonialism as ostensibly rehabilitating the once great culture. Furthermore, the picturesque gives the impression that India looks like this throughout: it suggests that India is an ancient land, and that the contemporary Indian lives with and in this ancientness. This image of temporal concurrence (however constructed and problematic) produces that same simultaneity found in Rai's quote. In collapsing the two ends of time together, picturesque images also erase the history in between, ahistoricising India. In addition to suggesting that India needs colonial rehabilitation, these images thus create an impression of India as "stuck in the past," the negative side of being ancient and modern simultaneously. India's ancientness represents one aspect of its essential identity, something valued by Western viewers such as Le Corbusier, who saw it as a continued element of the pure primitive in the present day (Prakash 2002, 94). If Le Corbusier was the quintessential modernist, or at least if we may use his example as such, we can see Rai's comment in the epigraph appears to valorize the former's interest in vernacular architecture for its essential qualities. India's essence, found in the authenticity of the contemporary villager, for Le Corbusier was both timeless and modern. In architecture he embraced the simplicity of the post-and-lintel forms he saw in the Punjabi countryside. In constructing his modernist buildings for the capitol complex at Chandigarh, Le Corbusier wished to relate to the villagers of the neighboring town, going so far as to demand that the view from the village to the new buildings not be interrupted (Prakash 2002, 85–87). Le Corbusier's approach to the Chandigarh capitol buildings demonstrates the intersection of authenticity, modernity, and the primitive in his work; it also articulates the connections between the modern and Rai's notion of India's temporality. In other words, if the modern seeks an essential core for humanity and finds it in a so-called primitive villager, then modern temporality involves a collapsing of the now into the ancient, paralleling the Orientalizing move of Rai's statement. The works discussed in this chapter examine engagements with

mythological pasts as well as with historical ones and consider the concept of time in order to deconstruct the inheritance of colonialism.

I begin to lay out this engagement with story, history, and time by looking at examples of narrative imagery by Krishen Khanna, an artist known for his imaging of historical and religious narratives. I then expand the categorization of narrative outward, moving from a strict definition of actual stories being told to a more conceptual understanding of narrative as having to do with a broader engagement with time. Narratives themselves are elements of Indian culture told and retold, and in the retelling they tap into a mythical ancient past seen as foundational to India's heritage. Thus the very ancientness of narrative is taken up as a subject matter by artists and architects such as Kovalezhi Cheerampathoor Sankaran (K. C. S.) Paniker and Satish Gujral, who deploy the concept of ancientness to mount a critique of India's relation to the past in its postcolonial condition. Particular moments in the past, and the way memory operates, also become centers for an elaboration of time. I view Yash Chopra's "multistarrer" Bollywood film *Waqt* (*Time*; 1965) as an exploration of the fraught relationship to Partition in postindependence India. I use the film's focus on time and fate as a way of accessing attitudes of nostalgia and disappointment in the modern context.[2] Each of these objects offers rich depths to plumb, as none of them engages with narrative, time, or history in a straightforward manner. I have chosen my examples because they provide a wide range of objects from which to think through the problems of temporality, history, and narrative within the paradox of the Indian/modern. These works demonstrate that time, narrative, and memory are tropes wider than mere storytelling, and they show that these interconnected themes shape the ways in which an Indian modern is articulated in the decades after independence. At its most powerful, the trope of time allows works to explore relations to the past, questioning the commonly held preconception that India is simultaneously ancient and modern and pointing the viewer toward the problems inherent in holding India up as a place of "all time." This move allows an acknowledgment of the *construction* both of India's past and of its present, producing a negotiation with what it means to be modern that relies on an understanding of the complex colonial, nationalist, and communal sources for India's historical knowledge. When dealing with particular religious stories or specific historical events, time operates to situate contemporary, tension-filled India against moments in its past, whether mythical

or historical, offering artists and viewers an opportunity to engage with those moments and to reconsider their role in shaping India's present. Time, then, and narrative more specifically, serves as a powerful pathway through which works of art, architecture, and film find a position within an Indian modern.

REINTERPRETING ANCIENT STORIES

In several works of the late 1970s Khanna looks to Christian narrative moments, revealing the ways in which these stories speak to a contemporary Indian context in much the same way that Caravaggio updated these stories for the seventeenth-century Italian viewer. Storytelling for Khanna is not merely a recapitulation of ancient tales. Nor is the retelling merely an updating of these stories for modern viewers. Rather, Khanna's works seize on those story elements that speak to the contemporary postcolonial condition, highlighting the struggles within the tales and drawing out their messages for the way they participate in constructing a modern India—both for art and for the broader national imagination.

Khanna's *The Last Supper* (1979; plate 6) springs from a narrative idiom developed by the artist over the previous decade and a half, during which his work explored various contemporary historical conflicts (such as the Bangladesh war of the early 1970s). *The Last Supper* is the first in a series of images that explores New Testament stories' creation of an atmosphere of love and interconnection among participants even as events conspire to tear them apart.[3] In taking on the subject of the Last Supper, Khanna's painting enters into dialogue with this long-standing iconography in both Europe and India. Christian iconography traveled with Christianity itself, and it came to the subcontinent soon after its birth in the Mediterranean (Pothan 1963; Woodcock 1967, 31–4). The interconnections between later Indian painting and northern European Christian imagery are well known, with the Mughal court in particular embracing elements of the prints brought over from Antwerp and elsewhere (Dalmia 2001, 205; Bailey 1998). Thus the choice of topic might be seen as an Indian one. Artists ranging from Kesu Das in the sixteenth-century Mughal court to Jamini Roy in early twentieth-century Bengal took on Christian subject matter. The purposive exploration of biblical stories in Khanna's oeuvre can also be understood in the context of a dichotomous Western/non-Western approach

to religious identity in India during the 1970s and 1980s. Rising communalism pushed Islam and Christianity out of the constructed religious identity of India-as-Hindu. In that context the Last Supper as subject matter thus figures as a broadly Western one.

Khanna has set this story in Delhi, specifically, he says, in Nizamuddin, the neighborhood centered on the shrine of the Sufi saint from which it takes its name (qtd. in Dalmia 2001, 210). However, we have no exterior or interior architectural elements to provide a clue to the setting, only the dress and personal appearance of the individuals around the table. Caravaggio used contemporary Italian dress in his biblical works. Similarly, Khanna includes a man in a sleeveless undershirt, and a figure wearing an Indo-Islamic cap to indicate a location in India. Beyond that, the garments remain nondescript, though they include shawls and other types of clothing often seen on the streets of Delhi. Khanna has given us a range of figures, each one distinct without being an actual portrait of a particular individual. In the front right corner we see a bald, overweight man in what looks like a business jacket—perhaps a relatively wealthy businessman, and a reference to Saint Matthew, the former tax collector. We see a figure bowing toward Jesus wearing a white undershirt, indicating an economic status much lower than that of the businessman across the table from him. The figures interact dynamically through gesture and pose, much as they do in Leonardo da Vinci's famous mural painting of 1498. Indeed, certain gestures, such as Saint Thomas's upward-pointing hand, are directly quoted here in the centrally placed foreground figure. Khanna has chosen the same moment as Leonardo, but he gives us a different composition. Jesus remains in the center, here figured in white with hands open to the group and glowing. But the open, stable triangular form of Leonardo's Jesus is here replaced by a figure with arms bent at the elbow, creating a diamond shape that is partially open, partially closed, and more dynamic than stable. The square composition of the table (unlike Leonardo's long, narrow one) pushes the figures to the outside, emphasizing the enclosed, somewhat cramped quality of the space—inward looking and all-embracing in its warm colors and earth tones. The dynamism of Jesus's gesture is echoed by the dramatic tilt of the table, both up toward the viewer but also at a slight diagonal so that the viewer is not symmetrically aligned with the image.

The apostles' gestures—from hands covering a face to a body bent low in respect—reflect the drama of the moment. The Saint Thomas gesture guides the eye toward Jesus and reinforces the inward focus of the composition toward the center and Jesus's diamond-shaped arms. The diversity of poses, dress, and types of figures not only echoes Leonardo's image of dramatic human interaction but also gives us a sense of Khanna's understanding of the Sufi-founded Nizamuddin area. Sufism has long been a space of syncretism, bringing together the diverse religions of the subcontinent. Various orders have bridged the gap between a congregational religion of the book and the rituals of Hinduism by establishing saints' shrines at which worship practices such as circumambulation and individual propitiation echo similar Hindu rituals (see Eaton 1993, 71–94). Choosing a Sufi-centered area of Delhi for the setting of this Christian narrative about love and forgiveness in the face of betrayal allows Khanna to transfer the resolution of the narrative to more local concerns. Specifically, tensions among Hindu and Muslim groups were on the rise in the late 1970s, and a Sikh separatist movement was growing in the Punjab. In the face of these communal tensions, Khanna's siting of a moment of Christian tension and resolution in Nizamuddin suggests hope for the resolution of the contemporaneous political situation.

Earlier images of Christian subjects in India had also tried to bridge existing tension among various groups. In the 1930s and 1940s, Roy's depictions of mother and child resonated with iconography familiar to colonial British viewers, while the style and content echoed the popular Kalighat paintings of Calcutta. Supporting nationalist arguments that claimed an equal value for Indian and Western imagery, this merging of the two iconographies took the nationalist contention a step further. Roy's work valorized the folk idiom of Kalighat, holding it up as more authentic than the degraded contemporary Christianity found in the industrial West.

Khanna's turn to the Christian here operates differently than Roy's, for the style does not plug into a local vocabulary. Rather, he deploys an international gestural tradition in oil, an approach already widely used by painters on the subcontinent. Khanna developed his own style within this idiom, and this painting recalls some of his earlier works including other compositions around a table such as *The Game* series of the early 1970s. The earthy colors, haunting light,

and watery paint had become, by 1979, Khanna's signature style. Thus, rather than looking to folk art, Khanna's *The Last Supper* rests firmly in the modern idiom.

Khanna uses that idiom to explore the energy and tension of this moment in the Last Supper, producing figures in related swaths of color to join them together. Through his use of light, this choice lends the composition an ethereal glow. The figures recall particular types from the streets of Delhi. We are faced with a Last Supper that reminds us of the Asian roots of Christianity and recalls the diversity of religion and background among the apostles themselves. In style it also emulates Caravaggio's move to relate the ancient stories to a contemporary time and place, bringing the narrative into the realm of viewers' everyday lives. A Last Supper in Nizamuddin with a Muslim, a poor man, and a businessman at the table suggests that the love and forgiveness represented by the leader of the apostles (along with their fears and doubts, seen in the prominence of the "doubting Thomas" figure front and center) truly speaks to the current situation of communal and regional tension in India as Hindus, Muslims, Sikhs, and Christians struggle to maintain a secular state.

The drama of the scene in *The Last Supper* is echoed in the general instability of the late 1970s, when Indira Gandhi's declaration of the Emergency (1975–77) shook the foundations of the nascent democracy. Spurred by a high court ruling that Gandhi's 1971 election was invalid, the Emergency included extreme anti-poverty measures such as slum clearance and forced sterilization programs, as well as a wide suspension of civil liberties. In the aftermath of the Emergency, Khanna's *The Last Supper* implies that some healing might be necessary in the face of a nervous population and worried apostles. Turning to the Last Supper and other New Testament narratives allows the painting to interpret the contemporary historical and political moment from within stories seemingly distant from these contemporary tensions. In this manner, *The Last Supper* signals the beginning of the end of a time of trial, but also the necessity for healing and restoration. In rough parallel with Jesus's age at his death—thirty-two years after the birth of the nation—Khanna's work suggests that India is coming to a crucial impasse, confronting the testing of its democracy and its ability to keep its myriad populations together on a unified path. The last days of Jesus serve as an appropriate narrative through which to tell the story of the continuing negotiation about India's potential modern form.

The biblical context of Khanna's painting quotes a particular, distant era and brings its relevance to bear on the contemporary moment. This quality of the old, the decayed, the ancient, and the antique is explored more directly and profoundly in other works of this period. K. C. S. Paniker's *Words and Symbols* series (1964–72; plate 7) presents a particularly aged image to the viewer, one that engages with and challenges Rai's quote above about the simultaneity of the contemporary and the ancient in modern India.

In chapter 4, I discuss Paniker's *Words and Symbols* to explore how it differs from Le Corbusier's articulation of the primitive (and its relation to the modern) and thus to demonstrate how it presents a more nuanced image of the role of the esoteric and of knowledge making in the construction of post-independence India. I foreshadow that discussion here by exploring the ways in which Paniker's canvas presents time and, to a lesser extent, narrative. At first glance, Paniker's painting seems to support Rai's statement. Recalling the visual playfulness of Paul Klee's canvases, the symbols of *Words and Symbols* dance across the surface of the painting, presenting astrological diagrams, scientific tables, and naive figural forms to the viewer. The illegible script acts as yet another symbolic element, giving us an additional layer of inscrutability. This unintelligibility points to an articulation of the modern that echoes that of late nineteenth-century European symbolists, while it simultaneously looks to South Asian visual culture by referencing the symbolic imagery often grouped under the rubric of tantra (Tonelli 1985).

In the late 1960s and early 1970s, two major exhibitions brought together a group of objects representing, and in effect producing, a category known as the art of tantra, itself an element of Hinduism and Buddhism dating to the sixth century CE (Mookerjee 1967; Rawson 1971; White 2000; see also chap. 2 of the present volume). The new popularity of tantric art led many artists to experiment with the symbols found in these exhibitions—whether cosmic maps or mandalas, intertwined snakes or human bodies in various sexual positions—all representing the union of the macrocosm and the microcosm (Brown 2005). During these decades Paniker participated in this engagement with tantric art loosely called neotantrism. Thus *Words and Symbols* appears ostensibly modern in its use of symbols and through its move toward abstractions, but it simulta-

neously seeks out those symbols in ancient elements of Indian culture. It serves as a visual correlate to Rai's statement: simultaneously ancient and modern.

A second look, however, reveals a more critical assessment of that simple assumption of temporal coexistence. Paniker takes advantage of the medium of oil in its ability to provide both translucent layers and a quality of stain. The painting begins its layering with ochre, brown, and golden oval stains at the base, followed by scribbles, and topped, in certain areas, with a milky, slightly obscuring haze. Each layer is flat, suggesting a series of overlapping transparencies rather than recessional space. Yet the layering remains inconsistent, which produces some uncertainty about how to understand the timing of each layer. As if examining an ancient wall painting, the viewer struggles to identify which element came first, which generation might have added each animal form or astrological symbol, which of the stains is purposive, and which markings merely show natural seepage through the cave wall. The layering thus helps to evoke an extremely ancient visual form, a temporality underscored by both the coloration (brown, ochre) and the quality of the gestures—from seeping stains to naive stick-figure scribbles. These ancient qualities come together to suggest that the painting might have been recently dug up or cut from a larger wall surface to then be presented to us for decipherment.

Indeed, the edges of the painting underscore this sense of excerpting from a larger whole. Figures extend beyond the border of the work: both the floating torsos of the bottom right and the bird form at the top of the canvas extend beyond the frame. The cropping of figures suggests that this canvas is only a fragment of something larger. The edges, too, break down, at times revealing whiteness underneath the brown base and presenting the canvas as something broken or torn. Paniker's work thus gestures toward the practice of hacking out sections of wall from ancient sites (e.g., Dunhuang in western China) and hanging them in museums across the world, separate from their initial physical, historical, and national contexts. Like plaster murals cut from walls that reveal their materiality in the rough edges of their physical form, Paniker's paintings present the viewer with rough, white edges that give them the quality of three-dimensional objects. These objects then serve as windows into the culture they represent, something Paniker's painting offers us for India as well.

But what kind of window do we get here? This reference to the museum-ing of India, putting its heritage into an architectural box for visitors to absorb, sug-

gests simultaneously that this window allows us to look into the larger whole and that it is merely a small, decontextualized part of that whole. In its excerpted form, the work presents a quality of incompletion; it appears to be a painting in progress. Furthermore, with the multiplicity of inconsistent layers causing us to wonder when each layer was added to its surface, we also find that the excerpted quality of the image puts us in medias res, asking what came before and what came after on the wall from which this image was taken. To put it another way, as in the cartoon panel paintings of Roy Lichtenstein, we are urged in Paniker's work to wonder what lies outside this painting as it provokes assumptions about a larger context. It exists mid-narrative.

Further underscoring connections to stories outside the image are the references to Warli painting, that is, folk imagery often used to tell a story or narrate a passage in life, whether a wedding or a yearly festival (Dalmia 1988; Martin 1989). Painted on the walls of homes in village settings, these stick-figure images not only themselves excerpt from larger stories but they also often serve as sites for retellings. They interlock the visual with the oral and the performative. Paniker's painting thus not only references ancientness and the museumization of India's past but also suggests a narrative in progress, something very partial but nonetheless developing before our eyes. This sense of development and of viewers entering midstream becomes even more poignant when one realizes that this work forms part of a series—or perhaps more appropriately, a thematic grouping—that Paniker explored for almost a decade. Thus, in terms of Paniker's oeuvre, the painting represents one small part of a larger whole.

But this is not metonymy, for again and again Paniker reiterates the painting's partial nature. Rather than standing in for the whole, the work demonstrates the fundamental impossibility of summing up "India" and instead focuses on the fragmented nature of the country's postcolonial condition. Paniker's painting does not tell or even reference a story as do pieces by Husain or Khanna discussed earlier; instead it uses the idea of narrativity, of a story to be told, to present the viewer with a sense of the slippery quality of postcolonial India. Rather than embodying the simultaneity of the two solid poles of ancient and modern, as Rai's quote might have it, Paniker's work presents a work in progress, one struggling with the ancient but separated from its original context. *Words and Symbols* does not tell a story so much as present the quality of narrativity

found in oral retellings, in which each story connects with the previous telling, extending and reshaping it without losing the connection to the past. One has always heard the story before and enters it midstream, slipping in and out of the tale as the storyteller weaves the narrative depending on both the audience's interest and the concerns of the teller (Lyotard [1979] 1984). Paniker's painting powerfully captures that narrative temporality.

If narrative is seen as a core element of Indian culture—and thus one way of tapping into Indianness while working through a modern stylistic idiom—Paniker has taken this idea to the next level. Rather than *use* particular narratives to reference India, he has made his work a study in how ancientness and storytelling operate to articulate what it means to exist within the postcolonial condition. One can tell stories of India's history and of its ancient past, but this storytelling must always negotiate the colonial construction of that history and the museumization of India as an ancient culture. Paniker's work makes obvious the problems with excerpting one moment of India's past to stand in for Indianness as a whole. It argues, I believe, that we should reconceive our relation to the past through the metaphor of storytelling: by repetition, retelling, updating, reacting to the audience, and making the old relevant to the new. This relation figured in narrativity resists the temptation to make any one piece of a story stand for the whole; as an approach to time, Paniker's work embraces the fragmentation of Indianness in the postindependence context. In presenting us with a modern easel oil painting and injecting it with ancientness, folk imagery, and the pregnant possibility of a continuation outside of its edges, Paniker's work represents India's modern as a space of negotiation and renegotiation with the colonial as well as the ancient past, not merely as a space of simultaneity with it.

DECONSTRUCTING THE PICTURESQUE

Paniker's use of the ancient and of narrative time attempts to negotiate a colonial vision of India's past to present a postindependence Indian modern. Satish Gujral's Belgian embassy complex (1980–83; figs. 5 and 6) also engages the colonial past, but rather than exploring the way colonialism museumized India's ancient cultures, it instead examines the Orientalizing production of a picturesque India. The embassy also has an unfinished quality to it, echoing

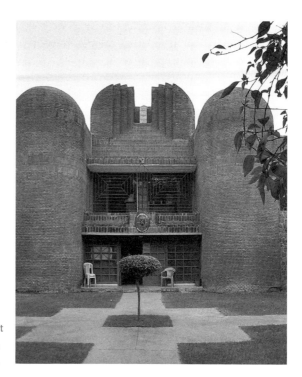

5 Satish Gujral, Belgian embassy, front façade of main building, New Delhi, 1980–83. Photograph by the author.

Paniker's sense of interruption, but rather than have that interruption occur in the present, the building suggests that its development was arrested centuries ago. Gujral's structure also reveals a gesture to ancientness and narrativity, but it focuses on a particular colonial vision of India-as-ruin and rearticulates that image for a postindependent modern.

The embassy is located in the diplomatic district, a short walk from the much earlier Ashok Hotel (1955; figure 3), on a sweeping corner set back from the large divided avenue. The façade can be seen from the road and invites visitors to pass between two large brick towers, funneling their eyes and bodies through a central fold in the architecture (figure 5). The front courtyard provides an initial separation from the traffic outside, enveloping the visitor in controlled greenery, some stone masonry, and, most ubiquitously, red brick. The silhouette of the structure takes advantage of the brick medium, allowing the texture of the repeated blocks to warm the shape of the cylindrical towers

while producing a stepped articulation in the central cleft of the façade. The entire effect references built forms in a variety of settings, sometimes evoking ancient Egyptian monumental columns and gateways, at other times suggesting Frank Lloyd Wright's vaginal entryways that move the visitor from light to dark through a narrow passageway. The additive and repetitive quality of brick recalls early architectural forms on the subcontinent as well, whether that of the most ancient, brick-based culture of Mohenjo-daro or the mound and stepped structures of stupa forms from Sanchi to Nalanda. Brick also has modernist associations—and ones very particular to India, as Louis Kahn's structures in Ahmedabad employ intricate brickwork to achieve both texture and various arcuated forms. The Belgian embassy incorporates both elements in its structure, gesturing both to Kahn and to his followers such as B. V. Doshi (see Doshi 1993). Thus the brick medium and the curved forms of the embassy evoke a variety of modern and ancient references, both in and outside of the subcontinent.

Toward the back of the complex one finds multiple, echoed arches in brick (figure 6). These forms look to Kahn, but they lack the controlled geometry of many of his buildings. Instead, an organic quality permeates these areas, resembling plant cells multiplying in clusters rather than strict geometric patterns. The natural, generative elements of the architecture are matched by the placement of plant life around the complex. The building's surface design includes a combination of stone facing toward the bottom of the structure's outer walls with exposed brick above. The stone wraps around the surface of the brick as if it once covered the entire surface and only now has been peeled away to reveal the underlying built form. Where the stone ends, a small horizontal space enables plants to grow in the transition between stone and brick. The combination of the evocation of a formerly stone-clad building now partially decayed with the plant life taking advantage of that constructed decay makes the entire complex seem like a ruin rising out of an ancient platform.

Circumambulating the complex, visitors get an excellent sense of both the iconography of the ruin—even in its constructed, neatly planned context—and the way in which the building is set apart from its surroundings, just as an ancient sacred space might be. The building, which from the front entrance looks to be at the level of the surrounding landscape, is actually built on a hill, with retaining walls marking the distinction between the mundane space outside

6 Satish Gujral, Belgian embassy, detail of
 rear of complex, New Delhi, 1980–83.
 Photograph by the author.

the embassy and the private, almost sacred space inside. Stone walls, echoing the texture of the base of the building itself, provide further reinforcement of this spatial separation. As an embassy, of course, the complex requires this separation from the surrounding space, both for protection and to proclaim its symbolic sovereignty within the bounds of India and New Delhi. Gujral's building achieves this separation by gesturing to monumental religious spaces on the subcontinent. The Dhamekh stupa at Sarnath comes to mind, for example, with its decaying brick cylinder form covered in stone relief carvings at the base.

The gesture, moreover, is not merely one to religious space. The reference to ruins at sites like Sarnath, Sanchi, or Nalanda separates Gujral's Belgian embassy from the surroundings through time as well. As a newly built ruin, the building participates in the ancientness of India's heritage while also separating itself from the surrounding region through height, walls, and references to

sacred space. Moving through the gate, visitors immediately find themselves in a quiet, vegetation-filled, monumental (and therefore important) ruin, now used as the headquarters of a foreign government on Indian soil.

Much like postmodern architecture of the 1980s in Europe and the United States, Gujral's structures look to the past. Rather than an ancient Mediterranean past, however, here we find an ancient Indian one. In its reworking of many different historical referents, the Belgian embassy participates in a post-independence construction of India's history, one that pulls these disparate temporalities together—including Harappan culture, the Mauryan empire, the Gupta era and its aftermath, and modernist Kahn-influenced brick architecture. This synthesis produces an image of contemporary Indian architecture with a temporality as fragmented as that found in Paniker's painting discussed above. The Belgian embassy brings together India's pasts to anchor the building in the subcontinent's own heritage.

That heritage, however, is extremely specific. Rather than choosing either obviously Hindu elements or ones reminiscent of Sultanate and Mughal monuments, Gujral's embassy turns instead to a more remote past. Like Edwin Lutyens's Viceroy's House (1931), which draws on the Sanchi stupa in its domical profile and echoes the stupa railing in the drum of the dome, as well as in the walls around the compound, Gujral's complex turns to Buddhist referents. Thus unlike Herbert Baker's New Delhi Secretariat buildings (1929–30), which amalgamate Italianate Renaissance architecture with Sultanate and Mughal elements from the Delhi region, and unlike post-1947 Delhi structures such as the Ashok Hotel (Evenson 1989, 225–30; Lang, Desai, and Desai, 1997, 185), which turn to Mughal decorative elements, both the Belgian embassy and the Viceroy's House draw on earlier, ancient Indian historical referents. In the context of the late 1970s and early 1980s, as communal tensions simmered, one can understand the gesture toward Buddhism rather than toward Hinduism or Islam.

Despite these many gestures to India's architectural past, the Belgian embassy does not merely present an amalgam of various historical elements. Gujral's building must be distinguished from the citationality of Sir Samuel Swinton Jacob's Albert Hall in Jaipur (1881–86; Sachdev and Tillotson 2002, 103–106). The latter structure directly quotes elements from other Indian buildings, from elaborately decorated, bangla-roofed chhatris to overhanging

eaves supported by multilevel bracketing. In the Belgian embassy one finds gestures to the media and the form of brick- and stone-based archaeological sites without direct quotations of any one element. Thus we see not citationality in the embassy, but rather a gesture toward an aesthetics of the past.

The setting is crucial here, as the embassy's power to recall archaeological pasts relies on the artificial grooming of Archaeological Survey of India (ASI) sites throughout the subcontinent. Walking into the embassy parallels walking up to and past the ticket booth at Humayun's tomb, the monastery at Nalanda, or the remains of the deer park at Sarnath. One enters a mowed, grassy space with architectural elements rising up through that manicured lawn with its ashok trees and other felicitous plantings. When coming out behind the embassy building and looking over to the ambassador's residence, one seems to stand atop one structure to look at the next. Traversing the distance between them involves walking over mounded grassy knolls (clearly artificially created), and then down into a hollow from which one sees the rear both of the embassy and of the residence. The knolls suggest ruins yet to be excavated, and the depression between the buildings heightens this sense of excavation, of archaeologists finding multiple levels of history here at the site. Throughout the tour of the grounds, however, the structure does not present a ruined aesthetic so much as an archaeological one. It may be a ruin, but it is preserved and maintained for the visitor's benefit. The archaeological past the building gestures to is not, therefore, Mohenjo-daro or Nalanda; it is filtered through two intermediate historical moments: the colonial and the modern.

The construction of a canon of important archaeological sites begins with the picturesque paintings of the eighteenth and nineteenth centuries in India and continues through the work of the ASI (founded in 1861) and of contemporary tourism heritage campaigns. Both colonial and national discursive strategies produced a group of Indian monuments and articulated the way in which these monuments should be presented to the public as representatives of India's heritage and culture. Gujral's embassy works through both of these intermediate moments, and in doing so, the building articulates both colonial (picturesque) and modernist (heritage-site) knowledge production about the subcontinent. Rather than recapitulating a Buddhist or ancient past for the viewer, the Belgian embassy instead acknowledges the ways in which this past has been reconstructed to serve both colonial and modern aims. The embassy

complex, in its engagement with the construction of India's history, challenges the assumptions of both colonial and modern epistemes.[4]

The Belgian embassy tackles the question of the colonial head-on in its form, presenting us with a three-dimensional image of picturesque India. In the late eighteenth century and in the nineteenth, paintings, lithographs, and etchings of India circulated to feed a curiosity about the East India Company's and later the British crown's possessions. Artists such as Thomas and William Daniell, Sir Charles D'Oyly, George Chinnery, and William Hodges produced images of India focused largely on ancient monuments, ruins, and cities (Pal and Dehejia 1986; Rohatgi and Godrej 1995; Brown 1997; Tillotson 2000). These images contributed to a larger valorization of the picturesque, an aesthetic category celebrating the rough edges of overgrown ruins, used in imagery of ancient Rome and constructed on the grounds of large English estates in the form of false Greek temples covered in vegetation. This fashion for the ruin is seen in the imaging of cities such as Dhaka and Calcutta (Ahmed 1986; Losty 1990; Brown 1997). In addition to overgrown ruins, these landscapes were dotted with "colorful natives" usually leaning against the structures, lazing about, or occasionally (in the case of women) carrying cloth or water jugs on their heads (Pal and Dehejia 1986; Rohatgi and Godrej 1995). The translation of the picturesque to India produced an image of a once-great subcontinent now fallen, leaving its monuments to be taken over by the jungle, a visual rhetoric employed in many colonial contexts (see Nochlin 1983). The colonial construction of India, while by no means uniform across the eighteenth and nineteenth centuries, celebrated the ruined landscape such that this became a trope in the imaging of India, presenting the subcontinent as one large overgrown ruin.

The Belgian embassy complex presents us not with a picturesque image but rather with a fully formed and truly *constructed* vision of picturesque India. The brick with its partial stone facing, the vegetation growing out of the tops of partial walls, the mysterious hillocks on the grounds: at the Belgian embassy one encounters many of the touchstones of the picturesque. Gujral's sketches for the design incorporate both vegetation and animal life; the stairs cascade down the buildings, and the lines of the sketches indicate the multifarious textures found in picturesque landscapes and at sites of ruin (see Falisse 2005). In addition, the building aligns compositionally with traditional picturesque imagery, never providing a full-fronted façade, but instead continually offering a three-

quarter, isometric view. The alignment of the buildings and the grounds with the surrounding roads means that one is always approaching the structures from the oblique, much as picturesque imagery always provides us with a view from the diagonal.

By encompassing this picturesque aesthetic, the building filters its antiquity through the colonial episteme of India-as-ruin, an episteme employed to justify the intervention of a colonial power in order to rehabilitate both the building and the culture overall. But Gujral's building cannot so easily assume a nineteenth-century posture. The Belgian embassy's own political and historical context interrupts this colonially-inspired Orientalizing and allows for a critical understanding of the deployment of the picturesque. Although it was a colonizing power, Belgium never colonized India, and this lack of direct colonial connection makes the building possible; a British embassy could never inhabit such a newly-built, picturesque structure. The Belgian embassy actually emerges as differing from the picturesque in several key compositional elements.

First, the inhabitants of this ruin are not the "colorful natives" one might find in the foreground of a painting by the Daniells or a print by Hodges. Instead, we have Belgians inhabiting the structure, undermining the neat exclusions of nineteenth-century picturesque and Orientalist landscapes, in which the burgeoning European presence is markedly absent (Nochlin 1983). Second, this is *not*, in point of fact, an ancient monument. Instead, we have here, quite literally, a *construction* of ancientness—not a reflection of any particular ancient period, but rather a rearticulation of colonial understandings of India's cultural history. Buddhism was seen by nineteenth-century Orientalists as a valid subject of study, a religion akin to Christianity in having a figurehead of sorts, with an artistic heritage in the northwestern subcontinent related to classical Mediterranean sculpture (Almond 1988; Mitter 1994; King 1999, 143–60). Gujral's structure asserts the importance of Buddhist antiquity for the nineteenth century by employing that era's picturesque imaging of India's monuments.

The layering of historical moments (ancient, colonial) occurs because the structure is not in fully ruinous condition. That is, rather than seeing a complete picturesque scene, with scattered remnants of the building in the foreground and moss and mold growing over the stones surrounding the structure, we see instead a rehabilitated ruin. That is, we see an ASI site. At first we observe in the Belgian embassy certain elements of the picturesque. But then, the tidy

landscaping, the tight, reconstructed brickwork, and the noncolonial European presence emerge in such a way as to undermine any claim to an uncritical picturesque. One sees the Buddhist gestures, the vegetation growing on the building, the isometric views, but the edifice fails to fall fully into the trap of the picturesque as the reverie is interrupted by the building's status as an embassy, its population of Europeans, and its tidy heritage-site aesthetic.

The building therefore unmasks the picturesque's status *as* production. Any gestures to the past can thus not be taken as a simple reuse of the ancient. They instead operate more broadly as a critique of the way in which that ancientness functioned in producing an image of India. In other words, the Belgian embassy complex, in its rehabilitation as a heritage monument (itself recapitulating an image of picturesque India) uncovers for the visitor the role of history in India's colonial and postindependence periods. Because it does not directly cite ancient forms, the complex suggests a means of negotiating the colonial past by facing it head-on rather than attempting to return to a precolonial time. Indeed, the building's references to the ancient Indian past—filtered through the lenses of both the colonial picturesque and the modern heritage—demonstrate the impossibility of reclaiming or even locating a pure space before the colonial. Independent India's multilayered, even fragmentary, relationship to its precolonial past thus serves as the subject matter of the building, so that at the moment at which visitors recognize the modernity of the structure, they also see the problematic colonial heritage so central to the negotiations of postcolonial Indianness.

Because Gujral's structure takes on the picturesque through the use of what one might call an ASI aesthetic, the embassy also grasps India's history through the lens of the contemporary heritage industry in India. By weaving together a critique of the colonial approach to the past with an iconography of contemporary heritage sites, Gujral's complex opens up the question of the construction of India's past not only during the colonial era but even as that era has been inherited by contemporary bureaucracies in postindependence India. We witness a layering of histories in the Belgian embassy: from the Buddhist monuments it calls to mind, through the colonial construction of India's ancient past that it evokes, to the contemporary claiming of that same past in a nation-building narrative. These layers of different times and different epistemes reveal themselves to be of a piece; together they constitute the fragmented stratification

present in Paniker's painting—a fragmentation central to postcoloniality. That this building is the Belgian embassy, operating as a link between the states of India and Belgium, underscores its fragmented and liminal position, thus making the critique possible.

If Gujral's building works through the colonial construction of India's past by producing a critique of India as picturesque, the film *Waqt* looks to a very specific moment in India's history and probes it for the production of a modern, postindependence India. *Waqt* has been held up as one of the first multistarrers in Bollywood, with a cast including many of the top names of the day from both the younger and the older generations. In addition, it transmitted to the wider public certain fashions of modern interior design taken directly from the pages of publications such as the *Illustrated Weekly of India* (figure 7). Yash Chopra, the director of the film, looked to interior design magazines for the set design and later saw it emulated by his relatives in their own homes (Dwyer 2002, 39). *Waqt*'s popularity started fashion trends as well, most prominently the turn to *churidar kurta* in women's fashion, a tighter, gathered trouser topped by a close-fitting, usually sleeveless tunic.

Waqt was also one of the first so-called lost-and-found Bollywood films, in which a family is separated toward the beginning of the narrative and the story then follows them as they live their lives, experience near reunions, and finally meet again in the happy conclusion (Dwyer 2002, 42). The name of the film indicates its overarching theme: Time can bring prosperity or drought, and one should not assume it will always be the former. Hubris in the face of time will lead to one's downfall. This lesson is learned the hard way by Lala Kedarnath (Balraj Sahni), whose celebration of his newly expanded storefront turns into disaster when an earthquake destroys the town that same night, separating him from his wife and three sons. The film sets up a stark contrast between the before and after settings of the family, and in the distinction provides a clear temporal shift between a pre- and postindependence time and location. Thus the moment of the earthquake serves as the major break, standing as a metaphor for Indian independence and the destruction wrought on families and property by Partition.[5]

7 Interior of Meena's house.
Still from *Waqt*, dir. Yash
Chopra, 1965.

Because of the sensitivity of the topic, the film does not directly portray
Partition; its treatment, even metaphorically, of this moment in India's his-
tory is therefore striking. Why attempt to represent Partition in the mid-1960s?
Nehru served as prime minister of the new Indian nation from independence
until his death in 1964. The Nehruvian era, as it is often called, is marked by
a push toward the modernization of industry and an optimism about India's
future. *Waqt* was released a year after Nehru's death, immediately after the
India-Pakistan war of 1965, and therefore at a transitional period for the na-
tion—and, by extension, for Hindi cinema (Chakravarty 1993, 204). The film
shows us a moment in India's formation of a national identity fraught with
regret, nostalgia, and the memory of past hubris during the pre-1947 drive for
nationhood. The mid-1960s were a period of nostalgia for the notion of a free
India as envisioned prior to independence. Yet despite Nehru's modernization
schemes, the ideal was not realized in the lives of most Indians (Chatterjee 1998,
5–17). The Partition metaphor allows *Waqt* to perform several tasks. First, the
film participates in a certain nostalgic melancholy for pre-Partition India, a
longing for a simpler time prior to the devastation of the earthquake/Partition.
At the same time, *Waqt* shores up an ebbing hope in the new, modern inde-
pendent India, particularly important in the face of continued tension between
India and Pakistan and the recent death of Nehru, himself a central symbol of

national unity and modernization. Finally, *Waqt* provides its viewers with a vision of what a modern India might look like, showing us spaces, fashions, and relationships that offer models of how to live as Indian and modern.[6]

This last element can be clearly seen in the film's architecture and interior design. The viewer can easily distinguish between the two periods and, more importantly, see how modern India looks in contrast to the subcontinent before independence. The opening shot of the film sets up the location as we watch a horse-drawn cart come toward us through a bustling street. Signs are primarily in Urdu, indicating that the region is in northern India, possibly in what became West Pakistan after Partition. A new sign is raised over the shop: "Lala Kedarnath & Sons," announcing the sale of carpets and dry goods, with smaller signs advertising specialty Kashmiri goods (reemphasizing the setting as northern). When we move into the interior, the overarching decor is Bollywood baronial style, with high ceilings, large moldings, chandeliers of etched Dutch glass, ebony headboards, and various European- and Mughal-inspired details throughout (Dwyer and Patel 2002, 52, 71). The camera makes sure we observe these details, pausing to linger over the chandelier in the main room both in this scene and again in Kedarnath's memory after the earthquake.

The primary articulation of the film's moral center occurs just prior to the destructive earthquake. After the first, famous song, "O meri zohra jabin" (Oh my special one), in which Kedarnath declares his love for his wife, an astrologer is urged to read Kedarnath's palm. The latter protests, stating that he does not believe in these things and asserting that he already knows what his sons will accomplish, listing off their future successes for the guests. The wise astrologer then suggests that "one can't really say what time will force a man to do" and urges Kedarnath to forsake his hubris and be wary of time's fickleness. Kedarnath dismisses this advice, and later that evening serenades his wife with visions of their wealthy future together, stating that he will buy a car for them to ride around in, so that people will say: "There goes Kedarnath." At that moment, the earthquake devastates the house and the town. In a series of quick-cut disaster shots, we are shown the architecture of the town more broadly than in the earlier street scene. It includes late-Mughal and colonial-style housing, anchored by a Taj Mahal–like tomb. Fire consumes the town as shadowed figures run screaming through the cityscape. In an interesting twist, the Mughal past seems the only thing not to fall to the earth-shattering rumbles. We see

the dome still standing as the later structures disintegrate. The entirety of the past has not been destroyed—only the most recent era.

These early scenes establish a before that operates both on the filmic level—a happy family together, facing the future with confidence and hope—and on the allegorical level, marking the optimistic moment before independence when the possibilities of a new nation, one freshly freed of the yoke of British colonialism, seemed infinite. That the before phase is situated in a colonial-era city in the northern subcontinent echoes the experiences of many in the film industry, as it mirrors the broader experiences of South Asians displaced after Partition. The migration from the Punjab and other northwestern regions of the subcontinent to Bombay, and the perceived value of the lighter-skinned, Urdu-speaking northerner as the quintessential movie star, meant that a large number of those in Bombay's movie industry were Punjabi (Dwyer and Patel 2002, 20). The division of the Punjab during Partition split apart innumerable families and moved people away from their ancestral family homes. Nostalgia for a preindependence space and time, when families were together and settled in their ancestral villages, permeated much of the culture, making *Waqt*'s lost-and-found theme even more poignant for those living in mid-1960s India.

This nostalgia differs from a longing for a precolonial, ostensibly pure Indian space as might be found (and deconstructed) in Gujral's architecture and Paniker's use of the ancient in his painting. Where both of those examples attempt to articulate the modern through the colonial construction of India's ancientness, *Waqt* understands post-Partition India through the moment of disruption itself, idealizing the pre-1947 period as one of peace and prosperity standing in opposition to the chaos and confusion of resettlement. The modern, then, is figured against this pre-Partition backdrop. Thus rather than trying to work through the colonial past, the film works through a specific moment in time—Partition—and through the subsequent loss of optimism after independence.

Like the pre-earthquake picture of Kedarnath's life, the postearthquake image is largely communicated through architecture and interior design. The first image we see of the now in the film is of the eldest son, Raju, now called Raja (Raaj Kumar), running through a landscape that defined the fast-paced movement of modern urban India (figure 8). The architecture includes boxy modernist buildings with primary-color decoration, echoing the newly constructed buildings of Le Corbusier's Chandigarh with their geometric color-

8 Raja running through the
 modern city. Still from *Waqt*,
 dir. Yash Chopra, 1965.

ation, as well as recalling the low-slung, horizontal residential architecture of
the era. Raja runs into his modern dwelling, and over the next few scenes we are
introduced to several interiors, including a party scene overlooking the curve of
Bombay's Marine Drive, the modern decor of the middle son Bablu's adopted
parental home (Bablu, now Ravi, played by Sunil Dutt), and the humble dwell-
ing of Kedarnath's wife (Achala Sachdev) and their youngest son, Munna (Sha-
shi Kapoor). Raja and Ravi's mutual love interest, Meena (Sadhana), lives in
a wealthy home that we see a few minutes further on, fully decorated in the
modernist style including red carpet, low-slung couches, molded plastic dining
chairs and minimalist glass table, and the ubiquitous grand piano set in front of
the geometric black-and-white pattern of the hearth. The first twenty-five min-
utes of our time in the now primarily involve showing the audience both who
the characters are and also what it should look like to live in a modern house.

 That modern house includes primary colors, clean lines, curved, manufac-
tured shapes, and geometries—all the elements of an international modern-
ist interior design style. References to popular modernist furniture designers
abound, from the Eero Saarinen executive chairs around the dining table to the
sofas reminiscent of George Nelson's 1950s designs. The decor is a laundry list
of the latest fashionable home furnishings culled from contemporary maga-

zine advertising and 1950s Douglas Sirk films' too-perfect interior design. The internationalism is underscored by various decorative elements highlighted in these spaces of the now, in particular a Japanese geisha doll Meena croons to as we are introduced to her space. Much like the chandelier in the earlier scene setting up Kedarnath's pre-earthquake abode, this gesture establishes Meena and Meena's parents as both modern and worldly. The interior decor is matched by a narrative construction of the modern woman, particularly in the figure of the younger woman in the film, Renu (Sharmila Tagore), who teaches Munna to drive, enjoys both badminton and the swimming pool, and generally has progressive ideas about caste and class. Her dress, like that of Meena, reflects these tastes with the latest styles: bare arms, beehivelike hairdos, and the fashionable churidar kurta (Dwyer 2002, 40; Dwyer and Patel 2002, 88). Thus for most of the rest of the film we are presented with an image of modern India through interior decor, architecture, and the actions of the women in the movie—an India that stands in contrast to the earlier preindependence moment figured by Kedarnath's mansion.

In its use of the earthquake as a metaphor for Partition, *Waqt* gives the mid-1960s viewer two very important outlets for imagining the Indian nation. First, the film acknowledges the destruction wrought by Partition and the feeling of hubris associated with the time before independence, when anything seemed possible. The message of the film—that Kedarnath too glibly assumed that his life would continue on its prosperous track—applies also to the nationalist hopefulness for the future of India after the British had left. The unbelievable horror and destruction of Partition severed independent India's link to that time of hopefulness, only to be rebuilt in part by the planning and optimism of the early Nehru years (Rahman 1998). By 1965, when the film was released, India had entered a new phase, with the promises of independence undelivered for many. *Waqt* indirectly addresses topics difficult to discuss even almost two decades after Partition and allows for a certain catharsis (Chatterjee 1998, 5).

Its second outlet for imagining Indianness is the full construction of a vision for what it means to be a modern Indian subject. The three brothers and the people around them negotiate postindependence India against a backdrop of fabulous modern furniture. In a gender reversal of the earlier generation, we watch Renu teaching Munnu to drive. The earthquake at the beginning of the film destroys the lives of those in that Mughal-colonial northern Indian town

and thrusts them head first into a new, modern era. Of course they are thrown off balance, only finding their moral center and successfully navigating this new world when they are reunited as a family. That this vision of the modern subject is a bit too neatly tied together stems from the context in a Bollywood film, understandably tinged with the melodramatic and the necessity of a happy ending. *Waqt*, then, in this neatly arranged package, allows the viewer to come to terms with the vicissitudes of time as it has played out since independence, providing, in the end, a guarded optimism for the future even in light of the devastations and disappointments of the past.

THE MODERN NARRATIVE

As with many stereotypes, a grain of truth likely lies behind the two tropes that began this chapter, namely, that India's artistic heritage often springs from narrative forms and that India today is simultaneously ancient and modern. The works in this chapter explore these themes head-on, examining the role of time and storytelling in the formation of what it means to be modern and Indian. Each of the maneuvers these objects engage in involves a relation of modernism to time and the past, whether that means a national acknowledgment of the destruction of Partition, a deconstruction of the ancient within the modern, or a retelling of ancient stories within a modern idiom. Taken as a whole, they belie the simplicity of a coalescence of modern and ancient in the postindependence context. The relation to the past, whether a mythic-religious one, a distant ancient one, or a recent traumatic one, is far from simple in these works, and each of them rethinks how the telling of these stories operates for postcoloniality.

Thus *Waqt* retells Partition through the metaphor of an earthquake, something that individuals cannot control but that nonetheless affects the lives of those in its path. Telling the story of a family thrown into the modern without a choice, the film provides a space through which viewers might begin to negotiate their own relation to an Indian modern, giving them multiple models to follow—from the modern woman to the rehabilitated father figure.

Paniker's *Words and Symbols* and Gujral's Belgian embassy guide us through the problematic construction of India inherited from the colonial period. Both the painting and the building produce a nuanced relation to the precolonial

and the colonial past. In doing so, they construct a vision of modern India that acknowledges the continuing presence of the colonial in the postcolonial condition. In this sense, the ancient and the modern do coexist in India, but their folding over on themselves operates through colonialism and its construction of India's past and future.

Khanna's reworking of various religious narratives certainly participates in a long history of storytelling in Indian visual culture, but it does so while also recasting these narratives for the contemporary moment. Acknowledging the way storytellers often weave present-day politics into their morals, Khanna does not give us Indian stories that are timeless, but rather ones that have continually negotiated their present context, bringing the complexities of those negotiations to the surface. Narrative is not essentially Indian, but these works in paint, brick, and film employ narrative and time to navigate and construct a modern Indian visual culture.

These works also acknowledge the contingent relation between space and time. Khanna's painting gives us biblical time-space and the now of Nizamuddin. *Waqt* depicts a movement from preindependence to post-Partition, but it does so by shifting from an Urdu-inflected northern Indian space to Bombay. The Belgian embassy operates as a new ruin, referencing specific sites of archaeological importance and highlighting the space of ancient sacredness as much as its quality of antiquity. And Paniker's references to lost languages and ancient cultures take place within a presentation of the excerpted, far-off cave wall from which his painting appears to be cut. The production of modern Indian visual culture engages not only with the question of *when* that modern might be but also with the question of *where* it might be. These works thus also engage with space and territoriality, in addition to time, whether in the form of the map on which the line of Partition was drawn or of the space of the cosmos represented by diagrams in Paniker's work. I discuss *Waqt* again in terms of Bombay in chapter 5, which addresses urban space; Paniker's interest in questions of mathematics and geometric space is examined in chapter 4. Just as articulating modernity involves asking after its time and its location, these chapters demonstrate that time and narrativity cannot be separated from the places they engage, and time functions as only one aspect of an Indian modern.

SCIENCE, TECHNOLOGY, AND INDUSTRY

⇒ TIME AND NARRATIVE represent only a part of the tension arising between India and modernity; this chapter explores the related temporal question of modern-as-modernization. I say related, because modernization involves a feeling of being behind on the long road of progress, so that regions of the world outside of Euro-America have not yet achieved modernity and thus must modernize to "catch up."[1] Modernization is of course often linked to Westernization and raises the specter of neocolonial dependence on the West. In postindependence India, however, the memories of nationalist politics, Gandhi's nonviolence movement, and the difficult relation to Europe during the Second World War precluded any naive appropriation of Western culture, science, or industry. An overarching concern to prevent wholesale Westernization meant that the shape of the modern and of modernization differed from that seen in other regions of the globe.[2]

This chapter examines modernization as a part of the larger question of the book itself: how do the works of art and architecture from 1947 to 1980 navigate the terrain of a newly independent Indian nation and an international, universal modern? I focus this question on the ways in which science, technology, industry, and mathematics are both deployed and examined in visual culture.

I argue that the visual culture of this period served both to further the Nehru-sponsored push for modernization and to highlight India's fraught relationship to that modernization. Some works look to the purity and universality of geometry, explore its roots in India's ancient history, and participate in a modern Indian visual culture that straddles the universal and the particular. Other works take on the question of scientific knowledge and discovery, questioning the ways in which the progress so central to modernism derives from colonial practices of knowledge production. Buildings serve as markers of India's success in the race to catch up—both aesthetically and technologically—but they also mark the human scale at which that historical movement takes place. This chapter traces the ways in which India's postindependence visual culture grappled with science, mathematics, and industrial modernization to produce an art simultaneously modern and Indian.

Because I have just discussed time and will now investigate historical progress, I begin with a work that attempts to assess the twentieth century from a point near its end: M. F. Husain's *Portrait of the Twentieth Century* (1992–93; figure 9). This work provides the chapter with a perspective on India's relationship both to science and to world history. Husain's mural was installed at the National Gallery of Modern Art in 1992, and it highlights several elements of twentieth-century history including the atrocities of Adolf Hitler, the writings of Karl Marx, the ideas of Mao Tse-tung, the peaceful achievements of Gandhi, and the humanitarian outreach of Mother Theresa. Between his iconic portrayal of Mother Theresa's robe and Gandhi's *khadi* (homespun) cloth, Husain places Albert Einstein, seated in a thinker's pose above the inscription "$E=mc^2$." Einstein's prominent position here, framed on each side by towering Indian figureheads (although ironically both Gandhi and Mother Theresa lack a head per se, his head replaced by a star or asterisk and hers indicated only by the drape of her sari), signifies the centrality of science in his view of the events of the twentieth century, at least looking back on it from the early 1990s.

Husain's choice to bracket a major German American scientific figure with two icons of Indian history shows viewers the extranational effect of all three individuals' legacies. It also indicates what different nations have given the wider world: the United States and the West offer science and (in the case of Hitler) fascist aggression, while India and the so-called non-West offer humanitarian approaches to poverty, peaceful resistance to oppression, and (in the case

9 M. F. Husain, *Portrait of the Twentieth Century*, detail, 1992, installation at the National Gallery of Modern Art, New Delhi. Acrylic on canvas.

of Mao) totalitarian control in the name of communism. Of course, Husain complicates this story by interweaving these figures, acknowledging the oppositional pairing of Gandhi and Hitler, for example, and marking the contradiction of modern science and humanity's need for Mother Theresas. These are not portraits of specific people but rather symbols of their legacies. Husain makes more than one iconic move, as the figures of both Gandhi and Mother Theresa are self-referential quotations of Husain's own paintings of the same subject matter: *Gandhiji* of 1972 and his *Mother Theresa* series of the early 1980s (Bean 1999; Mitter 2001). Husain thus paints not only a history of the twentieth century in terms of the world's major actors but also a retrospective of his own iconization of various twentieth-century figures. Husain's history, and the history of twentieth-century contemporary art, is intimately bound to the century's progression of "great" individuals.

His composition provides a portrait of India's relationship both to science and to its twentieth-century nationalist and postindependence identities. Ar-

riving from outside the subcontinent—at least in their mid-twentieth-century guises—science and technology appear to be imports. Yet within the rubric of catching up, they are central to the growth of India's industrialization and to its movement from a peripheral, colonized country to an important participant in modernity. Gandhi and Mother Theresa allow India to remain true to its recent past: the iconic energy of both figures connects India's identity to its most desperate and downtrodden citizens. Their presence in the image reminds the viewer that while the twentieth century was indeed about scientific progress, it also centered on the struggles of the poor and included the birth of a new nation. These two iconic figures allow Husain to show a relationship to both the rural poor and to the heroism that has risen above that poverty in the name of national independence and the production of an Indian national identity.

Like Husain's work, Jawaharlal Nehru's 1950s vision for the nation examined the tension involved in looking to the modernized future while retaining the honor of India's long history. Yet Nehru's work (and many of Husain's paintings) also explores the parallel tension between the benefits of urban industrialization and the valorization of the rural peasant. Husain's portrait of the twentieth century, painted almost fifty years after independence, acknowledges the role of the past in India's modernity by juxtaposing major historical figures. It does so not simply by choosing major Indian figures, but by anchoring itself in scientific discovery: science and mathematics center the question of progress Husain presents here. Earlier, mid-century art addresses these tensions at levels both more allegorical and more mundane, but rarely do earlier works obviously and clearly engage with science. Where does one thus find an articulation of the tension within modernization in earlier work? Where are the moments of grappling with India's technological, scientific, and industrial development?

Despite a lack of analysis of mid-twentieth-century Indian visual culture specifically focused on these issues, a wealth of works—from large-scale architectural projects to small drawings on paper—do engage with science, mathematics, and technology as aspects of modernity. The works discussed in this chapter fruitfully draw together a wide range of science and technology concerns related to modernization and modernity more broadly—from the ancient Indian roots of mathematics to the reworking of Le Corbusier's concrete visions in the Punjab. While they certainly do not represent the predominant mode for a modern Indian art, these works shape our understanding of moder-

nity and modernization more profoundly than expected. Each object illustrates a different aspect of the connection among India, modernity, and the sciences and industry. By incorporating questions of science, technology, mathematics, and their relations to the West, these paintings, drawings, buildings, and photographs reveal a direct struggle with the problematic of modernization in India. I have chosen them for their ability to speak to this relationship and for their distinctness from one another; they serve as emblematic of this question, rather than offering a comprehensive catalogue of it. As a result, they produce understandings of Indian modernity that can be productively employed in examining other works of the period.

I demonstrate in this chapter how these buildings, paintings, photographs, and drawings strike a balance between a universalizing modern and the local articulation of various scientific developments. What emerges in the end is a sense of trepidation about so-called scientific advances, a warranted and historically grounded suspicion of science-as-Westernization, and a nostalgia for an Indian past, always related to that search for the new and the avant-garde, as part of the modern.

CONCRETE, LE CORBUSIER, AND THE PRIMITIVE

To get at the question of technology, science, and industrialization in post-independence Indian art, I examine the construction of Chandigarh (ca. 1951–1980s) and a series of paintings by K. C. S. Paniker entitled *Words and Symbols* (ca. 1964–1970s).[3] The former is perhaps too obvious an example, but it spurs investigation into several elements: materiality, the cityscape, geometry, and mathematics. Paniker uses these elements in compositions that, much like Chandigarh in the end, present a balance of scientific and technological elements to convey the fragile equilibrium of scientific knowledge, inquiry, and intrusion that exists at this time in India.

Upon the Partition of India at independence in 1947, the state of Punjab found itself split in two, with the colonial capital of the state, Lahore, on the Pakistan side. A new Indian capital city was required, but the existing cities and towns were deemed either inadequate or too politically problematic as choices. The construction of an entirely new city in the Punjab created an opportunity for the new India to assert an architectural and urban identity designed

to match the significance of the country's move onto the international scene as an autonomous entity. A site was chosen on the plains against a backdrop of mountains and at the confluence of two rivers. Over the course of the two decades following independence, Chandigarh consumed the energy of many architects, planners, and builders. The final piece of the central monumental program was not complete until the early 1980s.

Although the Punjabi capital was initially planned by the architects Albert Mayer and Matthew Nowicki, the administrators of the project invited the Swiss modernist architectural icon Le Corbusier (1887–1965) to revise the plan for the city in 1950 after the untimely death of Nowicki in a plane crash earlier that year (Prakash 2002, 43). Le Corbusier had already established his reputation as a modernist city planner with his utopian plans called "skyscrapers in a park" (Fitting 2002, 2; Fishman 1977). His *Plan for a Contemporary City* (1922) included just this: skyscrapers of residential spaces symmetrically arranged around a central transportation platform that shuttled automobile traffic underneath while offering space for planes to land above. Trees surround the skyscrapers, creating green spaces between the arteries that flow into the city center ([1929] 1987). While never built, this utopian vision shaped much of early twentieth-century modern city planning. It melded some elements from Ebenezer Howard's Garden City movement, including green spaces and separate residential areas, with the Baron Haussmann style of monumental city planning, embodied here by skyscrapers and wide avenues (Fitting 2002, 71). On the surface, this vertical modernist arrangement, interspersed with greenery and easy transportation flow, does seem ideal. The vision of applying it universally, however, encounters myriad problems, as it ignores local history, climate, and landscape. All utopian plans must be modified to fit particular contexts, and Chandigarh was no different.

In Chandigarh, Le Corbusier was limited by the directive that skyscrapers not be used. Thus, while great height would not center the achievements here, the use of concrete as a building material, particularly in a rusticated manner, was a technological and design experiment meant to signify India's newest capital as simultaneously a space looking forward in its medium and a site rooted in ancient building practices and materials.[4] For if concrete was a contemporary medium, the rough surfaces chosen for Chandigarh's buildings recall mud-brick construction in the region (Werner 1999; Fitting 2002, 76). Chandigarh

thus takes a specific modern element and reshapes it to articulate the balance between modern, forward-looking India and a rootedness in the subcontinent's past. This collapsing of the past and the present anchors Le Corbusier's approach to a universal modern in India. Indeed, Le Corbusier saw in India's mud-brick huts support for the idea that utopia involved a return to humanity's primitive roots.

This purposive balancing between the so-called primitive and the future reflects the dialogue between Nehru and Le Corbusier over the course of this project. Nehru's hopes for the city lay in its potential to reinvigorate what he saw as a static, moribund Indian culture—a culture rendered stagnant by centuries of colonial rule (Nehru [1946] 1960, 384–86). Moving into dialogue with the modern through the use of dynamic new forms, Chandigarh was, Nehru believed, a beacon for the future of India (Prakash 2002, 9–12). While Nehru wanted to maintain links to India's past, he emphasized throwing off the old and embracing the new. While Le Corbusier's Chandigarh certainly took part in the valorization of the new that is central to modern art and architectural practice, the city also drew on the architect's idea of India's past and present.

The texturing of the concrete walls of the main buildings at Chandigarh—the Secretariat, High Court, and Assembly buildings (see figures 10 and 11)—recalls local, vernacular modes of building. Likewise, the lack of gable roofs in favor of flat or slightly sloping rooflines and the use of concrete jali screens to filter sunlight (and ostensibly to provide relief from the heat) both refer to local idioms. As Vikramaditya Prakash points out, Le Corbusier's valorization of a "poor but proportioned" Indian architectural tradition does not oppose the tenets of modernism; rather, this approach is undergirded by modernist ideals and dovetails with the modernist interest in primitivism (2002, 16; see Hurtt 1999).

Thus the static elements in India's past that Nehru wished to overcome had in their depths a universal geometry and "truth" that Le Corbusier valued (and that Nehru would likely not have denied). A Jungian search for humanity's shared aesthetic meant that basic shapes—the square, flat-roofed hut, the wheel, the hand—could serve *both* as universal markers of humanity and as specific markers of Indianness (Hurtt 1999). A five-fingered palm facing toward the viewer might appear as a universal form, while it simultaneously resonates with the Islamic symbolism of the Hand of Fatima and its representation of

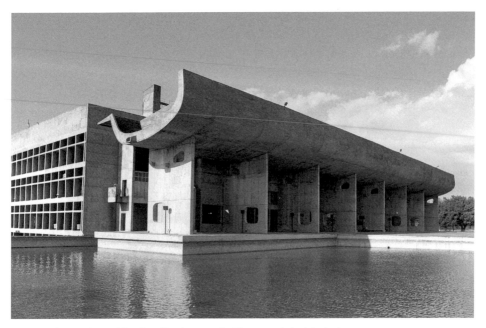

10 Le Corbusier, Assembly, Chandigarh, 1951–63. Photograph by Iain Jackson.

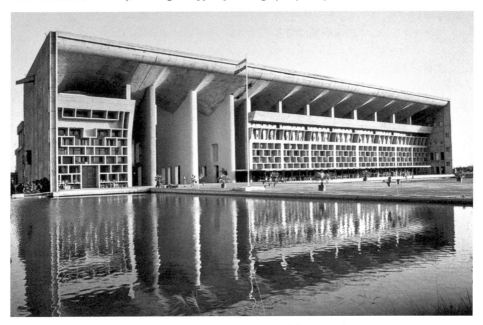

11 Le Corbusier, High Court, Chandigarh, 1951–63. Photograph by Iain Jackson.

the Prophet's family. A wheel might be just a wheel—a symbol of transport or motion—but it might also be the chakra: the wheel of the life cycle or the bodily center of energy in various South Asian traditions. With this multivalence and the overlapping of the universal and the local, the European architect could, in Nehru's vision, redirect India's moribund architectural tradition. It could turn it toward dynamic modernism, doing so without merely repeating the colonial importation and imposition of European aesthetics (Nehru [1946] 1960, 384–85). Modernism, somewhat ironically, offered a way out of part of the colonial bind—though it meant an essentialized, simplified understanding of India's rural and lower classes.

If concrete for Le Corbusier expressed the purity of the modern in its medium, it also encapsulated a generalized idealization of the elemental functionality of peasant life. Indeed, in his records of this time, Le Corbusier includes photographs of the construction of Chandigarh that juxtapose, seemingly incongruously, the stark concrete structures with the rickety scaffolding and low-tech construction methods of the workers employed there. The photos often highlight the presence of the peasant worker—in the work reproduced here, a woman with a basket on her head climbing up the scaffolding dominates the composition—rather than Le Corbusier's own buildings, which remain in the background (figure 12). Instead of commenting on the confluence of two very different levels of modernity, these images are actually wholly congruous (Prakash 2002, 94). Through simple, straightforward materials such as concrete, modernism is meant to allow us to return to the Edenic state of "primitive man" by tapping into the universals so valued by modernists. For Le Corbusier, the photographic juxtaposition of the capitol complex and the local villagers presents, in fact, no juxtaposition at all. It instead underscores the unity of a universal modern and a constructed primitive. Therefore India had in its villagers what modernity strove for; Le Corbusier's structures were there to assist India in rediscovering that purity through contemporary media and technology.

Le Corbusier's use of geometric forms springs from a balance between the consideration of the surrounding landscape and the grounding in symmetrical, axial planned geometries. When looking at Le Corbusier's plans for the complex, one sees the alignments of geometric forms, but these are only loosely adhered to in the final construction (Doshi 1993, 19). Attempting to balance the

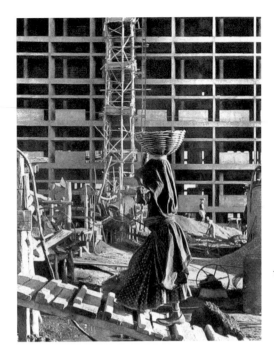

12 View of workers, published by Le Corbusier
in his *Complete Works*, ed. William Boesiger,
trans. William B. Gleckman (Zurich: Artemis,
1957), 87. © 2007 Artists Rights Society
(ARS), New York / ADAGP, Paris / FLC.

structures with the backdrop of the Himalayas and simultaneously articulating the spaces between buildings massaged any strict symmetries and alignments into a site plan only remotely derived from geometry (see Doshi 1993, 7). Likewise, the repetition across many of Le Corbusier's façades is often interrupted to draw attention to key elements of the building or to provide an asymmetry on one axis that reinforces symmetries on other axes. The façade of the High Court building, for example, begins at left with a wide bay, followed by two smaller, open bays, finishing with eight still smaller, closed bays (figure 11). This asymmetry calls attention to the symmetry produced by the reflecting pool (the horizontal axis of the earth producing symmetry) and the internal symmetries of each bay. Within the enclosed bays, Le Corbusier creates a pattern in concrete, one dependent on mathematical dialogue between rectangles and squares and colored in primary hues that remind the viewer of Piet Mondrian's math-derived compositions. In the plan of the capitol complex symmetry and geometric relations between forms thus only suggest an arrangement for the

buildings. On the surface of the structures themselves, Le Corbusier employs geometry more directly to transmit a universal mathematics, one that through his structures taps into the idea of a primitive, shared language. Le Corbusier's buildings deploy geometry as a marker of a connection between the modern, forward-looking India and what the architect perceived as universal in India's present: the primitive local villager.

Le Corbusier's Chandigarh finds its roots in India's distant past while—in line with Nehru's vision—seeking to move India into the future. To accomplish this double goal, the capitol complex at Chandigarh strives to create an un-problematic link between a constructed village primitivism and a constructed international modernism. Le Corbusier's buildings bring India into the modern by positing the country as already encompassing one of the key elements of that modern: pure, essential humanity. Putting the villagers on this modernist pedestal did little to elevate their actual status, or to acknowledge their crucial role in shaping independent India's identity. Linking two temporal poles in the bodies of the local villagers meant collapsing India's entire history into nothing, presuming that the workers who built Le Corbusier's structures merely consti-tuted examples of a larger universal. Chandigarh's solution to the problem of being both Indian and modern falls short precisely because it largely ignores India's recent colonial, nationalist, and independent history. Rather than es-caping the bind of modernization-as-Westernization, Chandigarh appropriates a vision of "village India" as another element of Euro-American modernism.

THE WRITING ON THE WALL

Paniker's paintings at first also seem to address a temporal conjunction between India's antiquity and its present. However, unlike Le Corbusier, Paniker's Indian modern undermines any neat connection between an ostensibly primitive past and India's contemporary postcolonial moment. If Le Corbusier looked to a primitive, remote past and found it in contemporary India, Paniker's past is filtered through the ever-present legacy of colonialism. Paniker's work takes on the question of scientific knowledge and the "discovery" that accompanies it to acknowledge the deep connection between India's search for modernity and its colonially constructed past.

A central artist on the Madras art scene, Paniker did not emerge from the

crucible of Bombay's postindependence context (see the introduction to the present volume) but from the somewhat distant Tamil Nadu—where he and his colleagues had briefly toyed with postimpressionist idioms before Paniker shifted the visual landscape in his *Words and Symbols* series.

In a context in which internationalism provided the key to the modern, Paniker refused to throw away the connection to India. At the same time he avoided the common misstep of falling too thoroughly into a national-centered idiom (Paniker 1972). *Words and Symbols* uses oil's facility for layering to give the surface a rough, antique quality, similar to that of Le Corbusier's structures in Chandigarh. Even in reproduction, Paniker's paintings have a look of antiquity to them (see plate 7). The stained quality of the canvas gives the works a feeling of organic decay associated with the ancient. Paniker moved away from older Indian media such as tempera and watercolor, used extensively by the nationalist Bengal school of the preindependence period, to reclaim oil as a medium not solely for Western work. If the Bengal school artists reacted against Raja Ravi Varma's use of oil in a Western academic manner, and the early Progressive Artists' Group of Bombay used oil as the medium of Western postwar contemporary abstraction, then Paniker here reclaims oil as a specifically Indian medium (Mitter 1994; Guha-Thakurta 1992). It moves his work forward into the now while its effect of age simultaneously ties the work to an eternal past. Again, like Le Corbusier's move with concrete, this juxtaposition is in fact not contradictory, but instead central to modernist ideals, as modernism intends to return us to a (mythically) purer, Edenic state through the use of these new materials.[5]

Paniker's iconography and subject matter reinforce this dialogue between the now and the then. We find on the surface of his canvas an exotic, unreadable language, mathematical diagrams, primitive outline sketches of animals and humans, and long text blocks reminiscent of genius scientists' notations on the blackboard before a great breakthrough (Paniker 1971). These elements all gesture toward the mysteries of genius, the production of scientific knowledge, and the scholarly study of the Orient found in the translations of ancient texts in unfamiliar scripts. Paniker's marks thus tap into both colonial and scientific knowledge making to construct a series of passages across his works that reemphasize the danger of that knowledge. The danger lies in the ability of such knowledge to exoticize even as it lauds Indian culture. In contrast,

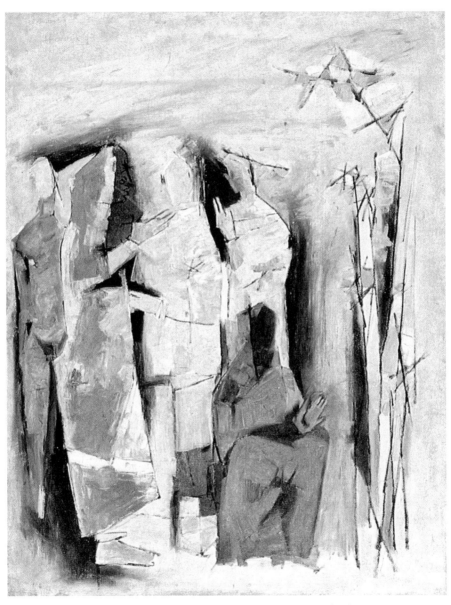

1 M. F. Husain, *Under the Tree*, 1959.
Oil on canvas. Formerly in the collection of
the Jehangir Nicholson Museum, Mumbai.

2 G. R. Santosh, *Untitled*, 1973. Oil on canvas.
 Courtesy of the Peabody Essex Museum,
 The Chester and Davida Herwitz Collection.

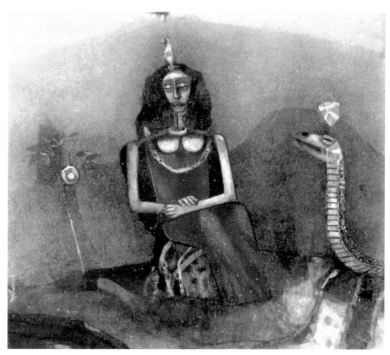

3 Ganesh Pyne, *Woman, the Serpent*, 1975. Tempera on canvas.
 Formerly at Sotheby's London, sold in 1996.

4 Raghav R. Kaneria, *Sculpture-I*,
1975. Wood, terracotta, and mixed
media. National Gallery of Modern
Art, New Delhi.

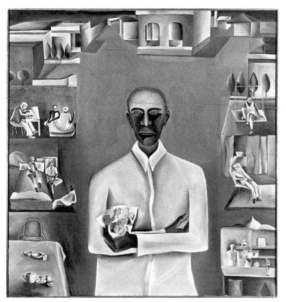

5 Bhupen Khakhar, *Man with Bouquet of Plastic Flowers*, 1976. Oil on canvas. National Gallery of Modern Art, New Delhi.

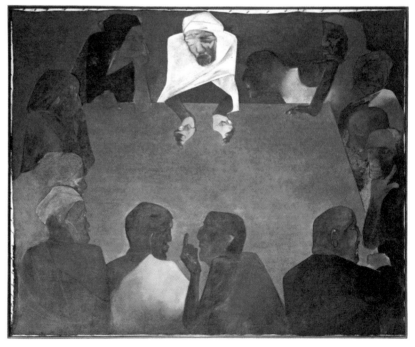

6 Krishen Khanna, *The Last Supper*, 1979. Oil on canvas. Collection of Mrs. Jeroo Mango, Mumbai.

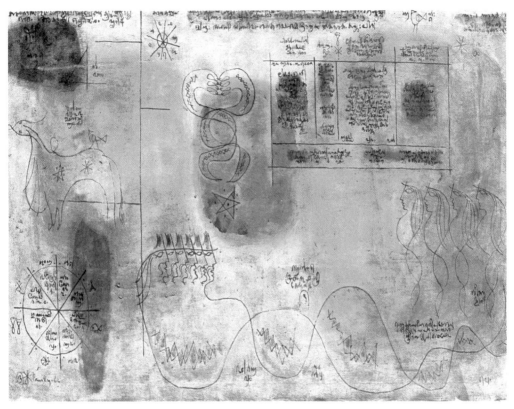

7 K. C. S. Paniker, *Words and Symbols*, 1964.
Oil on canvas. Courtesy of Shri S. Nandagopal.

8 F. N. Souza, *Landscape*, 1961. Oil on canvas. © 2007
 Artists Rights Society (ARS), New York / DACS, London.

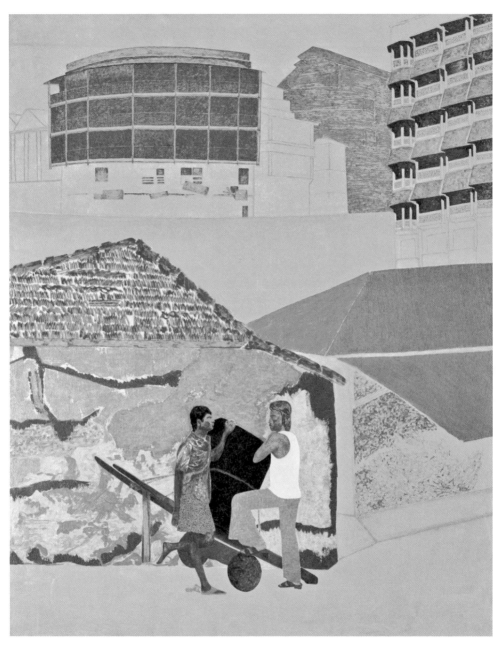

9 Gieve Patel, *Two Men With a Handcart*, ca. 1979. Oil on canvas.
Courtesy of the Peabody Essex Museum, The Chester and Davida Herwitz Collection.

10 Ram Kumar, *Varanasi*, 1964. Oil on canvas. Private collection.

the "scribbles" illuminate the overarching concept of opacity between cultures, the impossibility of transparent translation. Reminiscent of the "E=mc²" on Husain's *Portrait of the Twentieth Century*, Paniker's much earlier work links the scientific present (a present focused on discovery while looking into the future) with an inscrutable ancient past, and it does so through the use of mathematical and scientific scribblings.

India's history of achievement in mathematics finds its center in the claim of the invention of the concept of zero in around the third century CE (Joseph 1991, 241). Often framed as India's gift to Western geometry and math, this revolution in reasoning and calculation was mined by nationalists as another example of India's glorious past to be reclaimed (Subramaniam 2000, 74). Paniker's use of mathematical symbols such as zero and the infinity sign in his paintings thus points both to an Indian past and to the universalizing movement of the modern, just as Le Corbusier's rough walls and geometric architectural forms simultaneously suggest contemporary technological innovation and local vernacular "primitive," and therefore universal, forms.

In many of his *Words and Symbols* paintings, Paniker employs thin vertical and horizontal lines to cordon off space on the surface of the canvas, filling it with inscrutable notes. His charts reinforce the two-dimensionality of the canvas and remind us of the creativity involved both in scientific discovery and in artistic production. It is as if we are peeking into the room in which the professor works out ideas, voyeuristically sneaking a look at the work in progress. Color and texture reinforce this feeling, as large oval stains sometimes coincide with the charts (fitting neatly into their frame), and sometimes transcend that composition-within-a-composition to form the spatial ground for the entire painting. Viewed from afar these paintings appear as scribbles on top of large swaths of color—usually sepia toned with crimson and black accents. These underlying color-field compositions resonate with Mark Rothko's use of ovoid expanses of canvas humming with different colors.

But Paniker's canvases do not focus on those areas of color that serve to establish the background space in front of which his scribblings float. Much happens in these inscrutable notations, and each element of the painting has a different emphasis, a different weight. Many scholars examine Paniker's work through his interest in folk art—his founding of the Cholamandal artists' colony and his valorization of indigenous craft and tradition (James 2004). This con-

nection, of course, can be seen in the *Words and Symbols* series. But in addition to folk elements (including references to Warli drawing; see Dalmia 1988), and in some ways more prominently, Paniker uses diagrams, charts, and symbols to create a floating space of mathematical and scientific inquiry in the context of his primitive, folk canvases.

Le Corbusier puts the modern well within the reach of the peasant—or at least, even if he does not succeed in practice, his work hubristically assumes that the coalescence of the two might allow the peasant to enter into the modern. In contrast, Paniker's work questions this assumption, humbly refusing to speak for the villager or for Indians in general. The two differ in their acknowledgment of colonialism. For Le Corbusier, Chandigarh brings ancient purity and modernity together to coexist happily, but Paniker's paintings recognize that this coalescence happens only by way of colonialism and its legacy. *Words and Symbols* foregrounds that colonial presence in its articulation of the moment of discovery and of knowledge gathering. Colonialism largely operated through an information-gathering project, one in which knowing the colonized meant ruling more effectively. However, this project also held within it its own downfall because the colonized Other could never be fully known and mysteries always persisted.

In Paniker's work, the viewer encounters the mathematics and the scribbles on the way to scientific discovery, but the work allows the viewer neither to take part in this discovery nor to *understand* it. The paintings position viewers as voyeurs, and they thereby open the curtain to creative thought just enough for the audience to see it happening. But the conclusions and solutions remain obscure. The paintings do not reveal the mathematician's proofs or allow viewers to participate in the benefits of the scientist's discovery. There is no $E=mc^2$ here. Unlike Einstein in *Portrait of the Twentieth Century*, we do not even know that the conclusions *are* revolutionary, merely that science and scientists are doing something.

Words and Symbols obscures the conclusions for us in several ways. The most obvious is a lack of clarity in the texts: the script is universally illegible. One might have the sense, initially, that someone, somewhere, might be able to read this—that Paniker is using an obscure or perhaps even lost ancient script. But his writing does not reference an identifiable historical or esoteric past—it

is only the *semblance* of writing, a representation of communication through text rather than communication itself. The medium of oil paint also obscures our view into the inner workings of science. The surface of the canvas has a milky quality to it, a layer of additional, translucent paint in some areas that at times looks like erased chalk and at other times like soap scum. The texts are thus physically obscured with paint, creating an additional level of obfuscation: the spatial. For if we understand the ovoid stains of color to serve as the ground above which the scribbles float or hover, the layer of translucent scum presses these markings back into the ground in some areas, while they serve *as* the ground in others. The milky film lies both on top of and beneath the scribbles, confusing the viewer's sense of relations in space. These three elements then coalesce to present a scientific process without hope of scientific discovery. We will never know what the mathematician was doing or what experiment the scientist recorded on this canvas.

Thus if Le Corbusier saw technology and science as a way to free the peasant and ironically to return to primitive man the purest parts of the primitive, Paniker's painting acknowledges the deep fallacy in that modernist vision. *Words and Symbols* presents science as another obfuscation, another illegible language inaccessible to his viewers. Rather than see the modern as the valorization of the primitive—as a way to present universalizing modes of living and all-encompassing truths in any context—Paniker places both the modern and the primitive into the same space of unknowability. They are similar not because they offer freedom from the horrors of nineteenth-century industrialization and technology or because they allow us to return to first principles, but because both modernity and the primitive are equally inaccessible and unviable. We may peek in, voyeuristically desiring the glories of science or the bucolic simplicity of the primitive, but we may not *be* in those places. For Paniker, they remain forever out of reach.

Even though his work has been heavily criticized by modernists and others, Le Corbusier is considered a quintessential modernist because he captures a balance of looking to the so-called primitive and relying on universal truths such as geometric form. If this is so, then Paniker might be a quintessential *Indian* modernist. Paniker works with the same materials—mathematics, science, and the primitive—to produce a vision of the modern in dialogue with

postcolonial concerns of knowledge making, the dangers of primitivizing cultures, and of wishing to participate in a universal space. By taking on the postcolonial relation to colonial discourse and knowledge production, Paniker's modern directly incorporates a critique of modernity within itself. The critique is particularly pointed as Paniker's works acknowledge the intimate connection between the production of modern India and the production of India as an object under colonial rule. In doing so, they succeed in mounting a critique of colonial discourse as a way of accessing a critical modern Indian idiom.

DRAWING A STRAIGHT LINE: MATHEMATICS AND THE MODERN

The 1960s and 1970s in India witnessed the use of mathematical imagery, diagrams, and scientific drawings in other artistic contexts as well. The use of geometric, precise line can be found most prominently in the works of Nasreen Mohamedi (1937–90).[6] Neither her own writing nor critical assessments of her work directly connect Mohamedi's projects to mathematics. Yet her appreciation of geometric form—as seen in her photography, paintings, and drawings—points to her use of a scientific, abstracted visual language. Mohamedi's work deploys this language to create a space for the interface between a material reality and a spiritual, abstract metaphysics. Like Paniker's *Words and Symbols*, Mohamedi's works use the tension between two-dimensional space and the illusion of three-dimensionality to push and pull the viewer between and among multiple levels of her compositions. Composed of precisely drawn lines and patterns, and often based on an underlying grid, Mohamedi's works bring together the diagrams of science and math with the abstraction of mid-century art. When examined alongside her photographs,[7] her drawings reveal Mohamedi's vision of her surroundings—the material world and the human touch that shapes it. Thus her otherwise arid, minimalist compositions contain a humanizing element.

Mohamedi's works simultaneously portray the concept of art-as-object—two-dimensional markings on a piece of paper—and the cosmic diagram represented through geometry. Springing, as Geeta Kapur argues, from both the suprematists' search for utopic geometries and the constructivists' projection of these geometries into real-world architectures (2000, 69–70), Mohamedi's work connects us to these grander schemes in the world, whether it be the

pattern on the pavement in her photographs or the pattern on the paper in her drawings.

In her work from the mid- to late 1970s, Mohamedi offers a horizon-free gridded space, seen in her *Untitled* (ca. 1976) and her photograph of Fatehpur Sikri, also *Untitled*, from 1975 (figures 13 and 14). In both compositions, the available space is filled with lines—sometimes created from the architectural forms of the sixteenth-century Mughal palace or sometimes produced by Mohamedi's own mark making. In both cases, the grid remains imperfect. In the photograph, Mohamedi produces texture by highlighting the roughness of the pavement joins, even in their regularity of pattern. An unexpected water channel at right angles disrupts the grid of the pavement, almost violently. In the drawing, Mohamedi weaves together short horizontal lines, suggesting the weft of a textile and moving across the warp from right to left and back again. Like the pavement joins in the photograph, Mohamedi's short horizontal marks vary in weight—some dark and heavy, others barely there, faint traces of their position on the grid. Like that in the Fatehpur Sikri photograph, Mohamedi's penciled grid is also interrupted in several ways, most prominently by two longer slight diagonals that travel horizontally across the image, and more subtly with the lightly drawn additional horizontal pattern of long, almost invisible lines, joined in some cases by fanned-out diagonals. These patterns repeat, so while they disrupt the darker, more prominent weft pattern above, they teeter between a feeling of randomness and a mathematically driven purposiveness.

Mohamedi's work is often compared to Kasimir Malevich's suprematist compositions, Mondrian's golden mean geometries, Frank Stella's black paintings, or Carl Andre's minimalist sculpture (e.g., see Moszynska 1990). But unlike those projects, Mohamedi's works continually insert a modicum of human presence and of time. Rather than producing perfection or a rigid pattern, Mohamedi allows her hand to show, even if ever so slightly. She thereby reveals a passage of time in the drawing—either through compositional layering, as in the drawing reproduced here, or through a hint of fourth-dimensional motion in the shape of the geometry she employs. Her photographs usually avoid people directly—although the Fatehpur Sikri image includes a lone person—but they indicate clearly the human presence by focusing on architecture, streets, or plowed and manipulated landscapes. While remaining on the level of

13 Nasreen Mohamedi, *Untitled*, ca. 1976. Drawing on paper. Formerly XAL Praxis collection, Mumbai.

14 Nasreen Mohamedi, *Untitled*, ca. 1971. Private collection. Courtesy of Talwar Gallery, New York.

mathematics and science, Mohamedi's work thus constantly reminds us of the humanity—perhaps even the biology—of creation, whether it be conceptual or material.

Thus, as does Le Corbusier's architecture, which seeks through primitivism to bring the modern to humanity (even to humanize the modern), Mohamedi's work expresses the human element at the center of the abstract/material divide and, indeed, at the heart of much scientific questioning. Her works allow us a glimpse of the intersection of the conceptual and the physical. Again examining Le Corbusier's façades in comparison to Mohamedi's two-dimensional works, one finds a similarly rigid and yet random geometric pattern in the *brise-soleil* (sun-breaker) wrapping he uses on his surfaces (Abbott 2000, 20). Repetitions of pattern in Le Corbusier's architecture are broken by color, on the one hand, and by reflection, on the other, shifting the pattern of the surface based on the time of day or the position of the viewer. Glass and water both serve as reflective elements at Chandigarh, and they undermine the abstract geometries by emphasizing the placement of the viewer and the gaze as part of the production of the architecture itself. That is, without the viewer there, in a particular position at a particular time, the pattern would not shift as it does.

Kapur describes Mohamedi's imagery as moving away from this European gaze-centered approach to what the critic calls a more "Eastern" glance: Mohamedi's images seem to emerge from the corner of our eyes, as shadows rather than as icons or as figures (2000, 68). Mohamedi's works would thus exist in the shadows that Le Corbusier's façades cast, articulating a particular space for geometry in modern Indian art, one that allows for a humanist element without privileging the viewing I/eye. This glance that Kapur describes—coupled with the materiality of Mohamedi's textures as she reveals her hand in the precise works—shows us a different path to abstraction than that offered by Mondrian or Stella. This is an abstraction that articulates the submerged subjectivity of postindependence India in its glancing gestures toward human presence.

In other words, Mohamedi's drawings and photographs dance between the perceived rigidity of geometry and the variability of humanity, and in their liminal location they reveal a tension between universal, modernist perfections and the material reality of day-to-day life. These works also subtract the figure from the composition, forcing us to search for the human presence in its traces, not in a readily apparent bodily form. As a result, Mohamedi's images show us

precisely the difficulty of producing a fully evident, embodied modern Indian subject. We get hints of it, we see evidence of its potential, but it can never be complete or whole. Mohamedi's abstraction, then, provides us a glimpse into the postcolonial condition by articulating how the postcolonial self exists only in glances, shadows, and traces.

NEGOTIATING MODERNIZATION: THE FACTORY

If Mohamedi's work articulates modernity through an abstraction of geometry and mathematics, it also employs architecture to facilitate that vision. Architectural monuments serve as no less powerful markers of this modernity. Returning to Chandigarh for a moment, its monuments offer an example of both the success and the failure of modernization through architecture. The *Open Hand* monument there, meant both for the city and for the top of the dam at Bhakra, could not be built until the mid-1980s, primarily because of the political situation in the Punjab in the mid-1960s (Prakash 2002, 139-45). The Bhakra dam, completed in 1958, in Nehru's words constituted a "temple of resurgent India" and was meant to increase agricultural production as well as provide hydroelectric power to the Punjab. However, it fed agricultural lands only spottily, serving more to escalate tensions among the three major religio-linguistic groups there—the Sikh Punjabis, and the Hindi-speaking Hindus of Haryana and Himachal Pradesh. Following the regional drought in 1965, and the assassination of the pro-Nehru Punjabi chief minister Partap Singh Kairon in that same year, the Punjab was divided into three states in 1966: Punjab, Haryana, and Himachal Pradesh. Chandigarh became the Union Territory, administered by New Delhi and housing the governments of Punjab and Haryana. Instead of representing a triumph of Indian engineering and modernity, the Bhakra dam thus communicated the divisive social and political issues at stake in the country after Partition.

Le Corbusier was meant to create an artistic program for the Bhakra dam including the installation of a monumental sculpture called the *Open Hand*. As Vikramaditya Prakash writes, the sculpture was intended to symbolize the Cold War nonalignment movement led by India, as well as the optimism of the new India in its modern guise. With the political collapse of the planned message for the Bhakra dam and with the division of the Punjab, Prakash argues that

the *Open Hand* could not be installed: "Under the circumstances, the erection of the Open Hand, I would therefore posit, was simply not apposite—it did not remain unbuilt for financial reasons and certainly not for reasons of lack of cultural translation. On the contrary, the Open Hand could not be built precisely because it would have been understood too well—as the blighted crown atop a temple that was no longer in grace" (2002, 143). The Bhakra dam and the *Open Hand* illustrate that Nehru's push for large monumental structures to represent the new India and to serve as symbols of its rising modern-industrial identity often backfired, providing lightning rods for postindependence political conflict. The danger of these grand schemes lay in the ways in which they could easily redound to the opposite of the intended message. Architects and artists dealt with this aspect of technological advance by building and imaging places—cities, factories, slums—with a balancing act in mind. To explore this dynamic, I turn first to architecture and then to photographic imagery of the factory.

The difficulty in expressing a clear message helps explain why so few of these major projects have registered on the consciousness of contemporary architectural historians. They are made to serve primarily as examples of engineering rather than of architecture. Yet this period in Indian history saw the construction of numerous factories, many of them built by prominent architects working through modern ideas. Achyut Kanvinde's Dudhsagar Dairy Complex at Mehsana, just north of Ahmedabad in Gujarat (figure 15) represents a rather small-scale exploration of modernity. It is neither a huge dam nor a complete city, but merely the national dairy plant, which produces milk powder from milk.[8]

Dairy products are central to India's diet: ghee-based cooking, yogurt, and milk-based sweets offer only the most prominent examples. Kanvinde's factory, now central for Gujarat's milk production, was commissioned by the Cooperative Milk Producers' Union, one of many groups in India bringing together smaller milk producers to share processing plants and distribution networks among the entire group (Bhatt and Scriver 1990, 29–31; Banerjee 1994). In the early 1970s, the cooperative milk movement had gained substantial governmental support. Its beginnings in the 1940s came from farmers' responses to middlemen and corporations taking most of the profits from the milk industry. Cooperative dairy farming took hold in Gujarat at Kheda, with the Kaira Milk

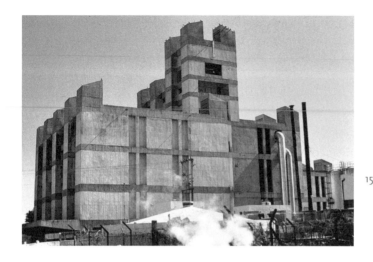

15 Achyut Kanvinde,
 Dudhsagar Dairy Complex,
 main building, Mehsana,
 Gujarat, 1970–74.
 Photograph by Peter Scriver.

Cooperative. Once established as a successful model that brought together local farmers and allowed them both decision-making power and profit from their labors, it was emulated elsewhere, in part because of the support of Prime Minister Lal Bahadur Shastri in the mid-1960s. By the time Dudhsagar was commissioned in 1970, Operation Flood—a project to increase the availability and consumption of milk in India's villages and to reduce dependence on milk imports—was well underway (Banerjee 1994). The plant thus centered a country-wide rural development scheme with an eye to bringing new technologies to milk production, but also raising awareness about food and personal hygiene, new cattle-breeding techniques, and the power of labor cooperation.

Originally, Dudhsagar primarily produced milk powder, valued for its longer shelf life, easier transport, and diversity of applications (from baking to reconstituting milk itself). This factory thus served not only as an economic boon to the milk producers but also as a symbol of the move toward the modernization of milk refinement and distribution. For these reasons its architecture carries the burden of national development schemes and serves as a symbol of their success (or indeed their failure) both locally and across India.

Dudhsagar's exterior form exploits the fact that milk processing requires vertical shafts to dry the milk and uses them to assert the profile of both wings

of the building. For the factory itself, tall, wide pillars emerge from the top of the structure, each culminating in two towers with symmetrical, pitched roofs, suggesting a head with ears or horns. The central two pairs of "horns" are echoed by lower pairs, symmetrically arranged in rows, cascading down the structure's façade. The receiving bay, connected to the main structure across a large elevated truck deck, continues these tower elements, here purely decorative, but affording a symmetry to the building as a whole and reinforcing its somewhat animal-like nature. The vertical shafts on the receiving dock present a dynamic vertical to the strong, gravity-defying horizontal of the dramatic, concrete-framed canopy that overhangs the truck bay.

That horizontal-vertical balance is matched in the main factory building by its roofs, each dropping and moving outward, reinforcing the program of towers while providing a horizontal element to the building's form. Similarly, Kanvinde's design emphasizes this outward movement with horizontal banding in a slightly darker tone of concrete than that of the main building, thereby offsetting the strong verticals of the tallest tower. The banding also calls attention to the building as a work of architecture rather than as merely a factory, making it clear that aesthetics were a primary concern for both the architect and the patron. These elements allow us to acknowledge the structure in its entirety as both functional and formal.

The animal-like imagery found in the form of Dudhsagar might be compared to that seen in Le Corbusier's Assembly at Chandigarh (figure 10). The Assembly, when viewed from a three-quarter angle, is said to incorporate the horns of a bull (the front loggia breezeway with its U-shaped roof), and from the back of the building, the hump of the animal (the conical sculpture on top, also intended to emulate the astronomical instruments built in Delhi and elsewhere by Jai Singh of Jaipur in the eighteenth century). Le Corbusier's fascination with the bull form is well known (Coll 1995; Prakash 2002, 120), and at Dudhsagar this form melds with a related, if inappropriately gendered, subject: the dairy factory.

The structure's modernist heritage is clear in its geometric forms, its use of concrete as a clean, precise material, and its simultaneous humanization of the scale of the structure. While the building towers over the visitor, the horizontal banding and large overhangs at the entry bays provide it with a relationship

to the human that recalls the cooperative movement's connection to the individual farmer and to the national dairy industry.

Kanvinde's factory also brings us back to geometric shapes, symmetry, and parallel lines. In this building, the division of the surface into square blocks and the coloration of the concrete recall Mohamedi's photographs: the structure presents clean intersections of lines and a variety of light and dark areas, with overhangs and vents providing deep shadows and the white concrete reflecting the sunlight of Gujarat. The factory operates as an abstract collection of parallel lines that, no matter the viewing angle, create diagonal recessions in space—from the lowest point of the building to the highest, or from front to back with the sloping roofs of the towers. The symmetry of both plan and elevation reinforce this regular rhythm of line—the repetition of horizontal rectangles on the surface echoed by the interior spaces. Although one cannot see the internal symmetry of the structure directly, as Le Corbusier notes: "Arithmetic lends itself to a simple operation of the mind. Twice two is four. It is palpable, comprehensible (I have not said 'visible')" (Le Corbusier 1958, 210). The internal geometry of the structure, reflected in the rhythms of surface decoration and the structural elements seen on the exterior, provides a conspicuous sense of geometric organization, of mathematical planning—and by extension, some of that modern purity Le Corbusier tried to attain at Chandigarh.

Dudhsagar presents the region, the dairy industry, the local farmer, and the urban viewer with a statement on the place of the modern in contemporary India. While perhaps pursuing similar goals as Le Corbusier's buildings, the dairy complex takes the modern visual idiom and uses it to communicate the local and national importance of the dairy movement in the 1960s and 1970s. It overturns the Corbusian collapsing of the present and the past, instead producing a modern imbued with particulars, rather than with universals. The strength of the structure, from the upward-pointing towers to the reassertion of its forms through horizontal repetition, communicates the collective strength of the farmers who joined together after independence to build an India-based dairy production and distribution network. While it still partially relies on international aid and trade, the cooperative movement owes its success to its ability to alleviate India's dependence on foreign aid and to empower the local farmers. It also balances the power of middlemen against that of

workers, a central and long-standing struggle. The modernist vocabulary of the Dudhsagar complex works both through the universalizing idiom of geometry and line and through the local iconography of the bull to represent this success story as the triumph of a modern, developed India.

Kanvinde's Dudhsagar dairy complex aligns with the environment around it—providing not only a workable factory but also a reference to the bovine character of the facility in its form. The structure does not embody the vision of universal modernity and an abstract relation to the peasants Le Corbusier believed in. The dairy complex acknowledges the material needs of local farmers rather than putting them on a pedestal as an example of ostensibly primitive purity. This crucial difference between Corbusian modernism and that exhibited at the Dudhsagar complex allows the dairy factory to represent the midcentury movement of autonomous action *in its modernity*, serving as a hub for cooperative activity, economic growth, and the articulation of industrial progress.

This balancing act between a large-scale industrial factory program and the needs of an individual dairy farmer or factory worker was not a new phenomenon when Kanvinde built his factory. Operation Flood and its concomitant cooperative dairy movement sprang from earlier debates over the appropriateness of large-scale factories for a nation teeming with manual laborers wishing to work. Even before independence, Gandhi and Nehru, among others, debated the relative importance of mechanized factories for India's economy over against the value of jobs for India's population (Nehru [1946] 1960, 327; Dasgupta 1996, 64–80). In the 1950s the push for modernization and factory-driven mechanized production met with a countermovement seeking to valorize the position of the worker in this new phase of India's industrial development.

Sunil Janah's photographs capture this tension during the 1950s, imaging factories, cities, and the Indian countryside.[9] His image of the Jamshedpur steel factory in Bihar (1957; figure 16) illustrates an approach to modernization that celebrates large-scale projects while acknowledging the potential for eliminating the worker as an actor in India's economy. The Tata Iron and Steel Works factory was founded well before independence, in 1907, by Sir Jamshedji Nausservanji Tata. At that time, the town was renamed after the factory's benefactor, and the local railway station was named Tatanagar (Government of Bihar 1962,

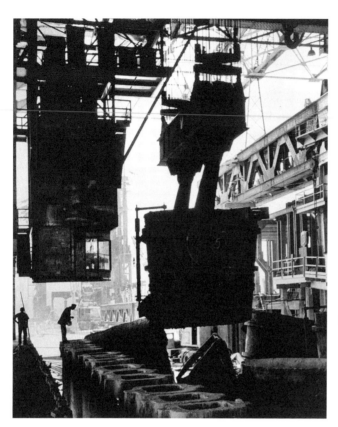

16 Sunil Janah, *Steel Smelting Shop, Tata Iron and Steel Works, Jamshedpur, Bihar,* 1957. © Sunil Janah, 1957, 2007. Courtesy of the artist (sjanah@aol.com, http://suniljanah.org).

70). Clearly of central economic importance for the region, the factory formed a part of the economic image of Bihar, appearing in various texts published by the government in the twentieth century.

Janah's photograph enters this framework and continues the celebration of the large steelworks, emphasizing their size and imbuing them with sublimity in his composition. Framed vertically, the smelting area of the factory angles away from us into the light, providing repetitive forms to guide our eyes back into the space. The image plays with light and dark, as both a large suspended vessel in the foreground and a viewing compartment further back block our access to the outside. The photograph uses that backlighting to shape what our eyes focus on. And the small bent figure at left, fully outlined by the light

behind him, carries the same weight in the photograph as the heavy, menacing and yet floating form of the vessel in the foreground. This bent figure wears a traditional Gandhi or Nehru cap, visible even from the camera's distance.[10] The photograph provides a striking contrast between the scale of the human and that of the factory, a contrast further emphasized by the way the other men in the image fade into the fabric of the factory building.[11] We are drawn into the space, past the sublime scale of the factory mechanisms toward the light-framed Nehruvian figure. The image does not decide for us what to think about this contrast, nor does it indicate whether this contrast should be taken as a critique of the factory. Indeed, the glorification of the space of the steel smelting shop is strong here, as is the humanization of that space created by the backlit man. As in the case of the milk factory, we thus find a balance between the felt need to modernize and the concern with honoring the humanity of India's citizens.

Unlike the photograph of Le Corbusier's capitol buildings and the village workers discussed earlier, Janah's work places a figure in a Nehru cap in his industrial landscape. Neither Le Corbusier's photograph nor Janah's, however, exhibits mere juxtaposition. In both cases a connection between the architecture and the human form vies with those small suggestions of contrast. These photographs show us a negotiation of the modern and the Indian. We move forward toward the light in Janah's image, guided by the figure in the cap, through the factory, toward the future. However, where Le Corbusier connected his modernist vision with a primitive essence in India's contemporary culture, Janah gives us an image of Nehru's modern: the factory and the worker moving toward the bright future. Most importantly, though, the image of the steelworks also raises the question of whether this projected trajectory is possible. By blocking our view of the light and putting the menacing smelting vessel in the foreground, Janah's photograph undermines any naive faith in modern progress, even as it presents a vision of such progress. Here we have no simple applauding of Nehruvian modernity, but rather its questioning: when individuals shrink in comparison to the vast machinery of modernization, the pure modern is not something to grab glibly.[12] I have noted this balance between modern, geometric forms and humanity in the works of Mohamedi as well. Her linear compositions reveal the hand of the artist and thus move between the materiality of the human world and the abstraction of mathematics.

Each of the examples in this chapter navigates the terrain of modern India, balancing the push for modernization with a suspicion of its promises. Janah's image of the steel factory highlights this tension between two moderns. On the one hand, we see a hopeful one pushing India toward the future by building factories, major new cities, and dams. This is the modern of Nehru, of the 1950s and its virus of optimism, as Salman Rushdie so aptly describes it (1981, 38–47). On the other hand, we witness the role of the individual in a new vision of India's modernity, where one finds trepidation and a sense of loss of the human scale. Mohamedi's lines, Janah's Nehru-capped figure, Paniker's gestural scribbles, and Le Corbusier's villagers all reinsert the human scale into the grand sublimity of Nehru's modernizing vision. Each of these examples illustrates the tension between these two elements of modernization, negotiating a path through the conundrum of the modern as deployed in India. Each retains some element of India's past—as constructed through mathematics, traditional dress, lost languages, or mud-brick architecture—while pushing the visual idiom into the future. Each inserts a certain humanity into a potentially technology-driven modern, whether through the wavering hand of the artist, an element of folk idiom, a belief in the essential qualities of village life, or the role of individual farmers and workers in the machinations of large factories. In doing so, they all walk a line between the international and the local, the mechanized and the human, and the potential future and the nostalgia-infused past. While they differ in the means and in the resultant form of the negotiation, each produces an example of an Indian modern produced through science, technology, or mathematics.

THE URBAN

≡ IF THE PREVIOUS CHAPTER focused on major industrial monu-
ments and scientific imagery, this chapter examines the urban spaces those
temples to modernity serve. Many objects related to modernization, whether
the Dudhsagar milk factory or the Jamshedpur steelworks, tend to be located
outside of major urban areas, but even so they relate directly to the increasing
draw of the city in postindependence India. The relationship between the urban
and the factory, the city and the farm, the village and the crowded *mohalla*
(neighborhood) plays a central role in the construction of a modern India.

After independence, as cities such as Bombay became magnets for migrants
from the countryside,[1] urban areas grew overcrowded. This put pressure on
the transportation infrastructure, produced housing problems, and lowered
sanitation standards. The migration caused by Partition left many stranded. In
the major cities of Delhi and Calcutta, many people were forced to live in rail-
way stations or in large slums, while Bombay pushed against its geographical
limits as a peninsula surrounded by water. Attitudes toward the city are framed
by this material context, as well by the valorization of peasant life evident in
the nationalist movement and spearheaded by Gandhi. Thus the figure of the

city—at once a central element of modernity, the intersection of national and international communities, and the site of an expanding gap between the privileged and the poor—became a rich source for modern art in India. Varied works of this period, whether architecture, painting, film, or the urban space itself, simultaneously produce an image of the city and seek to remake it.

The urban, then, alongside the village, provides a location for the negotiation of the modern and the Indian in postindependence India. Cities include traces of the past, whether in the form of memory or in that of actual structural remnants. They also serve as sites of a great cultural confluence, bringing together cultures that sometimes merge, and sometimes become strengthened in their individual identities. I argue here that the urban is deployed to articulate the combined hopefulness and disappointment of postindependence India, and that it works as an ideal metaphor for the problematic in-between status of Indian modernism: between the local and the international, the Indian and the Euro-American, the ancient past and the "not yet."

I begin to trace the hopefulness-disappointment axis by looking to images of the city as a general category by Raghu Rai and F. N. Souza. The bulk of the chapter then examines Bombay and its role in articulating what a modern urban India should be. Here I again examine the film *Waqt*, alongside another, *Shree 420*, to locate several images of Bombay in circulation during the 1950s and 1960s. Next, I turn to the "real" Bombay, examining Charles Correa's various plans for the development of the urban space itself, whether focused on pavement dwellers or the satellite city of New Bombay. Finally, images of the city in painting consolidate these approaches to the urban. I contrast two types of cities here by looking at Gieve Patel's painting of workers in a cityscape and Ram Kumar's image of an archetypal Indian spiritual city, Varanasi. Bombay anchors the chapter because it has become the classic example of urban sprawl, destitution, crowding, and the darker side of modernization. At the same time, Bombay serves as a glamorous magnet for hopeful villagers seeking their fortune. Its importance as an urban icon is unquestionable. Contrasting images of other kinds of cities frame the central pivot of Bombay; I have chosen them for their variety and for the way in which they highlight different aspects of the urban. The city images discussed here exhibit a multivalence that allows for a full exploration of the trope of the urban as it shapes the struggle to be both Indian and modern.

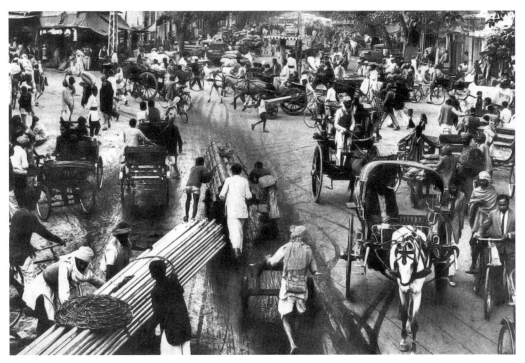

17 Raghu Rai, *Traffic at Chawri*, Delhi, 1965. © Raghu Rai. Photograph courtesy of Magnum Photos.

HOPEFULNESS AND DISAPPOINTMENT

One of the iconic twentieth-century photographs of India, Rai's *Traffic at Chawri* (1965; figure 17) works with the parallel-line geometrics of cart tracks to present an image of mathematical order in chaos. The photograph uses geometry to create a popular image of India's urban space: busy, bustling, and full of life—and simultaneously chaotic, crowded, dusty, and reliant on medieval modes of transportation such as tongas (horse-drawn carts) and rickshaws (see Dwyer and Patel 2002, 64). In Rai's city, the dynamism of the diagonals and the movement of the image win out over any impression of backwardness. Industriousness, as Nehru stated, comes in many forms: "Apart from the evils inherent in foreign rule and exploitation, and the lack of freedom to initiate and carry through big schemes of reform, the problem of India was one of scarcity of capital and abundance of labor—how to utilize that wasted labor, that manpower

that was producing nothing. . . . When the big machine is not there at all, then no question of comparison arises; it is a net gain both from the individual and the national point of view to utilize manpower for production" ([1946] 1960, 327). Rai's image captures not only the abundance of labor, but also a hoped-for shift from the waste of that labor under colonial rule to the use of it to build a nation. The photograph shows us construction equipment (pipes, boards) pushed by workers toward a site outside of the frame. The image communicates progress and development in the mid-1960s, a time that also saw the building of the dairy industry and other nationwide programs designed to alleviate dependence on foreign aid.

The image of the bustling city was not universal, however, and a critique of industrialization and of the city's crowdedness emerges in the works of some postindependence artists. Souza, better known for his figural work, also pursued landscapes and cityscapes as subjects, bringing the frenetic energy seen in his figures to the subject of the city.[2] In *Landscape* (1961; plate 8), Souza offers a vision of an unidentified town with tall towers of uncertain date, diagonal streets, half-open doors, and scattered vegetation. A coastline or riverbank seems to cut off the city in the foreground—vague boat shapes float at the bottom of the canvas. The horizon, while not a definitive line, provides another framing element at the top of the horizontal composition. The city does not seem to end at the left or at the right, and this openness extends to each of the buildings Souza depicts: they blend into one another, and we are not sure what is street and what is structure. Green elements invade the town from the top of the composition, with gestural paint strokes inside them that indicate trees. The city overruns its purported boundaries—into the foreground with diagonal lines that run off the canvas, and outward to the side. Perhaps a wall encloses the town on the left-hand side? Perhaps the trees on the right indicate the end of the city? The boundaries are not clear here, and Souza leaves these questions for the viewer to answer (Kapur 1978a, 30).

In trying to make sense of Souza's landscape, the viewer struggles to separate house from tree from sky and to understand the three-dimensional space the artist presents. This spatial tension suggests parallels with Rai's photograph: cities and towns are chaotic, messy places; they are dynamic, pushing outward and upward, expanding and growing. The amalgamation of vegetation

and human-built structure in Souza's work lends both elements an overgrown, organic feeling, underscored by the humid wetness of the colors chosen for the canvas: deep reds, oranges, and greens, with an occasional white shrouding parts of the city. As in Paniker's *Words and Symbols* (plate 7), Souza's lines seem to hover slightly above the ground of his colors, further confusing the spatial orientation that the viewer must adopt to understand the city. It is as if the town itself might slip off of the canvas into the viewer's lap at any moment. The vegetation seems to anchor the city, tying it to the landscape and to nature.

Thus, unlike Rai, Souza does not appear to embrace urban busyness and dynamism; his work instead points to a discord between the urban and the rural as the greenness seeps into the town, perhaps overgrowing its structures and reclaiming the human habitation. This urban-rural tension also appears elsewhere in 1950s and 1960s India, as in the valorization of village life seen in photographs of Nehru and other politicians at a "mass spinning" (Anant 1997, 43) or in the focus on rural life in many contemporaneous painters' oeuvres, from that of M. F. Husain to that of S. K. Bakre.

But here we see not merely a rural-urban split. Such stark dualities prove too simple for this work, for it depicts neither skyscrapers rising above a rural field nor a small village arranged around a tree. For the former we can look to Le Corbusier's Chandigarh, with its capitol complex isolated on the northern edge of the city, blocked from the city proper by a hill and open to the rural landscape around it (Prakash 2002, 67, 82–87). For examples of the latter, we can look to Bakre's image of a quiet town square surrounded by a well-bounded town, to Satyajit Ray's images of rural Bengal, or to Charles Correa's vision of an Indian architecture (see figures 1 and 2) (Khanna and Kurtha 1998, 62; Ray [1955-59] 2003; Correa 1996). Souza's image of urban life complicates the rural-urban distinction, acknowledging that India's urbanity not only has deep historical roots but also ranges across the spectrum from international cities like Bombay and New Delhi to large medieval cities like Varanasi. Souza's city may not even be a city: it could be a historic town or a large village. Like Paniker's images that obscure knowledge, barring us from understanding through illegible text, Souza's image relays the complicated and obscured town-country relationship as India negotiates the role of the rural farmer in the urban market or the influx of workers into major metropolises. India's relationship to towns

is fraught with an informed nostalgia, as seen in Ray's films and Le Corbusier's primitivist modernism; Souza captures that problematic in this painting.

The structures in the painting further deepen the confusion about the spatial and categorical boundaries in India that Souza's work explores. Gabled roofs, an uncommon architectural form for the subcontinent, predominate. Thus while the work purposively presents an anonymous town to us, we question its location. Are we looking at India, England, or somewhere else entirely? The locale's cultural identity comes under the microscope precisely because Souza's painting refuses to fix it for us. Again, he has captured a tension, a lack of certainty concerning the definition of "Indian." Souza's treatment of this subject matter opens up questions pertinent to mid-century Indian modernity as it struggles without the certainty of definitions. That uncertainty extends from the question of town versus country to that of India itself.

Souza's tormented—or as Yashodhara Dalmia characterizes them, "apocalyptic"—cityscapes offer a direct contrast to the overly ordered modernist cityscape of Le Corbusier's Chandigarh (Dalmia 2001, 93). Chandigarh's streets not only proceed in straight, even lines but they also follow a pattern of eight hierarchical levels based on their expected use, from cycle track to major intercity artery (Prakash 2002, 45). Souza and Le Corbusier thus offer us two very different attitudes toward the urban. Where Le Corbusier presents a progressive, hopeful modern rooted in geometric, mathematically gridded spaces, Souza undercuts this valorization in his distressed townscape, noting the interpenetration of urban and rural and presenting a more pessimistic view of the former.

Neither Souza nor Rai provides us with order in the city; we are left with two different images vying for primacy. On the one hand, the city appears bustling, industrious, and moving toward the future—yet doing so on the backs of India's laborers. On the other hand, the city melts into the countryside and is simultaneously invaded by vegetation and falling apart. Souza's city is the empty shell, devoid of the human element in Rai's image and somewhat violent in its expression. These two images are not entirely opposed to one another and provide a rather common vision of the urban during this period. Keeping Rai's Delhi and Souza's unidentified town in mind, then, I turn now to India's archetypal modern urban space, Bombay.

Whereas Madras (now Chennai) might be considered the prototypical colonial Indian city (Basu 1993; Brown 2003), Bombay is India's quintessential modern, international city. New Delhi also has an international flavor, but that element of its fabric rests much more on the city's diplomatic role. New Delhi compares to Bombay much as Washington compares to New York, or Canberra to Sydney. Bombay today is where movie stars rub shoulders with wealthy international businesspeople and where rich Indian club kids dance all night and shop all day. After independence, Bombay's character was imaged in various ways in the 1950s and 1960s, most clearly in film.

Bombay was the site of the most prominent Indian film industry, overshadowing filmmaking of earlier eras in Calcutta and the concurrent film production in southern India and Bengal. As the site of most Hindi- and Urdu-language film, Bombay's Bollywood created an image of modern India based in part on the mythos of Bombay itself, and on its contrast to the image of village India. Over the course of the 1950s, 1960s, and 1970s, the image of urban India via Bombay gradually shifted—beginning as a relatively hopeful space, but then transforming into a more pessimistic, rough locale.

A repeated story in 1950s films centers on the poor farmer, peasant, or vagabond traveling to the big city to make his fortune, or simply to work and get by. Raj Kapoor's *Shree 420* of 1955 offers one of the clearest examples of this plot (Kaviraj 1998, 150; Pinney 2001, 11; Dwyer and Patel 2002, 63). At the film's opening we encounter the hero, Raj (Raj Kapoor), trying to hitch a ride in the middle of nowhere. Having been passed by several vehicles, he feigns a fainting spell, lies across the road, and causes the next car to screech to a halt, pick him up, and begin transporting him to the hospital. Raj then reveals his deception to the wealthy Bombayites in the car, only to get thrown back out onto the highway. His moniker, Mr. 420, derives from two sources: the police label for a thief or a scoundrel, and the distance, 420 miles, he is from Bombay when he is dropped off. He covers the distance while singing the most famous song of the film, "Mera juta hai Japani" (My shoes are Japanese), traveling with camel trains, on an elephant, and by foot. Thus Raj quite literally sings and dances his way into Bombay, transitioning from an open, bucolic space into the hard-

edged, busy world of the urban through a framing gate. We move from trees framing the image to built edifices as our hero struggles to navigate the swell of people and vehicles around him (Kaviraj 1998, 151).

The narrative of the film continues to elaborate this space of Bombay as Raj asks those around him to describe the people, culture, and space he is now in. Eventually, after pawning his "honesty"—a medal he received from his orphanage back home—and having his money stolen, he wanders into a group of pavement dwellers. Here an initial altercation, in which he is buried in a pile of men, is echoed a minute later by his acceptance into the group, marked by a group embrace not dissimilar to the earlier belligerent pile. As Ashis Nandy has argued regarding these early 1950s representations of the urban, here Raj finds a village within the city—one where food is shared, family bonds are recreated among strangers, and a space not unlike a village square is carved out: "Kapoor is the ultimate street person, celebrating Bombay the way Woody Allen pays his reluctant, nervous homage to New York. Yet even in these films, the hero, while living by his wits off the street, turns the streets of Bombay into a friendly village neighborhood. . . . Raj Kapoor's Bombay, like R. K. Narayan's Malgudi, is also a tribute to a remembered village" (2001, 26). This location of a village space within the city speaks to the difficulty in the 1950s of articulating the relationship between the two spaces. The new perspective on the urban rejects earlier depictions of city life as wholly dark and utterly bereft of meaning; it instead acknowledges the camaraderie extant among those struggling to live within the city (Williams 1989, 39–44). Gandhi is often looked to as the figure who valorized the village as a central, constitutive element of India's identity, but Nandy gives Satyajit Ray the credit for moving that village element into a cinematic frame with *Pather panchali* (Nandy 2001, 19). In the Bollywood films of the 1950s, the tension between this oft-repeated image of the rural village and the problematic space of the urban street plays out in melodramatic form. Over the course of *Shree 420*, Raj must navigate a difficult atmosphere of corruption and greed to regain his honesty—both literally by buying back the medal and figuratively by doing the right thing in the end. Bombay corrupts Raj and turns him away from his created village, almost cheating his new "family" out of their hard-earned money in a fraudulent housing scheme. After unmasking the fraud and turning in his corruptors, Raj sets off to leave the city, singing the opening song once again. His true love comes up behind him, and he turns

back to the city with her: the final scene of the film frames them at the top of the hill, looking out over the city lights.

Shree 420 calls for balancing the village and the city, suggesting that one can retain one's honesty and purity in the face of the corrupt, dirty metropolis as long as one remembers to maintain villagelike familial relationships with others in similar straits. As such, the film captures one of the central tensions of the urban for the 1950s in India. At once a place of incredible danger and amazing wealth, the city represents endless possibilities for those seeking to move out of poverty. The hopefulness of the 1950s, linked to modernization and technological advance, is figured here as the vast potential of the city to increase the class status of those seeking their fortune there. In the early scenes of the film, however, this hopefulness is immediately questioned, as Raj's search for work turns up a message that work is scarce and jobs difficult to keep. Thus *Shree 420* presents disillusionment alongside Nehruvian optimism.

Indeed, the answer to any optimistic pleas is placed squarely with the government: Raj suggests to the defrauded street dwellers in a grandiose scene at the end of the film that the government will help them to find housing if they only band together and ask. Kapoor himself considered his filmmaking part of the larger project of Nehruvian social advancement, nation building, and optimism for the future (Varma 2004, 68). Ending on this oratory and with the ambiguity of a departure and partial return over the hill, Kapoor showcases the ambivalence toward the city characteristic of 1950s India. If we find the village in the city, then it can be a happy place; if we merely pursue monetary gain, we lose the central element of Indianness figured by the village space.

Where *Shree 420*'s narrative generates this optimistic yet cautionary approach to the urban, *Waqt* (1965), directed by Yash Chopra, uses a variety of visual and cinematic cues to provide a slightly different take on the city. *Waqt* engages with the issue of memory and its relationship to history as mapped onto a particular family's journey from wealth in a colonial context to dispersal in a postcolonial one. With its story line operating as a metaphor for Partition, *Waqt* creates a space for addressing the problematic transition to independence—also acknowledging the violence of that transition. In *Waqt*, as I discuss in chapter 3, the transition occurs due to an uncontrollable event—an earthquake—and the film articulates the before and after of that event through urban space and architecture. The city serves as a cue for the viewer to follow

the temporal shift of the narrative, so that the modern might be understood easily through the setting as the family slowly overcomes many obstacles on the path to reunion.

The opening scenes of *Waqt* take place in an urban space marked by Urdu signage and early twentieth-century architectural cues, for example, colonial interpretations of Indian and Western architectural decoration. The so-called baronial style of the interiors, with heavy wooden bed frames and grand mirrored halls, both indicates a temporal moment before independence and references earlier 1940s and 1950s representations of wealthy interiors in films (Dwyer and Patel 2002, 71). In *Shree 420*, for example, the wealthy businessman's mansion is decorated with grand marble staircases and ornate wooden furniture. The Urdu signage in *Waqt*, paired with archways and columns that echo Mughal designs, places this space in northwestern colonial India (Dwyer 2002, 43).

After several scenes that show the father searching for his family immediately after the earthquake, we transition from the past to the contemporary moment by following the eldest son, Raja (Raaj Kumar), as he runs away from the orphanage he has been placed in and toward us, into the future. In the next shot we see him running laterally, from right to left, now an adult. The context has jarringly changed. Rather than seeing him on a rural dirt road, we watch him jumping from flat rooftop to flat rooftop, sprinting past high-rise buildings articulated by steel and primary color patterns and running through an empty modern stadium. Finally he runs past a red convertible and into a large estate. The music for this sequence matches the visual speed and the contemporary mood, underscoring the action with a snappy rhythm.

Raja physically takes us through the temporal and spatial transformation that the family and the film go through. After the destruction of the old order, we find ourselves in a geometrically controlled rationality marked by modern materials (steel), bright colors, and right angles. Looking more carefully at this quick-cut sequence of spaces, we also see its barrenness. Raja is the only figure in all of these scenes as he dashes through the cityscape. In contrast to Raj's entry into Bombay in *Shree 420*, in which he is disoriented by the crowds and jostling of the busy street, in *Waqt* we find modern Bombay to be a space of empty architecture. This hollowness proves particularly poignant when Raja runs through the empty stadium seats. The visual composition is striking, with

the curved lines of the bleachers providing an abstract pattern for him to traverse (something Nasreen Mohamedi might have photographed), but their purpose as bleachers reminds us of his solitary status in this big, overwhelming, and cold modern space. Our first glimpse of Bombay thus stands in utter contrast to the warm scenes in the older city, where family and friends greeted one another before their storefronts and sang together in celebration of their familial relationships.

The narrative of *Waqt* takes us from this cold, transitional moment through the journeys of the three separated brothers as each of them explores his need for familial closeness in his respective economic and social context. Raja shows us not only the modern city but also an aspect of his personal situation: he runs because he is a thief, and his only friend is the wealthy crime boss whose estate he enters at the end of the scene. We follow him in the film as he faces moral challenges for the love of a woman and for that of a brother. Then we see him grow back into the generous person he used to be. At each stage, the city and its architecture underscore the transformation of the narrative and of the characters in the film.

Raja realizes that Ravi (Sunil Dutt) is in fact his long-lost younger brother Bablu only at the moment that he arrives to assassinate Ravi in his sleep. The scene opens on a flashing red neon sign reading "murphy" in lower-case separated script letters. A sheer curtain then blocks the neon as we move inside to view a darkened bedroom with Ravi asleep on his low, minimalist bed. The bed sits amid various modern accoutrements, including a sleek handset-only phone. The only light in the scene comes from the flashing neon, casting the entire bedroom in an eerie half-light. The blinking neon continues to shape the scene as Raja steps into the light with a gun in his hand, and the scene cuts between his face, the sleeping figure of Ravi, and a framed bedside picture of Ravi as a child—a child Raja finally recognizes. At that moment of recognition the flashing speeds up slightly, as does the cutting between the camera angles, heightening the revelation as Raja then moves closer to the bed. We hear his thoughts: "Mera bhai, mera bhai" (My brother, my brother).

The "murphy" sign references not only the brand name it represents—Murphy Radios—but the modernity of the entire film itself. That Ravi, the sophisticated adopted son of a wealthy family, should have his own apartment in a commercial or industrial district with neon signs reveals his status as a mod-

ern, independent man. He lives in an urban, rough space (despite the interior furnishings of his room), one that intrudes on his bedroom constantly through the pulsating red light. The choice of the "murphy" sign reminds viewers of a particular type of radio and television set from this United Kingdom–based company, one of the major manufacturers until the 1960s. Indeed, it was in the 1960s that Murphy radios and televisions began their decline as Japanese companies undercut the international market (Sully 2003). Murphy had recently changed its logo (in 1960) to a new, blockier font that reflected a more recent style. Thus the "murphy" sign gives us not only an image of the modern but also of a particular kind of modern, one already a bit retro in the mid-1960s. The neon sign thus encapsulates the period that the film traverses, from preindependence (Murphy started using the previous logo just after the Second World War) to the mid-1960s. It also brings the urban space into the interior and marks that space as stylish, technological, and international (see Grant 2000).

While both films offer similar narrative arcs—young man/men come to city to find village/family—the role of the urban in each film differs, marking an evolving sensibility of the modern from 1950 to 1965. *Shree 420* finds a small piece of the village in the city, thereby counteracting the cutthroat, destructive aspects of the strange and foreign place and finding hope even among vast economic and social inequalities. As the 1950s do more widely, the film focuses on the hope for the future, and its central question is whether the city can fulfill our hopes. *Waqt* concentrates instead on the fast-paced qualities of an already given urban, taking for granted that one might live in a city and yet also finding that space largely empty of real human interaction. Both films involve a recovery of something missing in the city environment. However, in the 1950s this meant bringing the village atmosphere into the street dwellers' lives, whereas in the 1960s it meant reclaiming a portion of preindependence hopefulness and familial closeness. *Shree 420* looks between two *spaces*; *Waqt* looks between two *times*. In doing so, these two films map a shift from the village-city tension of the period immediately following independence to a positive-yet-nostalgic image of life in the city during the 1960s.

The urban operates as a fully formed, participatory character in *Shree 420*, shaping Raj's actions and pushing him toward corruption. Bombay is not a backdrop signaling the modern; it *is* the modern. In *Waqt*, the city operates much more as a setting that cues the audience to the modernity of the film, only

making the point along the way that what makes this modernity livable is the strength of familial bonds. Thus the modernity of the city in *Waqt* plays a more contextualizing narrative role. The tension is not about whether or not the city is a good place (as it is in *Shree 420*), but about how to live in this location with its cold, hard-edged, empty spaces. We shift from the question of whether or not we should even go to the city to the question of how to navigate that already given, accepted space of the modern. This contrast is crucial for understanding the shift from the 1950s to the 1960s in India and for grasping the nation's relation to modernity in these two decades. By the 1960s the population shift to the cities was taken as a given, and the question for city planners became one of how to restructure the cities to accommodate this influx of people. In Bombay, Correa and others proposed a variety of improvement schemes in the mid-1960s, some of which were pursued later in the 1970s and 1980s (Shaw 1999; Correa 2000). While some tropes of the 1950s still occur in the 1960s—the coldness of the city, the corruption it can effect—this new modern city is now more comfortably inhabited. *Waqt* shows us the new Indian subject: one in sync with his or her surroundings, sprinting into the future, and able to move within a world of international fashion and style without losing the link to family and the past.

TOWARD A LIVABLE CITY

Waqt was made concurrently with a major development project in Bombay: the New Bombay plan shaped by Correa and his associates and carried out in modified form over the following ten years from the mid-1960s to the mid-1970s (see Kahn 1987, 44). The vision of New Bombay arose amid ongoing discussions and plans attempting to fix the city's problems. These discussions dated to the beginning of the independent Indian state, when N. V. Modak's and Albert Mayer's *Master Plan in Outline* of 1947 was published with recommendations for industrial, shopping, and residential area development in Bombay (Modak and Mayer 1947; Shaw 1999, 958). As it was not an official document, the suggestions were largely ignored; the state government had other more pressing matters to deal with. In 1961, the Study Group for Greater Bombay, formed by the state government under the chairman S. G. Barve, presented a series of recommendations based in part on the earlier Modak-Mayer plan,

recommendations that included the building of an underground transportation system, the implementation of zoning to restrict industrial development, the creation of dwellings for the poor, and other initiatives (Shaw 1999). In 1964, the Bombay municipality passed a plan to alleviate Bombay's overcrowding by expanding the city to the north, using many of the suggestions in these earlier groups' plans. This strategy followed the relatively organic growth of the city up the narrow peninsula it had occupied since colonial times, gradually extending commuting distances from the outer reaches of the city. As the Municipal Corporation for Greater Bombay (MCGB) only had purview over the peninsula, it could not recommend the expansion into New Bombay across the harbor. Business interests in the city helped support alternative plans, as the high cost of the MCGB's plan, combined with threats of rezoning, caused worries in the business community (Verma 1985). Alongside other international urban planning movements, from British new city developments to local concerns about crowding and job creation, the impetus behind creating a new city on the mainland grew. In 1965, Correa, Pravina Mehta, and Shirish Patel published a plan for New Bombay that differed substantially from earlier efforts to expand the city up the peninsula (Correa, Mehta and Patel 1965). Correa later argued that one of the forces working against the further expansion of residential areas northward was the growing number of workers who, rather than commute, would live on the street in the dense southern area of the city (Correa 2000, 116). While *Waqt* depicted the city through the wealthy classes, providing a glamorous image of parties, cars, and grand pianos, the reality of Bombay for many in the 1960s was closer to that of the street dwellers shown in *Shree 420*; they were drawn to the city in hope, yet they found it difficult to find work or a place to live.

The Correa-Mehta-Patel vision for New Bombay partially resided in the hopefulness expressed in *Shree 420*. That hopefulness helped to advance the idea of New Bombay and to express the promise of economic growth it represented. But a city cannot easily be made from nothing; besides economic and infrastructural concerns, an urban space must also have an image if it is to survive. Many cities' skylines embody this, particularly after the skyscraper booms of the twentieth century. Bombay's image, in contrast, lies in details, not in the skyline or in a particular building. We see snippets of modern-looking buildings in *Waqt*, the general street-level dwelling in *Shree 420*, and the neon light from

the industrial/commercial area, but not an overarching view of the urban that is recognizable as Bombay. Indeed, if Bombay has an iconic skyline or overarching view, it is the somewhat nebulous one that overlooks Chowpatty Beach from a park at the top of a ridge. While postcard images from this point focus on the sweeping curve of the urban space, they tend to frame that space with the bay itself and the trees of the park. The subject matter is the beach, not really the city. Bombay is therefore often represented as a city of small moments rather than of sweeping visual gestures.

In literature, for example, Salman Rushdie's portrait of the city takes in particular localities such as the Breach Candy Hospital and Haji Ali Juice Stand. Rushdie captures the city in miniature snippets, in tastes of the local street food *bhel puri*, and in the movements between these vignettes in cabs, cars, and trains (Rushdie 1981, 1989). When building communities such as New Bombay alongside this type of mythologized city, it becomes difficult to replicate such minutiae. In constructing New Bombay, then, Correa's task was not merely to replicate some sort of bay-front aesthetic Bombay embodied. New Bombay could not begin to echo the small moments Rushdie memorializes in his books. This is why New Bombay must turn elsewhere to construct its own mythology.

In early visions of the development, New Bombay would be not a bedroom community for Bombay but instead constitute its own hub of activity, or as Correa put it, its own "engine for growth" (2000, 137). This concept adapts for the Indian context new city theories from the mid-twentieth century. The metropolis of Bombay would then become a multicentered city, so that the commute would not always be down the peninsula but also possibly toward a new center on the other side of the bay. In 1970 Correa's plan was accepted in its general form, and, moving away from the more organic expansion plans adopted earlier, the state government created the City and Industrial Development Corporation (CIDCO), with Correa as the chief architect of the scheme. He held this post until 1974.

New Bombay's plan involved creating linear transportation axes served by smaller bus lines so that the area could be versatile as its population expanded (Correa 2000, 119). In addition to transport innovations, a new, sweeping coastline around a bay was implemented, providing the potential for New Bombay to produce at least an echo of Bombay's Chowpatty Beach. New Bombay's

population did not increase as much as had been hoped in the initial planning, reaching 1 million in the first few years of the twenty-first century, a time for which projections had been twice that (Correa 2000, 120). Chief among the factors limiting New Bombay's success has been uncertainty concerning the types of jobs situated in the new city. With New Bombay focused primarily on white-collar and service jobs, those working in manufacturing must still commute to Bombay, lessening the autonomy of the new development. Some critics have suggested that the idea of the new city appealed to middle-class Bombayites mired in congestion and seeking a cleaner location to buy homes, which meant that the competing vision for using New Bombay as a place for lower-income workers fell short of its goal (Harris 1978, 57).

While many factors contributed to its slower growth, one difficulty for all new cities is the lack of mythology embedded in their fabric. Bollywood films focus on the established areas of the city, and literary works expound on the charms of the Back Bay and on the bustle of the fort area. Thus while New Bombay may eventually produce an economic and physical pull similar to that of the existing urban area, it currently lacks the historical minutiae of established urban centers. These character-filled elements of city life cannot simply be constructed—nor can the power of myth be merely supplanted by the allure of clean, wide streets. Rushdie has not yet nostalgically written on the new homes on the other side of the bay. So instead, Correa has sought broader mythologies, ones that he often produces from universalization and an overgeneralization about spaces in India.

Correa's more recent construction in New Bombay therefore looks to the architect's idealized and somewhat essentialized understanding of South Asian built form: namely, that historical and "traditional" structures in South Asia are almost universally characterized by an open-to-sky space (Correa 1996; chap. 1 of the present volume). This concept centers on the idea that in India having access to open courtyard and village square–style spaces forms a crucial element of all life—whether rural or urban, religious or secular, historical or contemporary. Creating spaces along these lines is akin to turning the enclosed, box-style architecture of cooler climates inside out. Open-to-sky spaces can be found in outside space, porches, courtyards, and other shared areas in village architecture, as well as in religious structures of all types. Yet while one does find a great deal of open-to-sky spaces in India, one also finds other kinds of forms,

forms as varied as the climates and cultures of the subcontinent. Furthermore, open-to-sky architecture is not unique to India or South Asia. From the Mediterranean to Japan one can find cultures that orient their buildings in a similar manner. Thus while Correa's unifying theme certainly produces a lot of incredibly effective and fascinating architecture, it remains a generalization, to be treated with a healthy dose of skepticism.

Correa's articulation of these universals coincided with the construction of his artists' colony in Belaspur, New Bombay (1983–86). Using open-to-sky spaces, the housing produces a livable, malleable space in New Bombay. Instead of tapping into the iconic micromoments of skyscrapers, juice stands, or particular neighborhoods, the colony draws from the concept of the sky that Correa sees as universal. Each unit has a small, enclosed courtyard that opens out onto a shared area for multiple families. Dwellings are staggered so that these open spaces constitute not merely thoroughfares but also places of safety and intimacy, even in their openness. Thus, rather than engaging in historical mythmaking, Correa here turns to a physical element of Indian architecture he sees as unifying, using it to anchor the new development on the other side of the bay. Hope thus resides in his attempt to tap into some universal element of Indianness in the construction of this new landscape. The fact that New Bombay has fallen short of its goals for residents and workers reveals the problems with a reliance on such universalizing tropes.

Correa's vision of the urban has also extended to the street dwellers in Bombay. The architect sought a solution to the problem of overcrowding that would avoid the forced relocation of those sleeping on the sidewalks. Examining some of the most overused street and sidewalk spaces in Bombay, Correa in 1968 proposed constructing a platform on the edge of the road for street dwellers to sleep on at night and for hawkers to sell from during the day, thereby leaving the sidewalk clear for pedestrian traffic day and night. The proposal included water taps at intervals to allow for the cleaning of the platforms, and it provided a barrier between vehicular and pedestrian traffic. While the municipality did not adopt it, this plan shows an investment in a positive vision of the city, one in which the city offers a space of hope and growth, providing access to opportunity for all comers. The proposal for hawkers and pavement dwellers represents a moment in the thinking on urban planning that engaged with extant problems, rather than attempting to eliminate or ignore them. That the proposal

was not implemented points to the ongoing tension between hopefulness and disillusionment as figured in the cityform.

Despair sometimes imbues written commentaries on the reshaping of India's urban space. It appears in various forms: criticism of public works' architectural efforts (Hurtt 1999), analyses of the problems with "third-world cities" (Mehrotra 2000), or proposals that never come to fruition because of government or community committees. Indeed, early efforts to remake Bombay were often ignored in part because of a feeling of discouragement in the face of the overwhelming population, housing, and transportation problems (Shaw 1999). Various elements of politics, society, or the urban landscape itself are blamed for the lack of coherent planning in India's cities, and often even the question of whether to plan or not has come under review. No simple solution will ever present itself, and the complex ones are continually under debate. In some ways, then, the construction of the image of urban space matches the upheavals and roughness of the city itself.

We see some hope in images such as Rai's photographs, *Shree 420*'s importation of the village atmosphere into the center of the city, and *Waqt*'s fast-paced, alienating-but-forward-looking modern spaces. At the same time, however, the modern city must be redeemed with an injection of the nonmodern and the nonurban for it to strike a balance between modern and Indian. Each of the examples discussed in this chapter navigate the tension between some understanding of Indian, which often resides in a rural, villagelike, family-centered ideal, and an understanding of the modern, often associated with Western interior design, alienating, boxy architecture, and corrupting wealth. Paintings of the city participate in this tension as well, as I will show with an analysis of Gieve Patel's vision of the Indian urban.

HANDCARTS AND HIGH-RISES

Patel's *Two Men with a Handcart* of 1979 (plate 9) illustrates the tension between the urban and the rural often found in images of the city, and like *Shree 420* and *Waqt*, the painting shows the relation between the human and the urban.[3] *Two Men* presents a flattened cityscape, one in which the pseudohorizon of a wall cuts off communication between the foreground figures and the monumental buildings in the background. Diagonals and asymmetries heighten the dyna-

mism of the composition, encouraging our eyes to explore the wide range of architectural forms on the canvas. The two men of the title stand in conversation in the center of the foreground, backed by a luminous, multicolored, and decaying plaster wall. Their forms are abbreviated, without any indication of a body underneath the flattened articles of clothing. They lean on the handcart, which carries a large black object (an oil barrel? a black box? a stack of asphalt shingles?) and rests on its diagonal axis, with bands securing that unknown object to the cart's frame.

Patel's subject matter is difficult to pin down. That is, while clearly the two men are primary in the compositional frame, the buildings hover over them with great weight, pushing forward in the space so that one senses their immediacy and crowding presence around the human figures. If we contrast this to Le Corbusier's photograph of the construction of Chandigarh (figure 12), the effect is quite different. Le Corbusier has placed his workers in the midst of his building, without a real barrier between them and the architecture. Indeed, as they are working on the structure and not at rest, their presence coincides with that of the building itself; both are at work, in progress, dynamic. Le Corbusier's image surrounds the woman in the foreground with the fabric of his building, even recapitulating that fabric in the texture of the basket on her head and in the repetition of the wooden ramp she walks up. She is central, as are the two men in Patel's painting, but she is incorporated into the background, while they are not.

Le Corbusier's perception of the primitive in the modern meant that his structures were built for and with the surrounding peasants, not in tension with them (Prakash 2002). Patel has not given us peasants, for his figures are dressed in brightly colored, Western-style garb, while Le Corbusier's peasants are always dressed in generic "traditional" clothing of various sorts. Thus it makes sense that Le Corbusier's images of his structures include, in a holistic manner, the workers from surrounding villages. Looking back from our vantage point today, we can debate Le Corbusier's exploitation and objectification of these individuals, but we must still concede that his altruistic vision *included* them in the process, beyond their role as workers.

Patel's image gives us a different view of the modern, one that places it in tension with the human element more than Le Corbusier's ideal allows. His two men do not merely stand away from the large modern buildings in the back-

ground but they have further separated themselves: Patel uses the burden of the cart as a barrier or shield to fend off the crowding, large, empty structures. The men's comfort in this position—both of them appear at rest, chatting, their stances relaxed—indicates a general ease with the ostensible tension of modern urban life in India. Just as Raj turns back toward the city at the conclusion of *Shree 420*, these men strike a balance between the historical and the new, the technological and the backward, the organic and the built. They have found or even staked out a bit of the village in the urban, just as Raj did in the film.

Here we find the modern sweep of a building against a modernist recapitulation of a southern Indian gabled-roof vernacular architecture next to a structure that could be one of Correa's upper-middle-class housing blocks. Patel portrays a wide variety of architectural modes associated with postindependence India, from revivalist to Corbusian. Yet handcarts, so central to Rai's photograph of Delhi's bustling street, still center this world, offering the simple and effective transportation of goods and construction materials used to build these large high-rises.

Patel also uses color to alert us to the place of the men in the scene. Its coloration is perhaps the painting's most striking feature. The men are dressed in bright, primary hues—red, blue, green, bright white—and stand against a mottled wall colored sky blue, algae green, and olive. The pattern of their backdrop suggests organic, growing plants. The red of one man's shirt is echoed by the red roof of the decaying structure behind the pair, and the dark form on their cart anchors the bottom of the composition, drawing the two men together. The coloration of the remainder of the painting highlights the distinction between the men and the urban space that presses in on them. A stylized, almost mannerist pink tone permeates the entire urban space around them. This seeping pastel largely stops at the wall behind the men and does not affect their bodies or garments, which as a result pop out at the viewer in their primary color scheme. The city not only stands separate from the two men because of the physical separation via the cart. It also exists in a different color world, one that suggests fantasy and otherworldiness. As a result, only the men feel alive in the image; only they appear present and active. The structures appear empty, a feeling reinforced by this coloration. Because the buildings fill the composition, they loom over the foreground figures. This weight from the architecture is highlighted by the pink color of the sky, which extends

into the buildings, melding the atmosphere with the architecture. It is as if the space outside the foreground scene has consolidated around a pastel palette and therefore remains separate and unreal.

Patel's approach here suggests the alienation of these figures from their surrounding landscape—alienation in the sense that their immediate surroundings differ utterly from their broader context. That is, the organic, plantlike backdrop, the primary colors of the men's garments, and their own poses as they address one another stand in counterpoint to the rest of the painting. Their comfort indicates that this alienation also provides shelter from that context, a protection necessary for human-scale existence to proceed around these larger-than-life structures. Herein lies the problem with Le Corbusier's vision of the modern. Once one comes down from the ideal form—the universal that is to serve "man" and speak to the "primitive peasant"—the human scale collapses, leaving grand, empty dreams behind. Carving out a human space within this collapsed space becomes the job of the inhabitants of these cities, and as critiques and studies of Chandigarh and other urban centers have shown, this transformation is not always smooth or easy (Mehrotra 2000; Fitting 2002, 71).

Patel's attention to the local, rather than to the grand ideal, forms the core of his approach to the modern. Without denying the wealth of art elsewhere in the world, and without barring appropriation from that body of work, Patel's painting produces an image of the Indian environment. The work suggests that one must be cognizant of the local environment even in the production of images deployed for the modern. Patel calls the issue of "indigenism" "the great issue of the 1960s" (1989, 192), and explains that the debate is not about painting villagers at a well or about looking to one's immediate backyard for subject matter. He believes indigenism is important because it frees artists to work in different idioms, and Patel's realization in his essay is that India's chaotic diversity can either be brought together through unity or represented in multiplicity as long as the painter is honest to the environment itself.

The city, whether chaotic and uncontrolled like Souza's, or held at bay beyond the real like Patel's, serves as one touchstone both for the *definition* of an Indian modernity and for the *struggle* with that definition. Imaging the city means capturing the decay and desperation of many of its inhabitants while remarking on the modernization of the architecture and the bustling nature

of the city streets. But as Souza's work reminds us, the urban is not merely a foil for an ostensibly pure rural space, as the city in India takes many disparate forms and relates to the countryside in myriad ways.

If we take Le Corbusier's modern, at least temporarily, as that which most might consider a pure modernity—something that helped define the modern in the early twentieth century—then Patel's image of the city serves as one of several Indian negotiations of the modern. These are not revisions or restatements of Le Corbusier's modern but rather appropriations and reassertions of it as it operates locally. Patel's presentation of a tension between the modern buildings and the two men communicates the fraught relation of self and other; it reveals the fragmentation of space and identity. Here, rather than in the grand vision of Nehruvian industrial progress and urban growth, we have only glimpses of grandeur: we peek into what it might be and protect ourselves from it, and we depict shadows of it in our relation to the urban architecture.

OPTIMISM/PESSIMISM

Patel's painting portrays the tension within modernism in India. He describes it by leaning toward the human element in the work, emphasizing that central foreground grouping over the immense, hovering backdrop of the city. In this way, Patel's image might be seen as a critique of the urban space, as the latter demands negotiation from its inhabitants. But this chapter has focused on cities of the Bombay type: large, sprawling, crowded supermetropoles that dwarf the human element. Several other types of city exist in India, from provincial capitals to archaeological tourist sites. Thus the hypermodern, international city is not the only space of the urban in the modernist vision. The holy city of Varanasi gives us an entirely different image of urban modernism. In Varanasi modernism must take into consideration the city's millennia-long history, its centrality as a sacred site for many religions, and its importance for contemporary South Asian politics and India's national identity.

In the late 1950s, after approximately a decade of painting urban spaces with figures in them, Ram Kumar removed the human form to focus more centrally on the urban space itself. Geeta Kapur has argued that Kumar's broad city oeuvre—including works both with and without figures—underscores the alienation found in many images of the city (see also Alkazi 1978, 13). For Kapur,

Kumar's images of Varanasi articulate a "peculiar quality of alienation in the Indian experience." Kumar's work produces this "peculiar quality" by depicting the city in the background and pairing it with an empty foreground, thereby eliminating (in later painting) the human figure and depicting the urban space in a particularly two-dimensional manner (Kapur 1978a, 77).[4]

Kapur's analysis of Kumar's amalgamation of cubist, German expressionist, and abstract expressionist brushwork as a flattened space for urban alienation is convincing, even more so because it is Varanasi depicted in these works. As Hinduism's holiest city, and particularly as the endpoint of pilgrimage (whether a holy journey during life or the movement from life to death), Varanasi stands as a particular type of place. This is the city most central to a definition of Hindu identity, steeped in spirituality, and one that joins the contemporary to the most ancient. Thus choosing Varanasi to image urban alienation creates a deeper dimension than that of tension between the modern and the traditional, the village and the city. Kumar's works also engage with a discourse of spirituality, another element (perhaps in counterpoint to alienation?) often seen to be at the core of Indianness.

Kumar's painting thus shows us that the city and the urban are not foreign imports embodying part of modernization and remaining outside India's history. Varanasi has existed as an urban space for centuries, figuring as a locus of spiritual and religious belief in India's Hindu religious narratives (Eck 1982). Kumar's use of this particular city thus taps into a specific, essentialized element of a newly developing Indianness: spirituality.

In *Varanasi* (1964; plate 10), Kumar's treatment of the image distances us from that spirituality, not allowing us to immerse ourselves fully in Varanasi's spiritual element. Rather than placing us on a ghat, on a boat on the Ganges, or in one of the small lanes of the urban space, we instead have an odd view of Varanasi. We are positioned in the middle of a wide road or lane. The troubling form of the wide thoroughfare contradicts preconceptions about Varanasi as a warren of small streets; the open space suggests, in fact, a river, not a street, as it flows down the right side of the composition toward the viewer. I suggest that the thoroughfare might read simultaneously as a road (the primary reading) and a river (the secondary and metaphorical reading). The gate at top right precludes our understanding of this space as a river, as does the color: the entirety of the painting is worked in dark tones: ochres, browns, and a few

moments of green. These dark moments find some relief in the slightly lighter riverine street, still executed in grays, browns, and some cream tones. But the way in which the road presses against the houses, and the dynamism of the brushstrokes within it, point to a watery nature. It is as if the Ganges nearby so permeates the city's identity that its roads are figured as rivers. Indeed, during floods and monsoons this quite literally becomes true. This wide open space thus operates both as a street and as a symbol of the Ganges flowing through the town itself, marking its spaces with its magnetic presence.

The buildings crowd together, but unlike other images of ruins or of Varanasi in Kumar's oeuvre, here the crowding is alleviated by a dark open space behind the initial grouping on the edge of the thoroughfare. This calls to mind that Varanasi does have small open areas behind the initial crush of medieval streets. Indeed, Varanasi's urban landscape is incredibly varied, from the densely packed lanes behind the ghats to the planned pathways of the university campus in the north and the spacious streets of the colonial civil lines in the south.[5]

The buildings in the image are produced through a series of blocky forms, giving us triangular and rounded pediments atop square openings, either windows or doors. Like the experience of floating down the Ganges, here the architecture of Varanasi challenges us head on, barring penetration. The flatness of the space Kumar presents highlights this barrier. One finds small squares parallel to the picture plane, even as the diagonal of the river/street moves through them. The effect is of huddled buildings facing the viewer to form a unified front against any penetration of the space. Despite the blocky form of the buildings, Kumar handles the paint in such a way as to give the structures a dynamic, shimmering quality (Kapur 1978a, 79). The brushstrokes on the thoroughfare completely differ in weight from those in the architecture, causing it to pop forward and threatening the buildings in its scale, as if it were about to overtake the entire town. It is as if Kumar gives us Varanasi as it is: the spiritual weight of the Ganges overshadowing the small, empty warrens of the medieval city. Despite the ambiguous, multifaceted nature of the thoroughfare, the Ganges remains the focus, with the city putting up barriers to the visitor, resisting penetration and understanding.

The painting treads the line between a recognition of the image as a cityscape and as a completely abstract form, suggesting the way in which pilgrims

to the city might seek transcendence from the mundane world. *Varanasi* uses the notion of spatial flatness and references to cubism to provide at once an image of India's movement toward the future, a search for some sort of purity through abstraction, and a melding of the subject matter with the style—gestural brushstrokes that produce tension between this world and the unrepresentable, spiritual one.

That the image of the holy urban remains devoid of humans and separated from the viewer adds a further modernizing dimension to Kumar's work. In light of a push for the secular within Indian politics and of a dynamic that proclaims reason over the spiritual, this painting walks the line between the two, suggesting that modernity in India cannot fully cast off religious thinking in its quest for purity of reason. At Varanasi, Kumar invites us in with the overwhelming, dynamic river-street, but he simultaneously sets us back with the buildings on its "banks." His work depicts the struggle between, on the one hand, India's ancient, central figure of the Ganges and, on the other, the humanmade structure of the urban. Figured in semirepresentational, painterly abstraction, Kumar's spiritual city exists on the border between the spiritual and the material—squarely, then, within an Indian modern.

BOMBAY/VARANASI

Kumar's painting of Varanasi provides us with a different kind of urban than the Bombay images discussed earlier in this chapter. Urban historians have long acknowledged a wide range of nonrural areas in their analyses, from small towns to sprawling metropolises. In the context of postindependence India, only particular kinds of urban areas are included in the discussion. In chapter 1, I discussed the trope of the village, in particular the space of the central gathering area and of the tree. This small-town space is joined by two kinds of cities in this chapter: the modern, international megalopolis and the sacred city. Capital cities, such as Delhi or Chandigarh, also figure in the story of the modern in India, but they do so not as cities, but as architectural statements. In chapter 2 I examined the iconic elements of buildings in New Delhi, and in chapter 4 I analyzed Le Corbusier's capitol complex at Chandigarh. But these are not treated as urban spaces in the imagination of the modern for India during the decades after independence. Instead, Bombay, the site of film studios and of the hopes of

immigrants from the countryside, serves as a location for the imagined modern Indian urban. On the other end of the spectrum, Varanasi taps into the centrality of spirituality as a defining element of Indianness. Because the "holiest city in India" serves as a site for the articulation of a specifically *Hindu* national identity, Kumar's intervention into its spiritual identity and his rearticulation of the city as modern takes on particular political salience. The image of Varanasi allows a modern Indian idiom to dodge the choice between reason and religion, situating an Indian modern within a conception of the sacred. Images of bustling intersections and of towns unsure of their border with the landscape—as seen in the works of Rai and Souza—draw out the negotiations between the individual and the city and between the city and its surroundings.

Neither Bombay nor Varanasi, as constructed here, offers an unproblematic picture of modernity in India. Whether it is the brothers in *Waqt* struggling to find their moral center in the face of fabulous interior design and architectural experimentation, or the energy of the brush as it suggests the tension between the Ganges and the city in *Varanasi*, the works presented in this chapter express the tensions involved when inhabitants of these cities must navigate the modern urban Indian space. Perhaps Kumar's turn to abstraction, his elimination of the figure, best depicts the emptiness of modernity, or perhaps his work best taps into the universality that India's spirituality promises. Maybe *Waqt*'s snappy soundtrack and sprinting figure allow a glimpse into the modern Indian city, or perhaps that is best given by the bustle of the intersection photographed by Rai. In each of these cases, contradictory elements are brought together in a fragile balance: chaos and order, history and the present, family values and individualism, the pure village and the corrupting city, spirituality and materiality. The modern urban space in India might best be expressed by Patel's painting: an image of manual laborers using their handcart as a barrier against a backdrop of looming buildings—yet somehow remaining comfortable with this tension.

THE 1980S AND AFTER

 THE PARADOX THAT DRIVES this book and shapes the art within it largely falls away after 1980—not because it has been resolved but simply because it grows increasingly irrelevant. The period between 1947 and 1980 saw artists working through the difficult position that the paradox created, attempting to be impaled neither on the horn of indigenism nor the horn of universalism. The works of this period, by their very attention to the question of how to be modern and Indian simultaneously, produced varied strategies for negotiating postcoloniality in all its complexity.

Rather than isolating these works in their Indian context and claiming a separate but somehow equal Indian modern, I have instead acknowledged that they participated in Euro-American modernism. This participation is not akin to splashing in the already-existing pool of Europe's "masters," but instead means sharing in the production of modernity itself. Following Dipesh Chakrabarty and Timothy Mitchell, I strive here to acknowledge the dependency of modernity on colonialism and its aftermath. The works discussed throughout the book reveal the attention to this dependent relation during the decades after independence.

K. C. S. Paniker's *Words and Symbols*, for example, engages directly with the question of knowledge making, mounting a critique of science and knowing that centers both colonial efforts to control India and the development of modernity itself. Satish Gujral's Belgian embassy addresses India's postindependence relationship to its history, acknowledging that the historical narrative has been in large part constructed through colonial lenses and reconstructed through Hindu nationalist ones. Charles Correa's Corbusian/Kahnian Gandhi ashram in Gujarat negotiates the inheritance of these modernist icons by melding a faith in pure form with the spirituality it asserts in Gandhi's pilgrimage site. Ganesh Pyne draws on narratives of Chaitanya and on iconic biblical moments to present an image of alienation, death, and despair, plugging into a Bengali nationalist idiom and marking the location of so-called Western elements firmly within the subcontinent. The photography and drawings of Nasreen Mohamedi stage the modern in their abstraction, seemingly intersecting with internationalism; they also, however, articulate a relation to India's nation building, to its historical spaces, and to its investment in knowledge disciplines such as mathematics and geometry.

All of these works help bring to light the difficult terrain of postcoloniality. To live both with a colonial past and with the asymmetrical economic and political relations to Euro-America even after independence, these works have struggled to articulate an Indian subjectivity. We also see—in the humanity of Mohamedi's wavering line, the temporal layering of Paniker's oil paint, the escapist glances of Apu in Satyajit Ray's *Pather panchali*—the production of a path through the postcolonial paradox. Such a path seeks to embody Indianness and modernity at once. Some works take on the fragmentation directly, while other objects, like Achyut Kanvinde's Dudhsagar dairy complex, reshape existing modernist modes of visual culture toward a new end. Each of the works in the book reveals a different piece of the ever-partial "solution" to the postcolonial puzzle.

In addition to demonstrating India's continued fraught relation to Euro-America, the works reveal, when brought together, another aspect of the paradox: that Indianness itself is no less constructed than modernity. Each work offers a different view of what India might mean. Each view is bound up with historical and essentialist baggage, but it always moves away from that baggage as well. M. F. Husain's *Under the Tree* reframes that central icon of the Enlight-

ened One or the teacher, demonstrating how Indianness resides not in that central trope but instead in the layers of meaning surrounding it. Raj Kapoor's *Shree 420* shows us divisions within India and marks the city both as Other and, ultimately, as appropriated as Indian by combining the village and the urban. To produce India in these early decades after independence, the visual culture of the subcontinent struggled to work through the India/modern paradox, acknowledging that neither side of that dilemma could be understood outside the struggle itself.

I have examined these works closely, probing them for the ways in which they articulate the paradox of Indian modernity. They do not provide answers, nor for the most part do they attempt to. Rather, they work to understand what it means to be Indian and modern, and therefore what it means to exist in relation to a colonial past and a Euro-American–centered present. In their acknowledgment of the dependence of modernity on the colonial, they reveal how—to quote Chakrabarty's title—*provincial* Europe is. Europe's unmarked paradox, its inheritance of colonialism and its struggle with the postcolonial, finds its articulation here in the negotiations of the Indian modern.

AFTER THE INDIAN MODERN

Since the early 1980s, a new generation of artists, architects, filmmakers, sculptors, patrons, and critics involved in the visual arts has risen to prominence on the art scene. As inheritors of earlier generations, both nationalist and post-independence, these producers of India's visual culture now ask and answer different questions, address related but new paradoxes, and thus work in an idiom rather distinct from that examined in this book. Many elements of the scene changed after 1980, while others became solidified into norms against which artists and architects work. Politically and socially, India faces a variety of new challenges, perhaps exemplified by the rise of Hindutva and a series of destructive communal incidents. Thus, like the somewhat artificial break of 1947, the end of this book, at 1980, carries with it both continuities and discontinuities.

Painting continues to be the medium of prominence, and several galleries remain patrons of both the new and the old generations. Publications promote artists' collectives such as the Progressive Artists' Group of Bombay, monographs on architects and painters have begun to appear, and gallery shows are

now often published in lavish color catalogues. Geeta Kapur leads a group of critics, curators, historians, and gallery owners in the study of modern Indian art, and new periodical publications such as *Art India* provide a focused examination of the current scene in India and abroad. Much as earlier grand exhibitions had shown the world the cultural wealth of Britain's colonial possessions, the mid-1980s Festivals of India introduced the globe to what was happening in Indian art *right now*, alongside the expected imagery of ancient and folk Indian visual culture (Prakash 1994, 216; Dalmia 2002, 4). New institutions such as the Heritage Center in Delhi and the National Gallery of Modern Art in Mumbai (opened in 1996) provide exhibition spaces for both painting and new media.

India's economic growth—seen in the 1980s, but particularly important since the liberalization of trade rules in the early 1990s—supports the expansion of India's art scene including installation, performance, film, and video. Whereas the cost of equipment and the availability of gallery space limited earlier experiments in this direction, works in film and performance are now, since the mid-1980s, central to the Indian art scene. In addition, artists are moving out of the gallery through street-art movements and the installation of ephemeral works in Mumbai, Karachi, and New Delhi.

This media shift is matched by a generational gender shift as the center of gravity for contemporary Indian art consists in large part of a group of women artists exploring issues of the body, femininity, sexuality, and the construction of "woman" in the Indian context. As posing these questions became more acceptable and accepted, a wider range of artists (women and men) also began to explore the formerly taboo subjects of sexuality and gay culture in India. New questions about gender and sexuality are entering into the discourse of contemporary Indian art, displacing the questions of the earlier generation.

India's mid-twentieth-century emigrant population also plays a major role in this period as it begins to produce art focused on questions of postcoloniality in the different context of the diaspora. In some ways this development marks a continuity with the generation after independence, as many artists permanently relocated to Europe or the United States in the years under discussion in this book. The difference after 1980 is that this new generation *has grown up* in the diaspora, whether in London, Nairobi, Perth, or New York. Its members' work addresses very different transnational issues than those concerning the earlier generation's negotiation with international modernism. Identity poli-

tics, multiculturalism, and standpoint epistemologies all shape questions for artists in the diaspora through the 1980s and into the early 1990s.

A growing group of patrons in the diaspora have also shaped the direction of Indian art after 1980, as they now have enough wealth to purchase works of art, decorating homes with a particular type of Indian imagery. As the market for Indian art grew throughout the 1980s, the canonization of the Progressive Artists by the nonresident Indian (NRI) community echoed the beginnings of canon making in the Western academy. Textbooks published in the late 1990s and early 2000s include chapters on art after independence that tend to focus on the contributions of a few key artists associated with the Progressive Artists' Group and on regional schools such as that in Bengal or Baroda, alongside brief mentions of women artists and art in the diaspora (Dehejia 1997; Mitter 2001).

Post-1947 architecture has largely been treated as a separate category in these works. Greater experimentation can be found in architecture after 1980, in part due to a rise in wealth on the subcontinent and to an increasing interest in Indian architects for commissions outside South Asia. Major hotel complexes, educational institutions, and apartment high-rises were built in the 1980s and 1990s including, for example, Charles Correa's 1993 design for India's Permanent Mission to the United Nations building in New York (Sirefmann and Collie 2001). City planning and the provision of housing for the poor have continued in India, and many projects planned during the 1960s and 1970s came to at least partial fruition in the 1980s and 1990s. New Bombay was built during the 1980s, and new projects to reclaim the mill lands in Mumbai are currently under discussion in a manner not seen during earlier decades.

New questions, conundrums, and paradoxes face those participating in the art world of India today, alongside some continuing questions addressed in this book. The emphasis is different now, however, as the centrality of the paradox of how to be modern and Indian is less poignant. India's existence as a nation is no longer in question. Its relation to the West still depends on a postcolonial inheritance of colonial attitudes, but it does so without as pressing a feeling of "not yet" as had existed in those first decades after independence. The international art scene has also shifted focus, acknowledging at least in part the importance of Asian, African, and Latin American art to contemporary visual culture. International exhibitions and biennales have shaped the dialogue among vari-

ous regions, which now themselves are coming under fire as we begin to sense hints of a postnational art world (Kapur 2005).

It is not that the question of how to be both modern and Indian has been resolved. We do not—and cannot—have a neat, clean resolution to the paradox of modern and Indian posed at the beginning of this book. As each chapter and each example presented here shows, the paradox served as a productive problem that artists, architects, and others negotiated during the decades after independence. Looking to internal Others via folk art or tantra, addressing questions of modernization through geometry, concrete, or scientific discovery, raising the issue of the authenticity of the village or the corruption of the urban in a postindependence context, exploring the centrality of iconic imagery or narrativity for Indianness: the works discussed here use such paths to navigate the paradox of the modern and the Indian. Later works may touch on the same themes and delve into the question of Indianness and modernity, and that fundamental issue will always remain in the background for India and its visual culture. Nonetheless, the later works do not take the paradox of the Indian modern as their central question, but treat it rather as a subsidiary issue underlying new complications. On the foundations of the explorations of modernity in Indian art, the new generation faces the twenty-first century able to break apart colonialist assumptions, to describe more fully the postcolonial condition, and to address India's new presence in the world.

INTRODUCTION THE MODERN INDIAN PARADOX

1 The beginnings of this move can be seen in Homi Bhabha's work (1990, 1994). Arjun Appadurai has a slightly different focus, as he takes on the question of globalization in relation to both modernity and the postcolonial (1996). The outlines of postcolonial theory are varied, and many of its proponents have been criticized for falling into the universalizing trap of modernity, extrapolating from one region to the whole. My work focuses specifically on India, and while its conclusions can be discussed in relation to India's diaspora, to other states in South Asia, and, comparatively, to other postcolonial regions, the book itself remains engaged with India alone.

2 Sandra Cate's book (2003) on contemporary Thai art takes this approach.

3 For a further introduction to the debates in postcolonial theory and its relation to colonialism, Ania Loomba's *Colonialism/Postcolonialism* (1998) offers an excellent overview of the key issues. Several edited volumes and anthologies collect the writings of major authors including Gayatri Spivak, Franz Fanon, Homi Bhabha, and others. See Williams and Chrisman 1994; Afzal-Khan and Seshadri-Crooks 2000.

4 I focus here on Chakrabarty's reading of subaltern studies, rather than generalizing to subaltern studies as a whole, so as not to oversimplify a movement that has become more diverse in its focus as it has acknowledged and incorporated feminist and poststructuralist critiques. As my intellectual debt is largely to Chakrabarty, and not subaltern studies broadly, I discuss him specifically here.

5 Kapur's work on the postindependence artists is long-standing, in-depth, and formative for the field. Much of my own work here would not have been possible without her rigorous scholarship and theorizing. Her essays collected in the volume referenced here are mandatory reading for those interested in contemporary Indian visual culture.

6 This knife-edge of modernity and modernization has presented further problems concerning the relationship between popular art and discussions of modernity. See Jacob 1999.

7 Partha Chatterjee's critique of Benedict Anderson parallels the argument outlined here, as he suggests that Anderson's modular approach to the imagining of the nation reinscribes the privilege of Euro-American nation formation. Other regions'

nation-building efforts are thus only variations on that primary model. See Chatterjee 1993, 5–6; Anderson 1991.

8 The death toll from Partition has been estimated in a range from two hundred thousand to 5 million, with most estimates hovering around five hundred thousand (Pandey 2001). As Gyanendra Pandey has pointed out, however, the number of casualties has proven very difficult to ascertain and remains the site of rumor and guesswork (2001, 89; see also Das 2007). In addition to the deaths, millions of South Asians (some estimate 12 million; see Butalia 2000) migrated from their home regions to the other side of the new border, splitting up families and contributing to widespread poverty.

9 For Ravi Varma, nationalism, and the focus on Hindu subjects, see Mitter 1994.

10 See Tapati Guha-Thakurta's work (1992) for the interconnections among so-called traditional arts, urban-based popular art such as prints, and the new national movement within visual culture in Bengal.

11 Because this book focuses on the period prior to 1980, I follow the naming of cities appropriate to this period. Thus instead of the current usage of Mumbai, Kolkata, and Chennai, I have used Bombay, Calcutta, and Madras, respectively.

12 See Dalmia 2001 for an in-depth discussion of the Progressive Artists' Group.

13 Yashodhara Dalmia's book looks at each of the Progressives (2001); Karin Zitzewitz's dissertation (2006) engages with many of the Progressive artists as well, situating them within the wider context of art, politics, and culture in 1940s–1980s India.

14 One of the important contributions of the national Lalit Kala Akademi has been the ongoing publication of a journal devoted to contemporary art, *Lalit Kala Contemporary*. Like many national academies, the Lalit Kala Akademi also served as an institution whose standards and exhibitions were seen as discourses to work against.

15 Sheikh's book (1997) on the art school in Baroda is the authoritative volume on the institution and its many artists.

16 For more on the history of the biographical method in art history, see Mansfield 2002, particularly the essay by Greg Thomas.

17 Dalmia 2002 and Dalmia et al. 1997 both include short biographies of many of the artists discussed here. Architects' biographies are more difficult to find, particularly in cases where buildings were built largely under the Public Works Department purview. However, Charles Correa has been the subject of several monographs (Correa 1996; Kahn 1987; Cantacuzino 1984), and Satish Gujral has published his own autobiography (Gujral 1997). At appropriate points throughout the book, I point to monographs that include, among other information, the biography of the artist.

1 For more on Satyajit Ray's work, see Cooper 2000; for more on Ray's biography, see Robinson 2004. For Correa, the major monographs are Correa 1996 (with an introduction by Kenneth Frampton), Cantacuzino 1984, and Kahn 1987. Husain's work can be found in most monographs on contemporary Indian art; see especially Dalmia 2001. For his biography, see Kapur 1978a; see also his poetic autobiography, Husain with Mohamed 2002.

2 For more on the authentic and its repercussions in twentieth century Asian art, see Vishakha Desai's reflections (1995) on the "Asia/America" show (Machida 1994), and Ajay Sinha's critique (1999) of the "Traditions/Tensions" show (Poshyananda 1996).

3 The term *communal* differs in usage depending on its historical and geographic context. Whereas in European studies it usually refers to the unity of a community and to activities undertaken by that community, in South Asia and other limited cases *communal* refers to the construction of uniform religious identities in tension and in conflict with other religious identities. In South Asia this most often takes the form of Hindu-Muslim conflict. Communalism and the use of this term in its South Asian context have roots in preindependence colonial categorizations of populations according to religious community. Both Gyanendra Pandey (1990, viii) and Nikki Keddie (1998) have discussed the misleading nature of this term. See also Raychaudhuri 2000, 275.

4 Geeta Kapur (1978a) has characterized this decade as his village phase. While this early period certainly sees a concentration of village-related imagery, Husain's work never quite leaves these themes behind, and his paintings begin instead to link such images to other kinds of narratives such as the *Mahabharata*, to major historical figures, or in his more recent work, to icons like Gaja Gamini and other goddess figures.

5 For reproductions of these and other Husain images, see Kapur 1969; 1978a; Elliot and Alkazi 1982; Alkazi 1978; Dalmia et al. 1997; Bean 1999; Dalmia 2001, 2002.

6 Of course, Gandhi's ideal of small village democracies cannot be collapsed into an essentialized vision of India's village life, as it attempts to differentiate itself from the diverse patriarchal *panchayat* systems in use in rural India. Nonetheless, Gandhi's rhetoric of panchayat raj anchors one vision of India's hope for nation building within the village. See Bondurant 1988, 149–50.

7 Both Kahn and Le Corbusier saw the sacredness in the relation of the material to the spiritual: Le Corbusier in terms of the clarity of concrete or the "miracle of ineffable space" (Prakash 2002, 94; Doshi 1993, 4), and Kahn in terms of the simplicity of material and form (Doshi 2002, 21).

8 Compendia of these exhibitions include Doshi 1983; Jayakar et al. 1985; Mathur 1987.

9 See Coomaraswamy [1934] 1956; 1957; for Havell and others see Mitter [1977] 1992.

TWO THE ICON

1 See chapter 1 for a definition of *communal* as it is used in the South Asian context.

2 Some exceptions to this include the Baha'i Temple in southern Delhi by Fariborz Sabha (1986) and several mosques in Bangladesh and Pakistan (see Kahn 2002 for examples).

3 For more on these artists, see Brown 2005; Sen-Gupta 2001; Tonelli 1985.

4 This was the subject of a pair of panels at the Thirty-First Annual Conference on South Asia in Madison, Wisconsin, October 2002, as well as on the panel "Hidden Away: Tantrism and South Asian Art" at the meeting of the Association for Asian Studies, in New York, March 2003, which included yet-to-be-published work on tantric art and its relationship to political patronage and politics. The panel included studies of the Kanchipuram temple by Padma Kaimal and work on the terracotta imagery of Gaudiya Vaishnava temples in seventeenth-century western Bengal by Pika Ghosh.

5 Primitivism, as a label, most obviously carries negative connotations for the art or culture to which it is applied, in the sense that it labels a group of people as the opposite of civilized, the term against which *primitive* is defined. However, many European modernists, in appropriating the arts then called "primitive" from sub-Saharan Africa and the Pacific, employed the term in a more romanticized light, criticizing Europe for being too civilized and out of touch with the essential core of humanity. Rabindranath Tagore's and others' appropriations of tribal aesthetic productions from within India operate as modernist moves in this double-edged mode. The urban elites of India here take the place of the Euro-American modernist, appropriating a culture seen as purer and more authentic than their own. The designation as "tribal" differentiates groups like the Santals from other class-, caste-, or region-based distinctions, placing them in an utterly separate category from the urban Bengali on the basis of religion and language, among other factors. While in its mainstream form the appropriation of primitivism supports a certain elitism and reifies the distinction between the civilized and the primitive, in some cases artists have worked against this as part of people's movements from the Left. For primitivism, see Hiller 1991; Antliff and Leighton 1996; for arguments regarding primitivism in Bengal in the early twentieth century, see Kapur 1998.

6 The educational retreat at Shantiniketan was founded by Rabindranath Tagore in 1901; the art school there was established in 1920; and its transformation into a university occurred in 1951 (Clark 1998, 83).

7 Bose had moved from Calcutta, with its romanticized, historical idiom, to Shan-
 tiniketan, and in his later career he pursued a more folk-centered idiom. In both
 cases, he used a range of watercolor and tempera techniques (Clark 1998, 81–84).
8 The spelling of the architect's name varies substantially in publications, from R. L.
 Ghalot (Evenson 1989, 225) to R. I. Geholote (Lang, Desai, and Desai 1997, 206)
 and Ramprakash L. Gehlote (Lang, Desai, and Desai 1997, 335). On consultation
 with several colleagues, I have settled on the most common transliteration of this
 particular family name, Gehlot.
9 This is not meant to equate the postmodern and the postcolonial, but to make a
 connection to the architectural moves of the 1980s in the United States, in which
 monumental versions of classical columns decorated the surfaces of otherwise
 plain structures.
10 For more on Kaneria, see Sharma et al. 1996; Sheikh 1997.
11 While I acknowledge that this iconography can be problematic when analyzing
 ancient forms (see Lohuizen-De Leeuw 1949), this twentieth-century sculpture
 would make reference to the popularly accepted understanding of the protru-
 sion.
12 In addition to Kapur's chapter on Khakhar (1978a), see also Hyman's excellent
 volume on Khakhar's work and life (1998).
13 The Emergency was a period of martial law enacted by then prime minister Indira
 Gandhi. See Metcalf and Metcalf 2001, 250–52.
14 *Hindutva* is a neologism coined in the 1920s meaning "Hinduness." It is used to
 describe Hindu nationalism both by those who advocate it and by those who criti-
 cize it.

THREE NARRATIVE AND TIME

1 For the notion of discovery as articulated in the colonial framework, see Singh
 1996, especially the introduction, 1–19.
2 For more on Khanna, see Dalmia 2001; Khanna 2002; Sinha 2002, 2006. For Pani-
 ker see Paniker 1971, 1972; Dalmia 2001; Panikkar 2003; James 2004. For Gujral,
 see Gujral 1997; Sinha, Datta, and Bhatia 2006. For Chopra, see Dwyer and Patel
 2002; Dwyer 2002.
3 Khanna has painted several works on the theme of the Last Supper. For more
 discussion of these, see Dalmia 2001.
4 Geeta Kapur has argued that instead of a progression from modern to its critique
 in the postmodern, India embraces a postmodern sensibility in advance of the
 modern. This is due in large part to the fragmentation of time mentioned above,
 as well as, ultimately, to the postcolonial condition, which precludes an episteme
 of unity, universality, and perfection found in modernism. The secularism em-

bedded in modernism is also on shaky ground in India's twentieth-century visual culture, another mark against the possibility of fully embracing modernity. I am arguing in this book that India does grapple directly with the modern (and I do not think Kapur's thesis precludes this either) in that visual art practitioners in the first decades after independence engaged with the question of how to be modern. They often did not succeed in finding a path toward an Indian modernity, but the question itself proved central in this period. By 1980, when the Belgian embassy was being designed and built, a new sensibility had begun to take shape, one that recognized the failures of trying to embrace modernity within the postcolonial context. It is here that I find Kapur's argument compelling and helpful. See Kapur 1993; Das Gupta and Panikkar 1995.

5 Rachel Dwyer remarks briefly on this metaphor; see Dwyer 2002, 43.

6 The audience of *Waqt* would have included the urban middle and upper classes, but film viewing extended across India, even to nonurban areas. The cinema industry had been long established in small villages by the mid-1960s, and film viewing was a relatively widespread practice. Thus these movies speak to a rising urban middle class as well as to rural audiences.

FOUR SCIENCE, TECHNOLOGY, AND INDUSTRY

1 I discuss this concept of "not yet" more fully in the introduction; I derive my understanding of modernity's temporality from Dipesh Chakrabarty (2000).

2 India's path to modernization unfolds in contrast to Japan's trajectory during the Meiji era (starting in 1868). Japan sought out Western elements for architecture, industry, and art, bringing European experts to Japan and sending Japanese scholars, artists, and architects to Europe to appropriate the best of European technology and art. India's modernization process began under colonial rule and continues after independence with an awareness of the dangers of Westernization.

3 For more on Le Corbusier's time in India and particularly at Chandigarh, see Prakash 2002. For Paniker, see Paniker 1971, 1972; Dalmia 2001; Panikkar 2003; James 2004.

4 Concrete, while taking its form from earlier materials such as mud brick and Roman building techniques using cement, does not truly become what it is today until the late nineteenth century, when steel reinforcing increased the tensile strength of the medium and allowed for its use in quintessentially modernist technological marvels such as bridges.

5 Oil, of course, is not entirely modern in the same sense that concrete is. Oil dates to the fifteenth century in northern European painting. Acrylic would more closely parallel concrete, as its invention in the 1950s ushered in a new direction in painting based on the easier availability of bright colors and the malleability of

the synthetic plastic- and water–based medium. However, the use of acrylic in India is limited, possibly due to a lack of supply in its early phase. Artists such as S. H. Raza, who relocated to France, had better access to this medium, and thus we find it more often in the work of Indians who reside in the United States or Europe. Even so, acrylic has had a difficult time establishing itself as a medium for painting, with many artists of all regions turning to oil as a marker of legitimate art. In India, oil is the ostensibly Western medium of choice, just as concrete is the Western medium used by Le Corbusier.

6 For more on Mohamedi's life, see Kapur 2000; Atlaf 1995; Campbell and Watson 2000.

7 Mohamedi never showed her photographs; they exist both as works in themselves and as visual sketches for her drawings. Mohamedi's focus on her drawings in exhibitions perhaps reveals some of the bias against photography during this period in India. Many artists at the School of Fine Arts in Baroda (now Vadodara) took photographs, most notably Jyoti Bhatt and Raghav Kaneria, and their photos now appear in books about Baroda (see, e.g., Sheikh 1997). But none of these artists are known primarily for their photography. This is now, in the early twenty-first century, changing.

8 For more on Kanvinde, see Ashraf and Belluardo 1998.

9 For more on Janah, see Rahman 1998; Anant 1997.

10 For an in-depth discussion of the development of this particular piece of clothing and its political import, see Tarlo 1996, 62–93.

11 There are at least four other men in the image: two standing behind the silhouetted figure, one in the glass booth directly above him, and another, barely discernable, in the top right quadrant of the image standing on a steel girder.

12 Janah's background as a photographer for the Marxist party certainly colors his images. While he was not employed by the party when he took this image, his overall oeuvre shows sensitivity to the plights of the worker and of the rural farmer.

FIVE THE URBAN

1 Because I discuss both the constructed image of the city and Bombay's pre-1980 planning concerns in this chapter, I use the city's pre-1995 name, Bombay, rather than its new moniker, Mumbai (see Varma 2004).

2 For more on Souza, see Kapur 1978a; Delhi Art Gallery 2001a; Dalmia 2001.

3 For more on Patel, see Dalmia 2002; Patel 1989. I have provided the date based on the Peabody Essex Museum's records, which are drawn from discussions with the artist when the painting entered the collection. Patel has suggested to me in personal communication that the date may be slightly earlier, in 1976. It has also been published as dating to 1974 (Dalmia et al. 1997, 224). This variation in dates

and memories reflects the impossibility of pinpoint accuracy when working on this material.

4　In addition to Kapur's 1978a chapter on Kumar, see Gill 1996 for more information on the artist.

5　Many cities in India have areas designated as "civil lines," a colonial term for the residential area built for British civilians.

Abbott, Guy Mannes. 2000. "Indian Blooms: Seeding a Globalized Language of Art." In *Drawing Space: Contemporary Indian Drawing*, ed. Sarah Campbell and Grant Watson, 18–23. London: Institute of International Visual Arts.

Afzal-Khan, Fawzia, and Kalpana Seshadri-Crooks, eds. 2000. *The Pre-occupation of Postcolonial Studies*. Durham, N.C.: Duke University Press.

Ahmed, Akbar S. 1992. "Bombay Films: The Cinema as Metaphor for Indian Society and Politics." *Modern Asian Studies* 26, no. 2: 289–320.

Ahmed, Sharif Uddin, ed. 1986. *Dacca: A Study in Urban History and Development*. London: Curzon Press.

Alkazi, E. 1978. *M. F. Husain: The Modern Artist and Tradition*. New Delhi: Art Heritage.

Almond, Philip C. 1988. *The British Discovery of Buddhism*. Cambridge: Cambridge University Press.

Altaf, ed. 1995. *Nasreen in Retrospect*. Bombay: Ashraf Mohamedi Trust.

Alter, Joseph S. 2000. *Gandhi's Body: Sex, Diet, and the Politics of Nationalism*. Philadelphia: University of Pennsylvania Press.

Ameen, Farooq. 1997. *Contemporary Architecture and City Form: The South Asian Paradigm*. Mumbai: Marg.

Anant, Victor. 1997. *India: A Celebration of Independence, 1947 to 1997*. New York: Aperture.

Anderson, Benedict. 1991. *Imagined Communities: Reflections on the Origin and Spread of Nationalism*. 2nd rev. and ext. ed. London: Verso.

Anderson, Perry. 1998. *The Origins of Postmodernity*. New York: Verso.

Antliff, Mark, and Patricia Leighten. 1996. "Primitive." In *Critical Terms for Art History*, ed. Robert S. Nelson and Richard Shiff, 217–33. Chicago: University of Chicago Press.

Appadurai, Arjun. 1996. *Modernity at Large: Cultural Dimensions of Globalization*. Minneapolis: University of Minnesota Press.

Appadurai, Arjun, and Carol A. Breckenridge. 1992. "Museums Are Good to Think: Heritage on View in India." In *Museums and Communities: The Politics of Public Culture*, ed. Ivan Karp, Christine Mullen Kreamer, and Steven D. Lavine, 34–55. Washington: Smithsonian Institution Press.

Appasamy, Jaya, ed. 1972. *Twenty-Five Years of Indian Art: Painting, Sculpture, and Graphics in the Post-independence Era.* New Delhi: Lalit Kala Akademi.

Archer, W. G. 1974. *The Hill of Flutes: Life, Love, and Poetry in Tribal India; A Portrait of the Santals.* London: Allen Unwin.

Artists' Handicrafts Association of Cholamandal Artists' Village, et al. 1974. *Indian Art Since the Early Forties: A Search for Identity.* Madras: Artists' Handicrafts Association of Cholamandal Artists' Village and Progressive Painters' Association.

Asher, Catherine E. B. 1992. *The Architecture of Mughal India.* Cambridge: Cambridge University Press.

Ashraf, Kazi Khaleed, and James Belluardo. 1998. *An Architecture of Independence: The Making of Modern South Asia; Charles Correa, Balakrishna Doshi, Muzharul Islam, Achyut Kanvinde.* New York: Architectural League of New York.

Bahadurji, Shirin. 1984. "S. H. Raza: Point of Creation." *Bombay: The City Magazine* V no. 4 (March 7–21): 32–35.

Bailey, Gauvin A. 1998. *The Jesuits and the Grand Mogul: Renaissance Art at the Imperial Court of India, 1580–1630.* Washington: Smithsonian Institution.

Banerjee, A. 1994. "Dairying Systems in India." *World Animal Review* 79, no. 2: 8–15.

Barthes, Roland. [1966] 1977. "Introduction to the Structural Analysis of Narratives." In *Image, Music, Text,* 79–124. Trans. Stephen Heath. New York: Hill and Wang.

Basu, Susan Neild. 1993. "Madras in 1800: Perceiving the City." In *Urban Form and Meaning in South Asia: The Shaping of Cities from Prehistoric to Precolonial Times,* ed. Howard Spodek and Doris Meth Srinivasan, 221–42. Washington: National Gallery of Art.

Bean, Susan S. 1999. *Timeless Visions: Contemporary Art of India; From the Chester and Davida Herwitz Collection.* Salem, Mass.: Peabody Essex Museum.

Berger, John. 1955. "An Indian Painter." *New Statesman,* February 26, 277–78.

Berman, Marshall. 1988. *All That Is Solid Melts into Air: The Experience of Modernity.* New York: Penguin.

Bhabha, Homi K. 1990. "The Third Space: Interview with Homi Bhabha." In *Identity: Community, Culture, Difference,* ed. Jonathan Rutherford, 207–21. London: Lawrence and Wishart.

———. 1994. *The Location of Culture.* London: Routledge.

Bhatt, Jyoti. 2002. "Jyoti Bhatt." *Kala Arts Quarterly,* fall, www.geocities.com/kala-mag/ (accessed March 10, 2006).

Bhatt, Vikram, and Peter Scriver. 1990. *After the Masters.* Ahmedabad: Mapin.

Bhattacharyya, N. N. 1982. *History of the Tantric Religion.* New Delhi: Manohar.

Bhattacharyya, S. K. 1994. *Trends in Modern Indian Art.* New Delhi: M. D. Publications.

Blazwick, Iwona, ed. 2001. *Century City: Art and Culture in the Modern Metropolis.* London: Tate Gallery.

Bondurant, Joan Valerie. 1988. *Conquest of Violence: The Gandhian Philosophy of Conflict*. Princeton: Princeton University Press.

Boner, Alice. 1962. *Principles of Composition in Hindu Sculpture, Cave Temple Period*. Leiden: Brill.

———. 1972. *New Light on the Sun Temple of Konarka: Four Unpublished Manuscripts Relating to Construction History and Ritual of This Temple*. Ed. and trans. Boner and Sadasiva Rath Sarma, with Rajendra Prasad Das. Varanasi: Chowkhamba Sanskrit Series Office.

———. 1982. *Vastusutra Upanisad: The Essence of Form in Sacred Art; Sanskrit Text*. Ed. and trans. Boner, Sadasiva Rath Sarma, and Bettina Baümer. New Delhi: Motilal Banarsidass.

Borden, Carla M., ed. 1989. *Contemporary Indian Tradition: Voices on Culture, Nature, and the Challenge of Change*. Washington: Smithsonian Institution Press.

Brah, Avtar, and Annie E. Coombes, eds. 2001. *Hybridity and Its Discontents: Politics, Science, Culture*. London: Routledge.

Brown, Rebecca M. 1997. "Sir Charles D'Oyly in Dhaka: The Colonial Picturesque." *Journal of Bengal Art* 2:265–82.

———. 2003. "The Cemeteries and the Suburbs: Patna's Challenges to the Colonial City in South Asia." *Journal of Urban History* 29, no. 2: 151–73.

———. 2005. "P. T. Reddy, Neo-tantrism, and Modern Art in India." *Art Journal* 64, no. 4: 26–49.

Brown, Robert L. 2002. "Introduction." In *The Roots of Tantra*, ed. Katherine Anne Harper and Robert L. Brown, 1–16. Albany: State University of New York Press.

Butalia, Urvashi. 2000. *The Other Side of Silence: Voices from the Partition of India*. Durham, N.C.: Duke University Press.

Butterfield, Julia Lynn. 2002. "Tradition, Politics, and the Arts in Calcutta: Creating a Bengali Postcolonial Aesthetic." PhD diss., City University of New York.

Campbell, Sarah, and Grant Watson, eds. 2000. *Drawing Space: Contemporary Indian Drawing*. London: Institute of International Visual Arts.

Cantacuzino, Sherban. 1984. *Charles Correa*. Singapore: Concept Media.

Cate, Sandra. 2003. *Making Merit, Making Art: A Thai Temple in Wimbledon*. Honolulu: University of Hawaii Press.

Chakrabarty, Dipesh. 2000. *Provincializing Europe: Postcolonial Thought and Historical Difference*. Princeton: Princeton University Press.

———. 2002. *Habitations of Modernity: Essays in the Wake of Subaltern Studies*. Chicago: University of Chicago Press.

Chakravarty, Sumita S. 1993. *National Identity in Indian Popular Cinema, 1947–1987*. Austin: University of Texas Press.

Chatterjee, Partha. 1993. *Nationalist Thought and the Colonial World: A Derivative Discourse*. Minneapolis: University of Minnesota Press.

———, ed. 1998. *Wages of Freedom: Fifty Years of the Indian Nation-State.* Delhi: Oxford University Press.

Chopra, Yash, dir. [1965] 2003. *Waqt.* Yash Raj Films. DVD.

Chowdhury, Jorgen, Rakhi Sarkar, and Amiya Bhattacharjee. 2001. *Art of Bengal: Past and Present, 1850–2000.* Calcutta: Centre of International Modern Art.

Clark, John. 1998. *Modern Asian Art.* Honolulu: University of Hawaii Press.

Cohen, Andrew. 1999. "Contemporary Indian Art." *Art Journal* 58, no. 3: 7–8.

Coll, Jaime. 1995. "Le Corbusier's Taureaux: An Analysis of the Thinking Process in the Last Series of Le Corbusier's Plastic Work." *Art History* 18, no. 4:537–67.

Coomaraswamy, Ananda K. [1934] 1956. *The Transformation of Nature in Art.* New York: Dover.

———. [1943] 1956. *Christian and Oriental Philosophy of Art.* New York: Dover. Originally published as *Why Exhibit Works of Art?*

———. 1957. *The Dance of Shiva: Fourteen Indian Essays.* New York: Noonday.

Cooper, Darius. 2000. *The Cinema of Satyajit Ray: Between Tradition and Modernity.* Cambridge: Cambridge University Press.

Correa, Charles. 1982. "Open to Sky Space: Architecture in a Warm Climate." *Mimar*, no. 5:30–35.

———. 1989. "The Public, the Private, and the Sacred." *Daedalus* 118, no. 4: 93–114.

———. 1991. "The Public, the Private, and the Sacred." *A+D* 8, no. 5: 91–99.

———. 1996. *Charles Correa.* London: Thames and Hudson.

———. 2000. *Housing and Urbanisation.* London: Thames and Hudson.

Correa, Charles, P. Mehta, and S. B. Patel. 1965. "Planning for Bombay." *Marg* 18, no. 3: 30–56.

Curtis, William J. R. 1988. *Balkrishna Doshi: An Architecture for India.* New York: Rizzoli.

Dalmia, Yashodhara. 1988. *The Painted World of the Warlis: Art and Ritual of the Warli Tribes of Maharashtra.* New Delhi: Lalit Kala Akademi.

———. 2001. *The Making of Modern Indian Art: The Progressives.* Delhi: Oxford University Press.

———, ed. 2002. *Contemporary Indian Art: Other Realities.* Mumbai: Marg.

Dalmia, Yashodhara, et al. 1997. *Indian Contemporary Art: Post Independence.* New Delhi: Vadehra Art Gallery.

Das, Veena. 2007. *Life and Words: Violence and the Descent into the Ordinary.* Berkeley: University of California Press.

Dasgupta, Ajit Kumar. 1996. *Gandhi's Economic Thought.* London: Routledge.

Das Gupta, Anshuman, and Shivaji K. Panikkar. 1995. "The Transitional Modern: Figuring the Post Modern in India?" *Lalit Kala Contemporary*, no. 41, 17–24.

Datta, Ella. 1997. "Search for a Self Image." In *Indian Contemporary Art: Post Independence*, ed. Yashodhara Dalmia et al., 29–43. New Delhi: Vadehra Art Gallery.

———. 1998. *Ganesh Pyne: His Life and Times*. Calcutta: Centre of International Modern Art.

Dehejia, Vidya. 1990. "On Modes of Visual Narration in Early Buddhist Art." *Art Bulletin* 80, no. 4: 373–92.

———. 1997. *Discourse in Early Buddhist Art: Visual Narratives of India*. New Delhi: Munshiram Manoharlal.

———. 1998. "India's Visual Narratives: The Dominance of Space over Time." In *Paradigms of Indian Architecture: Space and Time in Representation and Design*, ed. G. H. R. Tillotson, 80–106. London: Curzon.

Delhi Art Gallery. 2001a. *The Demonic Line: F. N. Souza, an Exhibition of Drawings, 1940–1964*. New Delhi: Delhi Art Gallery.

———. 2001b. *Mindscapes: Early Works by S. H. Raza, 1945–50*. New Delhi: Delhi Art Gallery.

Desai, Vishakha. 1995. "Re-visioning Asian Arts in the 1990s: Reflections of a Museum Professional." *Art Bulletin* 77, no. 2: 169–74.

Dewan, Deepali. 2001. "Crafting Knowledge and Knowledge of Crafts: Art Education, Colonialism, and the Madras School of Arts in Nineteenth-Century South Asia." PhD diss., University of Minnesota.

Doshi, Balkrishna. 1993. *Le Corbusier and Louis I. Kahn: The Acrobat and the Yogi of Architecture*. Ahmedabad: Vastu-Shilpa Foundation for Studies and Research in Environmental Design.

———. 1995. *"Living Environments": Housing Designs*. Ahmedabad: Vastu-Shilpa Foundation for Studies and Research in Environmental Design.

———. 2002. *Architectural Legacies of Ahmedabad*. Vol. 2, *Canvas of Modern Masters*. Ahmedabad: Vastu-Shilpa Foundation for Studies and Research in Environmental Design.

———. 2003. *Models, Fifty Years: Architecture, Urban Planning*. Ahmedabad: Vastu-Shilpa Foundation for Studies and Research in Environmental Design.

Doshi, Saryu, ed. 1983. *Pageant of Indian Art: Festival of India in Great Britain*. Bombay: Marg.

Dwyer, Rachel. 2002. *Yash Chopra*. London: British Film Institute.

Dwyer, Rachel, and Christopher Pinney, eds. 2001. *Pleasure and the Nation: The History, Politics, and Consumption of Public Culture in India*. New York: Oxford University Press.

Dwyer, Rachel, and Divia Patel. 2002. *Cinema India: The Visual Culture of Hindi Film*. New Brunswick, N.J.: Rutgers University Press.

Eck, Diana L. 1982. *Banaras: City of Light*. New York: Knopf.

———. 1998. *Darshan: Seeing the Divine Image in India*. 3rd ed. New York: Columbia University Press.

Eaton, Richard. 1993. *The Rise of Islam and the Bengal Frontier*. Berkeley: University of California Press.

Ellias, Bina Sarkar. 1998. *Fifty Years of Indian Art*. Mumbai: Mohile-Parikh Centre for the Visual Arts.

Elliott, David, and E. Alkazi, eds. 1982. *India, Myth and Reality: Aspects of Modern Indian Art*. Oxford: Museum of Modern Art.

Evenson, Norma. 1989. *The Indian Metropolis: A View toward the West*. New Haven: Yale University Press.

Falisse, Philippe. 2005. *Inspirations: The Architectural Marvel of Satish Gujral and Memoires of Seven Ambassadors*. New Delhi: Bosco Society.

Fanon, Franz. 1963. *The Wretched of the Earth*. Trans. Constance Farrington. New York: Grove.

Fields, Rick. 1992. *How the Swans Came to the Lake*. Boston: Shambala.

Filliozat, Jean. 1937. *Étude de démonologie indienne: Le Kumaratantra de Ravana et les textes parallèles indiens tibétains, chinois, cambodgiens et arabes*. Paris: Imprimerie Nationale.

Fishman, Robert. 1977. *Urban Utopias in the Twentieth Century: Ebenezer Howard, Frank Lloyd Wright, and Le Corbusier*. New York: Basic Books.

Fitting, Peter. 2002. "Urban Planning/Utopian Dreaming: Le Corbusier's Chandigarh Today." *Utopian Studies* 13, no. 1: 69–93.

Foster, Hal. 1983. *The Anti-aesthetic: Essays on Postmodern Culture*. Port Townsend, Wash.: Bay.

Foucault, Michel. 1972. *Archaeology of Knowledge*. Trans. A. M. Sheridan Smith. New York: Pantheon.

Frampton, Kenneth. 1996. "The Work of Charles Correa." In *Charles Correa*, 8–16. London: Thames and Hudson.

Fuller, C. J. 1992. *The Camphor Flame: Popular Hinduism and Society in India*. Princeton: Princeton University Press.

Ghosh, Pika. 2005. *Temple to Love: Architecture and Devotion in Seventeenth Century Bengal*. Bloomington: Indiana University Press.

Gill, Gagan, ed. 1996. *Ram Kumar: A Journey Within*. New Delhi: Vadehra.

Government of Bihar. 1962. *Bihar*. Patna: Government of Bihar.

Grant, David. 2000. "Murphy-bilia," www.murphy-radio.co.uk/murphybilia/index.html (accessed April 22, 2005).

Grover, Satish. 1995. *Building beyond Borders: The Story of Contemporary Indian Architecture*. New Delhi: National Book Trust.

Guha, Ranajit, ed. 1982. *Subaltern Studies: Writings on South Asian History and Society*. Vol. 1. New Delhi: Oxford University Press.

Guha-Thakurta, Tapati. 1992. *The Making of a New "Indian" Art: Artists, Aesthetics, and Nationalism in Bengal, c. 1850–1920*. Cambridge: Cambridge University Press.

———. 1995. "Recovering the Nation's Art." In *Texts of Power: Emerging Disciplines in Colonial Bengal*, ed. Partha Chatterjee, 63–92. Minneapolis: University of Minnesota Press.

————. 2004. *Monuments, Objects, Histories: Institutions of Art in Colonial and Post-colonial India*. New York: Columbia University Press.

————. 2005. "Lineages of the Modern in Indian Art: The Making of a National History." In *Culture and the Making of Identity in Contemporary India*, ed. Kamala Ganesh and Usha Thakkar, 71–107. New Delhi: Sage.

Gujral, Satish. 1997. *A Brush with Life: An Autobiography*. New Delhi: Viking.

Haberman, David L. 1988. *Acting as a Way of Salvation: A Study of Raganuga Bhakti Sadhana*. Oxford: Oxford University Press.

Habermas, Jürgen. 1991. *Moral Consciousness and Communicative Action*. Trans. Christian Lenhardt and Shierry Weber Nicholson. Cambridge: MIT Press.

Harper, Katherine Anne. 2002. "The Warring Saktis: A Paradigm for Gupta Conquests." In *The Roots of Tantra*, ed. Harper and Robert L. Brown, 115–32. Albany: State University of New York Press.

Harper, Katherine Anne, and Robert L. Brown, eds. 2002. *The Roots of Tantra*. Albany: State University of New York Press.

Harris, Clare. 1999. *In the Image of Tibet*. London: Reaktion.

Harris, N. 1978. *Economic Development, Cities, and Planning: The Case of Bombay*. Bombay: Oxford University Press.

Hertel, Bradley R., and Cynthia Ann Humes, eds. 1993. *Living Banaras: Hindu Religion in Cultural Context*. Albany: State University of New York Press.

Hiller, Susan, ed. 1991. *The Myth of Primitivism: Perspectives on Art*. New York: Routledge.

Hurtt, Steven W. 1999. "Le Corbusier: Symbolic Themes at Chandigarh." *Marg* 50, no. 3: 94–106.

Husain, M. F., with Khalid Mohamed. 2002. *Where Art Thou: An Autobiography*. Mumbai: M. F. Husain Foundation.

Hyman, Timothy. 1998. *Bhupen Khakhar*. Bombay: Mapin.

"India's Harassed Artists." 1996. *Economist*, October 19, 40.

Jacob, Preminda S. 1999. "Between Modernism and Modernization: Locating Modernity in South Asian Art." *Art Journal* 58, no. 3: 49–57.

Jain, Jyotindra. 1989. *National Handicrafts and Handlooms Museum, New Delhi*. Ahmedabad: Mapin.

James, Josef. 2004. *Cholamandal: An Artists' Village*. Oxford: Oxford University Press.

Jayakar, Pupul, et al. 1985. *Festival of India in the United States, 1985–1986*. New York: Abrams.

Jogelkar, M. N., and S. K. Das, eds. *Contemporary Indian Architecture: Housing and Urban Development*. New Delhi: Galgotia.

Joseph, George Gheverghese. 1991. *The Crest of the Peacock: Non-European Roots of Mathematics*. New York: Tauris.

Kahn, Hasan-Uddin. 1987. *Charles Correa: Architect in India*. London: Butterworth Architecture.

————. 2002. "An Overview of Contemporary Mosques." In *The Mosque: History, Architectural Development, and Regional Diversity*, ed. Martin Frishman and Khan, 242–67. London: Thames and Hudson.

Kanvinde, Achyut, and H. James Miller. 1969. *Campus Design in India: Experience of a Developing Nation*. Topeka, Kans.: American Yearbook Corporation.

Kapoor, Raj, dir. [1951] 2003. *Awaara*. Yash Raj Films. DVD.

————. [1955] 2003. *Shree 420*. Yash Raj Films. DVD.

Kapur, Geeta. 1969. *Husain*. Bombay: Vakil.

————. 1978a. *Contemporary Indian Artists*. New Delhi: Vikas.

————. 1978b. *Pictorial Space: A Point of View on Contemporary Indian Art*. New Delhi: Lalit Kala Akademi.

————. 1987. *K. G. Subramanyan*. New Delhi: Lalit Kala Akademi.

————. 1993. "When Was Modernism in Indian/Third World Art?" *South Atlantic Quarterly* 92, no 3: 473–514.

————. 1998. "Globalization and Culture: Navigating the Void." In *The Cultures of Globalization*, ed. Fredric Jameson and Masao Miyoshi, 191–217. Durham, N.C.: Duke University Press.

————. 2000. *When Was Modernism? Essays on Contemporary Cultural Practice in India*. New Delhi: Tulika.

————. 2005. "Talk about Curating: The Making of International Exhibitions; Siting Biennales." *First City*, January, 56–58.

Kärkkäinen, Maija. 1992. *Functionalism: Utopia or the Way Forward?* Jyväskylä, Finland: The Symposium.

Karlekar, Hiranmay. 1998. *Independent India: The First Fifty Years*. Delhi: Oxford University Press.

Kaviraj, Sudipta. 1998. "The Culture of Representative Democracy." In *Wages of Freedom: Fifty Years of the Indian Nation-State*, ed. Partha Chatterjee, 147–75. Delhi: Oxford University Press.

Keddie, Nikki R. 1998. "The New Religious Politics: Where, When, and Why Do 'Fundamentalisms' Appear?" *Comparative Studies in Society and History* 40, no. 4: 696–723.

Khanna, Balraj and Aziz Kurtha. 1998. *Art of Modern India*. London: Thames and Hudson.

Khanna, Krishen. 2002. *The Time of My Life*. Delhi: Penguin.

King, Richard. 1999. *Orientalism and Religion: Postcolonial Theory, India, and "the Mythic East."* New York: Routledge.

Lang, Jon, Madhavi Desai, and Miki Desai. 1997. *Architecture and Independence: The Search for Identity—India 1880 to 1980*. Delhi: Oxford University Press.

Larson, Gerald James. 1995. *India's Agony over Religion*. Albany: State University of New York Press.

Latour, Bruno. 1993. *We Have Never Been Modern*. Trans. Catherine Porter. Cambridge: Harvard University Press.

Le Corbusier. 1958. *Modulor 2*. London: Faber and Faber.

———. 1974. *Sarabhai House, Ahmedabad, India, 1955; Shodhan House, Ahmedabad, India, 1956*. Ed. Yukio Futagawa. Photographs by Futagawa, text by Balkrishna V. Doshi. Tokyo: A. D. A. Edita.

———. [1929] 1987. *The City of To-Morrow and Its Planning*. Trans. Frederick Etchells. New York: Dover.

Liu, Lydia H. 1995. *Translingual Practice: Literature, National Culture, and Translated Modernity; China, 1900–1937*. Stanford, Calif.: Stanford University Press.

Lohuizen-De Leeuw, J. E. van. 1949. *The "Scythian" Period: An Approach to the History, Art, Epigraphy, and Paleography of North India from the First Century B.C. to the Third Century A.D.* Leiden: Brill.

Loomba, Ania. 1998. *Colonialism/Postcolonialism*. London: Routledge.

Losty, Jeremiah P. 1990. *Calcutta: City of Palaces*. London: British Library.

Lowe, Lisa, and David Lloyd, eds. 1997. *The Politics of Culture in the Shadow of Capital: Worlds Aligned*. Durham, N.C.: Duke University Press.

Lyotard, Jean-François. [1979] 1984. *The Postmodern Condition: A Report on Knowledge*. Trans. Geoff Bennington and Brian Massumi. Minneapolis: University of Minnesota Press.

Machida, Margo, ed. 1994. *Asia/America: Identities in Asian American Art*. New York: Asia Society Galleries.

Mansfield, Elizabeth, ed. 2002. *Art History and its Institutions*. London: Routledge.

Martin, Jean-Hubert, ed. 1989. *Magiciens de la terre*. Paris: Éditions du Centre Pompidou.

Mathur, Asharani, ed. 1987. *India: Specially Published for the Festival of India*. New Delhi: Brijbasi.

Mehrotra, Rahul. 2000. "Making Indian Cities: Urban Design in the New Millennium." In *2000: Reflections on the Arts in India*, ed. Pratapaditya Pal, 109–17. Mumbai: Marg.

Meister, Michael. 1971. "The Two-and-a-Half-Day Mosque." *Oriental Art*, n.s. 18, no. 1:57–63.

Melwani, Lavina. 1998. "Eyewitness of an Era." *Little India*, November, http://www.littleindia.com (accessed May 20, 2005).

Metcalf, Barbara D., and Thomas R. Metcalf. 2001. *A Concise History of India*. Cambridge: Cambridge University Press.

Metcalf, Thomas R. 1989. *An Imperial Vision: Indian Architecture and Britain's Raj*. Berkeley: University of California Press.

———. 1998. "Past and Present: Towards an Aesthetics of Colonialism." In *Paradigms of Indian Architecture: Space and Time in Representation and Design*, ed. G. H. R. Tillotson, 12–25. London: Curzon.

Milford-Lutzger, Mary-Ann. 1999. "Intersections: Urban and Village Art in India." *Art Journal* 58, no. 3: 23–30.

Mishra, Pankaj. 2004. "The Aspirers." *Granta*, no. 87:171–98.

Mitchell, Timothy, ed. 2000. *Questions of Modernity*. Minneapolis: University of Minnesota Press.

Mitter, Partha. [1977] 1992. *Much Maligned Monsters: A History of European Reactions to Indian Art*. Chicago: University of Chicago Press.

———. 1994. *Art and Nationalism in Colonial India, 1850–1922*. Cambridge: Cambridge University Press.

———. 2001. *Indian Art*. Oxford: Oxford University Press.

Modak, N. V., and Albert Mayer. 1947. *Master Plan in Outline*. Bombay: printed at the Bombay Municipal Printing Press.

Modi, Renu. "Raising a Family of Sculptures." 2000. *Art India* 5, no. 3: 60–63.

Mookerjee, Ajitcoomar. 1966. *Tantra Art: Its Philosophy and Physics*. New Delhi: Ravi Kumar.

Mookerjee, Priya. 1987. *Pathway Icons: The Wayside Art of India*. London: Thames and Hudson.

Moszynska, Anna. 1990. *Abstract Art*. London: Thames and Hudson.

Mukherjee, Rudrangshu, ed. 2002. *Art of Bengal, 1955–1975: A Vision Defined*. Kolkata: Centre International of Modern Art.

Nandy, Ashis, ed. 1998. *The Secret Politics of Our Desires: Innocence, Culpability, and Indian Popular Cinema*. Delhi: Oxford University Press.

———. 2001. *An Ambiguous Journey to the City: The Village and Other Odd Ruins of the Self in the Indian Imagination*. Delhi: Oxford University Press.

National Gallery of Modern Art. 1974. *A Handbook of Paintings and Graphics*. New Delhi: National Gallery of Modern Art.

———. 1975. *Selections from the National Gallery of Modern Art*. New Delhi: National Gallery of Modern Art.

Nehru, Jawaharlal. [1946] 1960. *The Discovery of India*. Ed. Robert I. Crane. Garden City, N.Y.: Doubleday.

Ngugi Wa Thiong'o. 2000. "Borders and Bridges: Seeking Connections between Things." In *The Pre-occupation of Postcolonial Studies*, ed. Fawzia Afzal-Khan and Kalpana Seshadri-Crooks, 119–25. Durham, N.C.: Duke University Press.

Niranjana, Tejaswini, P. Sudhir, and Vivek Dhareshwar, eds. 1999. *Interrogating Modernity: Culture and Colonialism in India*. Calcutta: Seagull.

Nochlin, Linda. 1983. "The Imaginary Orient." *Art in America* 71, no. 5: 118–31, 187–91.

Osborne, Peter. 1995. *The Politics of Time: Modernity and the Avant-Garde*. New York: Verso.

Pal, Pratapaditya. 2000. *2000: Reflections on the Arts in India*. Mumbai: Marg.

———, and Vidya Dehejia. 1986. *From Merchants to Emperors: British Artists and India*. Ithaca: Cornell University Press.

Pandey, Gyanendra. 1990. *The Construction of Communalism in Colonial North India.* Delhi: Oxford University Press.

———. 2001. *Remembering Partition: Violence, Nationalism, and History in India.* Cambridge: Cambridge University Press.

Pandya, Yatin. 2002. *Architectural Legacies of Ahmedabad.* Vol. 1. Ahmedabad: Vastu-Shilpa Foundation for Studies and Research in Environmental Design.

Paniker, K. C. S. 1971. "Contemporary Painters and Metaphysical Elements in the Art of the Past." *Lalit Kala Contemporary*, no. 12:11–12.

———. 1972. "Indigenous Sources in Contemporary Art." In *Twenty-Five Years of Indian Art: Painting, Sculpture, and Graphics in the Post-independence Era*, ed. Jaya Appasamy, 24–26. New Delhi: Lalit Kala Akademi.

Panikkar, Shivaji K. 2003. "Reading the Regional through Internationalism and Nativism: The Case of Art in Madras; 1950 to 1970." In *Towards a New Art History: Studies in Indian Art*, ed. Panikkar, Parul Dave Mukherji, and Deeptha Achar, 105–21. New Delhi: D. K. Printworld.

Panikkar, Shivaji K., Parul Dave Mukherji, and Deeptha Achar, eds. 2003. *Towards a New Art History: Studies in Indian Art.* New Delhi: D. K. Printworld.

Parimoo, Ratan. 1975. *Studies in Modern Indian Art: A Collection of Essays.* New Delhi: Kanak.

Pate, Christopher L. 1997. "Critical Regionalism, Le Corbusier, and Balkrishna Doshi." MArch thesis, University of Virginia.

Patel, Gieve. 1989. "Contemporary Indian Painting." *Daedalus* 118, no. 4: 171–205.

Patel, Sujata, and Alice Thorner, eds. 1995. *Bombay: Metaphor for Modern India.* Bombay: Oxford University Press.

Patel, Sujata, and Jim Masselos, eds. 2003. *Bombay and Mumbai: The City in Transition.* Delhi: Oxford University Press.

Phillips Collection. 1986. *Indian Art Today: Four Artists from the Chester and Davida Herwitz Collection.* Washington: Phillips Collection.

Pinney, Christopher. 2001. "Introduction: Public, Popular, and Other Cultures." In *Pleasure and the Nation: The History, Politics, and Consumption of Public Culture in India*, ed. Rachel Dwyer and Pinney, 1–34. New Delhi: Oxford University Press.

———. 2004. *Photos of the Gods: The Printed Image and Political Struggle in India.* London: Reaktion.

Pollock, Griselda. 1992. *Avant-Garde Gambits, 1888–1893: Gender and the Color of Art History.* London: Thames and Hudson.

Poshyananda, Apinan, ed. 1996. *Contemporary Art in Asia: Traditions/Tensions.* New York: Asia Society Galleries.

Pothan, S. G. 1963. *The Syrian Christians of Kerala.* New York: Asia Publication House.

Prakash, Gyan. 1990. "Writing Post-orientalist Histories of the Third World: Perspectives from Indian Historiography." *Comparative Studies in Society and History* 32, no. 2: 383–408.

———, ed. 1995. *After Colonialism: Imperial Histories and Postcolonial Displacements.* Princeton: Princeton University Press.

Prakash, Vikramaditya. 1994. "Productions of Identity in (Post)Colonial 'Indian' Architecture: Hegemony and Its Discontents in C19 Jaipur." PhD diss., Cornell University.

———. 2002. *Chandigarh's Le Corbusier: The Struggle for Modernity in Postcolonial India.* Seattle: University of Washington Press.

Prasad, M. Madhava. 1998. *Ideology of the Hindi Film: A Historical Construction.* New York: Oxford University Press.

Pyne, Ganesh. n.d. Interview by Mitra Banerjee, www.saffronart.com (accessed February 10, 2005).

Rahman, Ram. 1998. *Sunil Janah: Photographing India, 1942–1978.* New York: Gallery at 678.

Ramachandran, R. 1989. *Urbanization and Urban Systems in India.* Oxford: Oxford University Press.

Ramachandran, T. M., ed. 1985. *Seventy Years of Indian Cinema (1913–1983).* Bombay: Cinema India–International.

Ramachandran, V. K. 1998. "Documenting Society and Politics: A *Frontline* Feature on the Photography of Sunil Janah." *Frontline*, September 25, 69–76.

Rao, P. R. Ramachandra. 1969. *Contemporary Indian Art.* Hyderabad, P. R. Ramachandra Rao.

Rawson, Philip. 1971. *Tantra.* London: Hayward Gallery.

———. 1978. *The Art of Tantra.* London: Thames and Hudson.

Ray, Satyajit, dir. [1955–59] 2003. *Apu Trilogy: Pather panchali (1955), Aparajito (1957), Apur sansar (1959).* Columbia Tristar. DVD.

Raychaudhuri, Tapan. 2000. "Shadows of the Swastika: Historical Perspectives on the Politics of Hindu Communalism." *Modern Asian Studies* 34, no. 2: 259–79.

Reddy, P. T. 1982. *Forty Years of P. T. Reddy's Art.* Hyderabad: Andhra Pradesh Council of Artists.

Robinson, Andrew. 2004. *Satyajit Ray: The Inner Eye; The Biography of a Master Film-Maker.* 2nd ed. London: Tauris.

Rofel, Lisa. 1999. *Other Modernities: Gendered Yearnings in China after Socialism.* Berkeley: University of California Press.

Rohatgi, Pauline, and Pheroza Godrej, eds. 1995. *Under the Indian Sun: British Landscape Artists.* Bombay: Marg.

Roy, Jamini. 1997. *Jamini Roy: Bengali Artist of Modern India.* Gainesville, Fla.: Samuel P. Harn Museum of Art.

Rushdie, Salman. 1981. *Midnight's Children.* New York: Penguin.

———. 1989. *The Satanic Verses.* New York: Picador.

Sachdev, Vibhuti and G. H. R. Tillotson. 2002. *Building Jaipur: The Making of an Indian City.* London: Reaktion.

Said, Edward. 1979. *Orientalism.* New York: Vintage.

Sarma, Ramya. 2002. *Raghu Rai: In His Own Words*. New Delhi: Roli.

Sen, Amartya. 1997. "Indian Traditions and the Western Imagination." *Daedalus* 126, no. 2: 1–26.

Sen, Geeti. 1990. *Raza*. New Delhi: Lalit Kala Akademi.

———. 1996. *Image and Imagination: Five Contemporary Artists in India*. Ahmedabad: Mapin.

———. 2001. *Bindu: Space and Time in Raza's Vision*. New Delhi: Media Transasia.

Sen-Gupta, Achinto. 2001. "Neo-Tantric Twentieth-Century Indian Painting." *Arts of Asia* 31, no. 3: 104–15.

Serenyi, Peter. 1984. "Charles Correa." *Journal of Arts and Ideas*, no. 7, 75–86.

Sharma, Sudhakar, et al. 1996. *Shilpayan*. New Delhi: National Gallery of Modern Art.

Shaw, Annapurna. 1999. "The Planning and Development of New Bombay." *Modern Asian Studies* 33, no. 4: 951–88.

Sheikh, Gulammohammed. 1978. "New Contemporaries." *Marg* 31, no. 2: 87–112.

———. 1997. *Contemporary Art in Baroda*. New Delhi: Tulika.

Singapore Art Museum. 1997. *Tryst with Destiny: Art from Modern India, 1947–1997*. Singapore: Singapore Art Museum.

Singh, Jyotsna G. 1996. *Colonial Narratives/Cultural Dialogues: "Discoveries" of India in the Language of Colonialism*. New York: Routledge.

Singh, Raghubir. 2002. *A Way Into India*. London: Phaidon.

Sinha, Ajay J. 1999. "Contemporary Indian Art: A Question of Method." *Art Journal* 58, no. 3: 31–39.

Sinha, Gayatri. 2002. *Krishen Khanna: A Critical Biography*. New Delhi: Vadehra Art Gallery.

———, ed. 2003. *Indian Art: An Overview*. New Delhi: Rupa.

———. 2004. *Middleagespread: Imaging India, 1947–2004*. New Delhi: Anant.

———. 2006. *Krishen Khanna: The Embrace of Love*. Ahmedabad: Mapin.

Sinha, Gayatri, Santo Datta, and Gautam Bhatia. 2006. *Satish Gujral: An Artography*. New Delhi: Roli.

Sirefman, Susanna, and Keith Collie. 2001. *New York: A Guide to Recent Architecture*. New York: Ellipsis Arts.

Sirhindi, Marcella. 1999. "Manipulating Cultural Idioms." *Art Journal* 58, no. 3: 40–47.

Siva Kumar, R. 2003. *K. G. Subramanyan: A Retrospective*. New Delhi: National Gallery of Modern Art.

Sokolowski, Thomas W., et al. 1985. *Contemporary Indian Art: From the Chester and Davida Herwitz Family Collection*. New York: New York University Press.

Souza, F. N. 1955. "Nirvana of a Maggot." *Encounter*, no. 17: 42–48.

———. 1984. "Cultural Imperialism." *Patriot Magazine*, February 12.

Spivak, Gayatri Chakravorty. 1988. *In Other Worlds: Essays in Cultural Politics*. London: Routledge.

———. 1990. *The Post-colonial Critic: Interviews, Strategies, Dialogues.* Ed. Sarah Hara-
sym. New York: Routledge.

Steele, James, and Balkrishna V. Doshi. 1998. *Rethinking Modernism for the Developing
World: The Complete Architecture of Balkrishna Doshi.* New York: Whitney Library
of Design.

Srivatsan, R. 1993. "Cartier-Bresson and the Birth of Modern India." *Journal of Arts and
Ideas,* nos. 25–26: 37–54.

Subramaniam, Banu. 2000. "Archaic Modernities: Science, Secularism, and Religion in
Modern India." *Social Text,* no. 64: 67–86.

Subramanyan, K. G. 1978. *Moving Focus: Essays on Indian Art.* New Delhi: Lalit Kala
Akademi.

———. 1987. *The Living Tradition: Perspectives on Modern Indian Art.* Calcutta: Sea-
gull.

———. 1992. *The Creative Circuit.* Calcutta: Seagull.

Sully, John. 2003. "Classic Wireless," www.classicwireless.btinternet.co.uk (accessed
April 22, 2005).

Takhar, Jaspreet, ed. 2002. *Celebrating Chandigarh.* Chandigarh: Chandigarh Perspec-
tives.

Tarlo, Emma. 1996. *Clothing Matters: Dress and Identity in India.* Chicago: University
of Chicago Press.

Tillotson, G. H. R. 2000. *The Artificial Empire: The Indian Landscapes of William
Hodges.* London: Curzon Press.

Tobias, Michael, and Raghu Rai. 1996. *A Day in the Life of India.* New York: Harper
Collins.

Tonelli, Edith A., ed. 1985. *Neo-Tantra: Contemporary Indian Painting Inspired by Tra-
dition.* Los Angeles: Frederick S. Wight Art Gallery.

Varma, Rashmi. 2004. "Provincializing the Global City: From Bombay to Mumbai." *So-
cial Text,* no. 81:65–89.

Venturi, Robert, Denise Scott Brown, and Steven Izenour. 1977. *Learning from Las Vegas:
The Forgotten Symbolism of Architectural Form.* Rev. ed. Cambridge: MIT Press.

Verma, H. S. 1985. *Bombay, New Bombay, and Metropolitan Region: Growth Processes
and Planning Lessons.* Delhi: Concept.

Welch, Anthony. 1993. "Architectural Patronage and the Past: The Tughluq Sultans of
India." *Muqarnas* 10: 311–22.

Werner, Heike. 1999. "Das Capitol von Chandigarh, Indien." *Baumeister* 96, no. 5: 42–
47.

White, David Gordon. 2000. "Tantra in Practice: Mapping a Tradition." In *Tantra in
Practice,* ed. White, 3–40. Princeton, N.J.: Princeton University Press.

Williams, Patrick, and Laura Chrisman, eds. 1994. *Colonial Discourse and Postcolonial
Theory: A Reader.* New York: Columbia University Press.

Williams, Raymond. 1989. *The Politics of Modernism: Against the New Conformists.* London: Verso.

Woodcock, George. 1967. *Kerala: A Portrait of the Malabar Coast.* London: Faber and Faber.

Yanagi, Soetsu. 1972. *The Unknown Craftsman: A Japanese Insight into Beauty.* Tokyo: Kodansha.

Zitzewitz, Karin. 2006. "The Aesthetics of Secularism: Modernist Art and Visual Culture in India." PhD diss., Columbia University.

abhaya mudra (fear-not gesture), 32–33

abstract expressionism, 7, 45, 153

abstraction, 14, 16, 83; experiments with, 24, 114; in Nasreen Mohamedi's work, 118, 122, 129, 158; in Ram Kumar's work, 154–56; religious symbolism and, 45, 52–53

agonistic discourse, 30–31, 34, 43

Agra, 62

Ahmedabad, 25, 35–36, 38, 88, 123

Ajanta, 61

Alai Darwaza, 59

Albert Hall, 61, 67, 90

alienation, 151–53

allegory, 69, 73–74, 98

All India Fine Arts and Crafts Society, 15

ancientness, 83–86, 89–93, 98, 101, 113–15

Anderson, Perry, 3, 10

Andre, Carl, 119

Apu Trilogy (Rai), 26, 30

Archaeological Survey of India, 77, 91, 93

Archer, W. G., 24

architecture: colonial, 61, 63, 97; Indo-Saracenic, 61; Islamicate, 62; Sultanate, 59, 67, 90

artificiality, 73

Art India Magazine, 160

art market, 161

Arts and Crafts movement, 7, 42

art schools, 12, 14, 16, 169 n. 7

Ashbee, Charles Robert, 7

Ashoka, 63

Ashok Hotel, 48, 59–63, 74

astrology, 83–84, 97

astronomy, 125

authenticity, 7–8, 17, 24, 26, 46

avant-garde, 6–7, 107

Baij, Ramkinkar, 12, 54

Baker, Herbert, 61, 63, 90

Baker, Laurie, 46–47

Bakre, S. K., 135

Bangladesh, 11; 1971 war in, 47, 53, 79

baraka (spiritual proximity), 38

Baroda (Vadodara), 15–16, 161, 164 n. 15; fine arts school in, 169 n. 7

Barthes, Roland, 75

Barve, S. G., 143

Beat poets, 51

Belgian embassy (Delhi), 86–95, 101, 158, 168 n. 4

Bendre, N. S., 15

Bengal, 166 n. 4; in film, 26, 135; Ganesh Pyne's experience of, 58; nationalism in, 158; 1942 famine in, 47; preindependence art in, 76, 79, 164 n. 10

Bengal school, 12–15, 46, 54–55, 114, 161

Between the Spider and the Lamp (Husain), 31

Bhabha, Homi, 3

Bhakra dam, 122–23

bhakti, 55–56

Bharhut, 75

Bhatt, Jyoti, 16, 66, 169 n. 7

biblical reference, 53–54, 58, 79–80, 83, 158

Bihar, 127–28

bindu (cosmic dot), 49, 51–52, 66

Birla family, 47

Blue Night (Husain), 31–32

Bollywood, 78, 95–96, 101, 138, 146

Bombay, 41, 102, 131–132; as archetype, 135–36, 152, 155–56; art scene in, 12, 14–15, 159–60; Back Bay in, 146; colonial architecture in, 63; in film, 98–99, 137–48; fort area in, 146; Municipal Corporation for Greater Bombay, 144; naming of, 164 n. 11, 169 n. 1; Salvacao Church in, 47; Study Group for Greater Bombay, 143

Bose, Nandalal, 12, 46, 54, 57, 167 n. 7

Brahmanical texts, 40. *See also* Hinduism

Breach Candy Hospital, 145

brick, 87–91; mud-brick, 108–9

brise-soleil (sun-breaker), 121

Buddha, 70, 75

Buddhism: architectural elements related to, 61–65, 74, 90–91, 94; as seen by Orientalists, 93; tantric elements of, 50–53, 83; visual iconography of, 32, 34

bull symbol, 125, 127

Calcutta, 167 n. 7; art movements in, 12, 14–15, 46–47, 54; film in, 137; images of, 92; Kalighat paintings from, 81; naming of, 164 n. 11; 1946 riots in, 57

Calcutta Group, 14

calendar prints, 18, 48, 70, 72–73, 81

canon, 11, 20, 91, 161

Caravaggio, 79–80, 82

Caribbean, 9

caste, 25, 31, 100, 166 n. 5

Chaitanya, 48, 53, 55–56, 58, 76, 158

chakra, 111

Chakrabarty, Dipesh, 3, 6, 9, 157, 159, 168 n. 1

Chandigarh, 107–8; Assembly in, 109–10, 125; as capital city, 155; emulation of, 98; High Court in, 109–10, 112; Open Hand monument in, 122–23; planning for, 59; relation to the primitive of, 77, 111, 113–14, 116, 121, 149, 151; Secretariat in, 109; symmetry and, 126, 135–36

chandrashala archways, 2, 59, 61–63, 65

chhajja eaves, 59–62

Chhatrapati Shivaji Terminus, 63

chhatri (umbrella-like structures), 38–39, 59, 61, 67, 90

Chinese artists, 12

Chinnery, George, 92

Cholamandal: artists' colony in, 15, 115

Chopra, Yash, 2, 78, 95–96, 99, 139

Choudhury, J. K., 59–60

Christianity: in Bhupen Khakhar's work, 70, 72; compared to Buddhism, 93; in Ganesh Pyne's work, 53, 55–56, 58; Jamini Roy's imaging of, 76; Krishen Khanna's imaging of, 79–82; as source for iconography, 18, 34, 45, 47–48. *See also* religion; spirituality

churidar kurta (women's clothing style), 95, 100

City and Industrial Development Corporation, 145

class, 111, 166 n. 5; in Bombay, 146; in film, 100, 139, 144, 168 n. 6; in village contexts, 25, 31, 35

classicism, 61, 93

Cold War, 122

colonial city, 137, 170 n. 5

colonial discourse, 162; concept of discovery in, 167 n. 1; construction of India's past in, 86–87, 92–94; exoticization of India in 50, 102; in relation to

modernism, 111; valorization of India in, 24, 41, 43, 46

colonialism, 98, 106, 168 n. 2; art schools during, 13–14; colonial architecture, 61, 63, 97; colonial production of knowledge, 76, 118, 158; justification of, 77; in K. C. S. Paniker's work, 101, 113, 116; legacy of, 25, 30, 78, 94, 109; relation to modernity of, 5–6, 157, 159

color, primary, 112, 150

comedy, 28

communalism, 46–47, 57, 76, 78, 80–81, 165 n. 3. *See also* Hindutva; nationalism

concrete, 108–9, 111, 168 n. 4

constructivists, 118

Coomaraswamy, Ananda, 7, 24, 41–43, 46

Cooperative Milk Producers' Union, 123

Correa, Charles, 21, 150, 158, 161, 164 n. 17, 165 n. 1; articulation of village life by, 24–30, 34–35; construction of space by, 38; nationalism and, 42, 135; relation to religion, 46–47; as urban planner 132, 143–47; use of medium by, 36

Crafts Museum (New Delhi), 68

cross-dressing, 55

cubism, 7, 13, 54, 73, 153, 155

Dalai Lama, 51

Dalmia, Yashodhara, 136

Dandi, 36, 71

Daniell, Thomas, 92–93

Daniell, William, 92–93

darshan, 38–39, 49, 64–65, 68, 70, 72

Das, Kesu, 79

Das Gupta, Anshuman, 8

Dasgupta, Pradosh, 14

De, Biren, 49

death, 58, 70, 72

decay, 88, 114, 151

deities, 45, 50, 58

Delhi: Baha'i temple in, 166 n. 2; as capital city, 155; Heritage Center in, 160; in Krishen Khanna's work, 80–82; pre-nineteenth-century monuments in, 40, 63, 125; in Raghu Rai's work, 133, 136, 150. *See also* New Delhi

Delhi Shilpi Chakra, 15

demons, 50, 57

derivative: art as, 3, 9

development, 124, 134

Dhaka, 92

dharma, 34

diaspora, 160–61, 163 n. 1

diplomacy, 61

Discovery of India, The (Nehru), 76–77

display, 67–68

Doshi, Balkrishna V., 39, 88

D'Oyly, Sir Charles, 92

dress, 80–81, 130; Gandhi cap, 129; Indo-Islamic, 80

dualism, 72–73

Dudhsagar Dairy Complex, 123–27, 131, 158

Dutt, Sunil, 99, 141

earthquake: as metaphor for Partition, 95, 97, 100, 139

East India Company, 92

Einstein, Albert, 104, 116

Emergency, 74, 82, 167 n. 13

enlightenment, 23, 158; Buddhist, 34, 65; European, 9, 48

Euro-America, 103, 132; modernity and, 3, 5, 113, 157–59, 166 n. 5; nation formation in, 163 n. 7

Eve (biblical), 54

exhibitions, 40, 42, 160–61

exoticism, 50–51

famine, 57

Far Pavilions, The (film), 40

fashion, 95, 97, 99–100, 143

Fatehpur Sikri, 119

feminism, 19, 163 n. 4; third-world, 19

Festivals of India, 40, 42, 160

figure, 55, 72, 121, 134, 152, 156

film, mythological genre of, 76

folk traditions, 74, 82; construction of, 68; as internal Other, 162; in K. C. S. Paniker's work, 15, 85–86, 115–16; in nationalist art, 12–13, 46

fragmentation, 158, 167 n. 4; in Bhupen Khakhar's work, 70, 73; in Gieve Patel's work, 152; in K. C. S. Paniker's work, 85; in Raghav R. Kaneria's work, 67; in Satish Gujral's work, 94–95

Gaja Gamini, 165 n. 4

gallery display, 14–16, 19, 159–60

Game, The (Khanna), 81

Gandhi, Indira, 46, 82, 167 n. 13

Gandhi, Mohandas: centrality of the village for, 24–25, 32–39, 138; images of, 70, 103–6; industrialization and, 127; nationalism and, 131; rhetoric of *panchayat raj* by, 165 n. 6; Sabarmati ashram of, 43, 158

Gandhiji (Husain), 31, 105

Gandhi Smarak Sangrahalaya, 25, 35–38, 42–43

Ganges, 153–56

Garden City movement, 108

Garden of Eden, 54–56

Gaudiya Vaishnavism, 55–58, 166 n. 4. *See also* Chaitanya

Gauguin, Paul, 7, 14

Gehlot, Ramprakash L., 62–63, 167 n. 8

gender, 56, 160

Genesis, 54

geometry: in film, 140; in K. C. S. Paniker's work, 102; in Le Corbusier's work, 107, 111–15; as marker of modernism, 98–99, 104, 125–27, 136, 162; in Nas-

reen Mohamedi's work, 118, 121, 158; in Raghav R. Kaneria's work, 66; in Raghu Rai's work, 133; in Satish Gujral's work, 88; in tantric art, 51–52

German expressionism, 153

goddesses, 57, 64, 76

gothic style, 57, 63

Gottlieb, Adolph, 8

Group 1890, 15

Gujarat, 2, 15, 39, 123, 126

Gujral, Satish, 78, 86–94, 98, 101, 158, 164 n. 17

Gupta era, 90

guru, 17, 23, 25–30, 34, 40–42

Haji Ali Juice Stand, 145

halo, 65–66

Handloom Pavilion, Delhi, 35–36

Hand of Fatima, 32, 34, 109

Harappan culture, 41, 90; at Mohenjo-daro, 88, 91

Haryana, 122

Haussmann, Baron Georges-Eugène, 108

Havell, E. B., 41

Heritage Center (New Delhi), 160

heritage industry, 94

Himachal Pradesh, 122

Hindi, 137

Hindi cinema. *See* Bollywood

Hinduism, 18, 34; brahmanical, 50; iconography of, 45, 73; popular, 72; rituals of, 64, 73, 81; tantric, 50–53, 83; Varanasi and, 153. *See also* communalism

Hindu-Muslim relations, 46, 165 n. 3

Hindu nationalism, 41, 47–48, 158; Hindutva, 74, 76, 159, 167 n. 14

Hindutva, 74, 76, 159, 167 n. 14

historicism, 6–8

Hitler, Adolf, 104–5

Hodges, William, 92–93

homosexuality, 69, 160

Howard, Ebenezer, 108
hubris, 95, 97, 100
Humayun's tomb, 59, 91
Husain, M. F., 13, 17, 158, 165 n. 1; construction of history by, 104–6, 115; narrativity in the work of, 85; religious-themed work of, 46–47; village-themed work of, 25, 30–35, 43, 165 n. 4
hybridity, 3
Hyderabad, 11

iconicity, 18, 48, 53, 70, 74, 105
iconography, 18, 31–32, 45
Indianness, 5, 25, 39, 49, 68, 100, 109
India-Pakistan war of 1965, 96
indigenism, 15–16, 151, 157
industrialization, 9, 103, 106, 117, 131, 152
infinity, symbol for, 115
interior design, 97–100, 156
international (term), 10
internationalism, 100, 113–14
Islam, 32, 34, 47, 80, 82, 90
iwan arch, 59, 61, 63, 67

Jacob, Sir Samuel Swinton, 61, 90
Jainism, Digambara, 34
Jaipur, 61, 67, 90, 125
jali (carved stone screen), 59, 61–63, 109
Jami Masjid (Delhi), 40
Jamshedpur, 127, 131
Janah, Sunil, 127–30, 169 n. 12
Japan, 7; aesthetics of, 54; architecture of, 147; artists from, 12; Meiji-era modernization in, 168 n. 2
jarokha balcony, 59, 61, 63–65
Jesus, 80–82
Jewel in the Crown, The (film), 40
Judeo-Christian imagery, 56–57
Jungian thought, 8, 109

Kahn, Louis, 38–39, 88, 90, 158, 165 n. 7
Kaira Milk Cooperative, 123

Kairon, Partap Singh, 122
Kalighat, 12, 54, 81
Kaliya, 56–57
Kanchipuram, 166 n. 4
Kandinsky, Vassily, 48
Kaneria, Raghav R., 16, 48, 64–67, 169 n. 7
Kanvinde, Achyut, 123–27, 158
Kapoor, Raj, 137–44, 148, 150, 159
Kapoor, Shashi, 99
Kapur, Geeta, 13, 160; biographical approach by, 17; on modernism, 7, 167 n. 4; on Nasreen Mohamedi's work, 118, 121; on Ram Kumar's work, 152
Karachi, 160
khadi (homespun): cloth, 104; sensibility, 38
Khakhar, Bhupen, 16, 48, 69–72, 74
Khanna, Krishen, 13, 46, 78–85, 102
Kheda, 123
kitsch, 69
Klee, Paul, 13, 48, 83
knowledge: colonial production of, 76, 118, 158; scientific, 104, 113–14
Krishna, 55–57
Kumar, Raaj, 98, 140
Kumar, Ram, 132, 152–55

labor, 124, 133–36, 156
Lahore, 11
Lalit Kala Akademi, 15, 164 n. 14
Last Supper: as theme, 167 n. 3
Last Supper, The (Khanna), 79, 80, 82
Le Corbusier, 129, 168 n. 3, 169 n. 5; appropriation of, 2, 37, 39, 106, 150, 158; articulation of the primitive by, 83, 109, 111, 115–17, 121, 149, 151; collaboration with Nehru by, 59; construction of capital by, 135–36, 155; geometry in the works of, 112, 125–27; as quintessential modernist, 77, 108, 113, 152; use

Le Corbusier (*continued*)
 of technology by, 19; valorization of
 spirituality by, 24, 165 n. 7
Leonardo da Vinci, 80–81
Lichtenstein, Roy, 85
lila (play), 57
lingam, 53
lingam-yoni, 49, 52
Lutyens, Sir Edwin, 61–63, 90

Madras, 14–15, 113, 137, 164 n. 11
Madras Government College of Arts and
 Crafts, 14
Mahabharata (Indian epic), 75, 165 n. 4
Maharaja Sayajirao University, 15. *See
 also* Baroda
Mahmud Begarha tomb complex, 38
Malevich, Kasimir, 119
Malgudi, 138
Mali, 7
mandala, 45, 50, 70–73, 83
mantra, 50
Man with Bouquet of Plastic Flowers
 (Khakhar), 69
Mao Tse-tung, 104–5
Marx, Karl, 104
mask, 65, 72
materiality, 8, 107, 118, 121, 129
mathematics, 102–3, 106–7, 112–21, 126,
 129–33, 158
Matisse, Henri, 13–14
Matthew, Saint, 80
Mauryan empire, 90
Mayer, Albert, 108, 143
Mazumdar, Nirode, 14
Mediterranean, 79; architecture of, 39,
 90, 147
medium: acrylic, 168 n. 5, 169 n. 5; oil, 84,
 86, 114, 117, 158, 168 n. 5, 169 n. 5; tem-
 pera, 57, 114; terracotta, 12, 65; water-
 color, 114

megalopolis, 155
Mehsana, 123
Mehta, Pravina, 144
melodrama, 101, 138
memory, 69, 73
"Mera juta hai Japani" (song), 137
minaret, 62
minimalism, 118–19
Miró, Joan, 13
Mitchell, Timothy, 3, 9–10, 157
Modak, N. V., 143
modern, definition of, 4
modernization, 103–4, 130, 162, 163 n. 6;
 factories and, 124, 127; of India, in con-
 trast with Japan, 168 n. 2; in Indian art,
 18, 107; Nehruvian, 96; urbanization
 and, 131, 139; as Westernization, 9,
 113
Mohamedi, Nasreen, 8, 20, 126, 169 nn.
 6–7; materiality-abstraction in the
 works of, 118, 121, 129–30; modernity
 and, 158; postcoloniality and, 122
Mondrian, Piet, 112, 119, 121
Mookerjee, Ajit, 51–53
Morris, William, 7
Mother India, 47
Mother Theresa, 104
Mother Theresa (Husain), 32, 105–6
mud-brick, 108–9
mudra (gesture), 32–34
Mughal period: architecture, 38, 59, 90,
 119; court, 60, 79; iconography, 46, 54;
 painting, 12, 71; style, 97, 140
Muharram, 32
Mukherjee, Benode Behari, 12
multiculturalism, 3, 161
multistarrer, 95
multivalence, 111, 132
murals, 84
Murphy Radios, 141–42

murti (Sanskrit term) 46, 48–49, 52, 58, 64, 68, 74
museumization, 84–86
mythology, 16, 78, 146–47

Nalanda, 88, 91
Nandy, Ashis, 138
Narayan, R. K., 138
narrative, 18, 78–79; as central to Indian art, 75, 101; oral, 85–86; visual, 70, 72
National Gallery of Modern Art (Mumbai), 160
National Gallery of Modern Art (New Delhi), 15, 66, 104–5
national identity, 32–33, 66, 96, 152; as Hindu, 156
nationalism, 76, 100, 103, 113–15, 163 n. 7; Gandhian, 34, 131; as term, 10. *See also* Hindu nationalism
nationalist art, 12, 14–18; legacy of, for Ganesh Pyne, 54–55, 58, 158; of Ravi Varma, 47, 164 n. 9
nationalist discourse, 5; canon-building in, 91; knowledge production and, 78; valorization of Indian culture in, 24–25, 39, 43, 46, 81; village in, 30
National Museum (New Delhi), 59
Naxalite movement, 53
neem tree, 56, 58
Nehru, Jawaharlal, 11; architecture and, 59–60, 109, 111, 113; Bhakra dam and, 122–23; death of, 73; *The Discovery of India*, 76–77; modernization and, 18, 47, 104, 106, 127, 133, 152; optimism and, 42–43, 96, 100, 139; secularism and, 46
Nelson, George, 99
neocolonialism, 103
neotantrism, 46, 48–53, 83
New Bombay, 132, 142–46, 161; Belaspur artists' colony in, 147

New Delhi: architecture in, 59, 61–62, 67; diplomatic area of, 89; as international city, 135; Secretariat buildings in, 90
New Testament, 70, 79
Nizamuddin, 80–82, 102
nonalignment movement, 122
nonresident Indian, 161
nonviolence movement, 103
nostalgia, 96, 98, 107, 130, 136, 142, 146
Nowicki, Matthew, 108

"O meri zohra jabin" (song), 97
open-to-sky, 23, 25–28, 35, 37, 40–42, 146–47
Operation Flood, 124, 127
optimism, 42–43, 74, 98, 100–101, 122, 130, 139, 152
oral traditions, 85–86
Orientalism, 23, 42, 51, 77, 86, 93

Pakistan, 11, 96–97, 107
panchayat raj, Gandhi's rhetoric of, 32, 165 n. 6
Paniker, K. C. S., 14–15, 130; ancientness and, 83–86, 98; materiality and, 8; *Words and Symbols*, 20, 101–2, 107, 113–18, 158
Panikkar, Shivaji K., 8
paradox, 1–2, 11, 48, 68, 75, 78, 157, 162
Paris, school of, 14, 45
Partition, 11, 122; in Calcutta, 47, 53; Chandigarh and, 107; communalism and, 48, 76; deaths during, 164 n. 8; earthquake as metaphor for, 78, 95–98, 100–2, 139; migration due to, 15, 131
Passage to India, A (film), 40
Patel, Gieve, 132, 148–52, 156, 169 n. 3
Patel, Jeram, 16
Patel, Shirish, 144
Pather panchali (Rai), 25–27, 30, 158
pathway icons, 48, 64–68

patronage, 161

patua painters, 12, 54

peasant: for Le Corbusier, 111, 116–17, 127, 149, 151; in film, 137; valorization of, 106, 131

performance art, 160

performativity, 85

Picasso, Pablo, 7, 13–14

picturesque, 77, 86, 91–95

pilgrimage, 37, 43, 153

plastic, 73–74

popular culture, 66–69, 163 n. 6, 164 n. 10

popular prints, 18, 48, 70, 72–73, 81

Portrait of the Twentieth Century (Husain), 104–5, 115–16

postcoloniality, 2–6, 157–62; ancientness and, 78; fragmentation and, 58, 68, 70, 73, 85–86, 95; in M. F. Husain's work, 30–31; in Nasreen Mohamedi's work, 118, 122; postmodernity and, 167 n. 4, 167 n. 9; the village and, 25

postcolonial theory, 163 n. 1

postimpressionism, 114

postmodernism, 10, 64, 167 n. 9

poststructuralism, 163 n. 4

Prakash, Vikramaditya, 40, 109, 122

primitive: K. C. S. Paniker and, 116; Le Corbusier's approach to, 24, 77, 83, 111–13, 115, 117, 127, 129, 149, 151; modernism and, 39, 43, 109; as Other, 7–8, 54

primitivism, 109, 118, 121, 136, 166 n. 5

Progressive Artists' Group, 12–15, 114, 159, 164 n. 12

Progressive Painters' Association, 14

progressivism, 6–9, 103–6, 129, 134, 152

Public Works Department, 164 n. 17; Central, 63

puja, 73

Punjab, 77, 81, 98, 106–7, 110, 122

Pyne, Ganesh, 46–48, 53–55, 58, 72, 158

Rabindra Bhavan, 60

Radha, 56–57

Radha-Krishna, 55

Rahman, Habib, 60

Rai, Raghu, 75, 77, 83–84, 132–36, 148, 150, 156

Rajasthan, 40

Rajasthani painting, 71

Raj nostalgia, 40

Ramayana (Indian epic), 27, 75

Rashtrapati Bhavan, 61

Rawson, Philip, 51–52

Ray, Satyajit, 28, 35, 43, 135–36, 138, 165 n. 1; *Pather panchali*, 25–27, 30, 158

Raza, S. H., 13, 16–17, 49, 169 n. 5

Reddy, P. T., 11, 49

religion, 50, 63, 65, 68, 78, 80–81, 89. *See also* spirituality

revivalism, 63, 150

romanticism, 54, 57–58

roof: *bangla*, 67, 90; gabled, 136, 150

Rothko, Mark, 8, 115

Roy, Jamini, 18, 46, 54–55, 76, 79, 81

ruins, 77, 87, 89–93, 154

Rushdie, Salman, 130, 145–46

Saarinen, Eero, 99

Sabarmati Ashram, 35–36

Sabha, Fariborz, 166 n. 2

Sachdev, Achala, 99

Sadhana, 99

Sahni, Balraj, 95

Said, Edward, 3

Salt March, 36, 71

Sanchi, 75, 88–89; stupa at, 61–62, 90

Sanskrit, 26, 46–47, 49, 55, 89

Santal, 166 n. 5

Santosh, G. R., 48–49, 51, 53, 58, 74

Sarkhej, 38–39

Sarnath, 91; Dhamekh stupa at, 89

School of Fine Arts (Baroda), 169 n. 7

science, 39, 103, 130–131, 158; discovery and, 115–17, 162; modernization and, 18, 105–7; in Nasreen Mohamedi's works, 118, 121

script, 83, 116; exoticization of, 14

sculpture, 16; African, 7

Sculpture-I (Kaneria), 65–66

secularism, 34, 46, 48, 76, 82, 167 n. 4

Sen, Amartya, 41, 46

serpent, 54, 56

sexuality, 160

Shah Jahan, 40

Shaivite, 52

shakti (macrocosmic energy), 50

Shankarbhai, Shri, 69

Shantiniketan, 12, 14, 46, 54–55, 166 n. 6, 167 n. 7

Shastri, Lal Bahadur, 124

Sheikh, Gulammohammed, 15–16

Shiva, 45, 64

Shree 420 (Kapoor), 137–44, 148, 150, 159

Sikhism, 46, 82

Sikh separatist movement, 81

Singh, Gulzar, 59–60

Sir J. J. School of Art, 12–13

Sirk, Douglas, 100

skyscraper, 42, 108, 135

Souza, F. N., 13, 17, 46, 132–36, 151–52, 156

Soviet Union, 40

spinning, 135

spirituality: in art, 7–8, 48; cities and, 132, 153; modernist, 39, 45; pan-Asian, 51; secularized, 34–35; valorization of

India's, 23–24, 41–42, 45, 53, 156. *See also* religion

Spivak, Gayatri, 3

Sri Yantra, 52

Steel Smelting Shop (Janah), 128

Stella, Frank, 119, 121

storytelling, 75, 86, 101–2, 160. *See also* narrative

stupa, 61–62, 67, 88, 90

subaltern studies, 163 n. 4

Subramanyan, K. G., 12, 15–16

Sufism, 80–81

suprematists, 118

Swaminathan, Jagdish, 15

symbolism, 13, 31, 72, 74; bodies and, 52; Islamic, 34, 109; religious, 45; portraiture and, 105; tantric, 49, 84

symbolist movement, 7

symmetry, 52, 66, 126

syncretism, 66, 81

Tagore, Abanindranath, 12, 14, 46, 54–55, 57

Tagore, Gaganendranath, 54

Tagore, Rabindranath, 12, 14, 54, 166 nn. 5–6

Tagore, Sharmila, 100

Taj Mahal, 62

Tamil Nadu, 114

tantrism, 40, 49–51, 162, 166 n. 4; art of, 13, 52–53, 66, 83

Tata, Sir Jamshedji Nauservanji, 127

Tata Iron and Steel Works, 127

technology, 150; in architecture, 111, 115, 168 n. 4. *See also* industrialization; modernization

temporality, 33, 72, 74–75, 103, 119

Thailand, contemporary art of, 163 n. 2

Thomas, Saint (apostle), 80–82

Tibet, 45, 51

Traffic at Chawri (Rai), 133

translation, 68, 74, 114–15

Trenton Bath House, 38

tribal: cultures and practices, 7–8, 68; as term, 166 n. 5

Two Men with a Handcart (Patel), 148

Under the Tree (Husain), 25, 30–35, 43, 158

United States, 90, 160, 167 n. 9

Upanishads, 41, 50

Urdu, 97–98, 102, 137, 140

ushnisha (Buddha's head protrusion), 65

Vaishnavite imagery, 55, 58, 72

van der Rohe, Mies, 42

van Gogh, Vincent, 14

Varanasi, 2, 132, 135, 152–56

Varma, Ravi, 12, 18, 47, 114, 164 n. 9

Vedas, 40, 50

vernacular, 37, 39, 55, 64, 77, 150

Viceroy's House (New Delhi), 67, 90

Victorian attitudes, 50–51

Victoria Terminus, 63

Vigyan Bhavan Conference Center, 2, 48, 59, 61–63, 65, 74

village, 26, 162; critical readings of, 29–39, 43; film audience in, 168 n. 6; for Le Corbusier, 77, in M. F. Husain's work, 165 n. 4; in Raghav R. Kaneria's work,

66–68; within the urban, 135, 137–39, 142, 148, 150–51

Vishnu, 64, 70; Vaishnavite imagery, 55, 58, 72

Vishnupur, 56

Vistara exhibition, 40, 42

Visva Bharati University, 54. *See also* Shantiniketan

Vrindavan, 55–56

Waqt (Chopra), 2, 18, 20, 132, 156; audience of, 168 n. 6; modern city and, 139–44, 148; Partition metaphor in, 78, 95–102

Warli painting, 85, 116

Westernization, 103, 107, 113

woman, as icon, 54

Woman, the Serpent (Pyne), 53, 55, 72

womanhood: modernity and, 100–101

Words and Symbols (Paniker), 20, 101–2, 107, 113–18, 158

World War II, 103, 142

Wright, Frank Lloyd, 88

Yanagi, Soetsu, 7

yantra, 45, 66; Sri Yantra, 52

yoga, 41

yoni, 49, 52

Zen, 51

zero, concept of, 115

REBECCA M. BROWN is a visiting associate professor of art history at Johns Hopkins University.

Library of Congress Cataloging-in-Publication Data

Brown, Rebecca M.
Art for a modern India, 1947–1980 / Rebecca M. Brown.
p. cm. — (Objects/histories)
Includes bibliographical references and index.
ISBN 978-0-8223-4355-4 (cloth : alk. paper)
ISBN 978-0-8223-4375-2 (pbk. : alk. paper)
1. Art—India—20th century.
2. Modernism (Art)—India.
3. India—Civilization—20th century.
I. Title.
II. Series.
N7304.B68 2009
709.54—dc22
2008040666